SPIRIT OF CHIAPAS

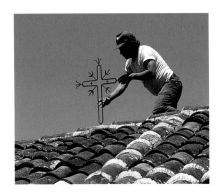

I dedicate this book to the *herreros*,
past and present, who have left their
fingerprints on the iron roof crosses of
San Cristóbal de Las Casas, Chiapas;

and to the memory of Don Polo,
a true maestro, who in the shadows of
his *herrería* first introduced me to the
beauty of hand-wrought ironwork.

SPIRIT OF CHIAPAS

The Expressive Art of the Roof Cross Tradition

FEATURING

THE FRANS BLOM COLLECTION

AT NA BOLOM

VIRGINIA ANN GUESS

Photographs and Maps
by Robert Guess

MUSEUM OF NEW MEXICO PRESS

SANTA FE

Jacket photograph: Procession of Saints, Santiago, 1972. Photograph by Robert Guess.

Project editor: Mary Wachs
Manuscript editor: Ann Mason
Art design and production: Deborah Flynn Post
Composition: Set in Berkeley Old Style with Gill Sans display
Manufactured in Korea
10 9 8 7 6 5 4 3 2 1

Library of Congress Cataloging-in-Publication Data
Guess, Virginia Ann, 1938-
 Spirit of Chiapas : the expressive art of the roof cross tradition :
featuring the Frans Blom collection at Na Bolom / by Virginia Ann Guess ;
photographs and Maps by Robert Guess.
 p. cm.
 Includes bibliographical references and index.
 ISBN 0–89013–428–6 (clothbound)—ISBN 0–89013–429–4 (paperbound)
 1. Maya art—Mexico—San Cristobal de las Casas—Themes, motives. 2. Maya
architecture—Mexico—San Cristobal de las Casas. 3. Crosses—Mexico—San
Cristobal de las Casas. 4. Symbolism in art—Mexico—San Cristobal de las
Casas. 5. Blom, Frans Ferdinand, 1893-1963—Ethnological collections. 6.
Museo Na Bolom (San Cristãobal de Las Casas, Mexico)—Catalogs. 7. San
Cristobal de las casas (Mexico)—Guidebooks. I. Guess, Robert. II. Title.
 F1435.1.A7G84 2004
 246'.558'097275—dc22
 2004000784

Museum of New Mexico Press
Post Office Box 2087
Santa Fe, New Mexico 87504

CONTENTS

ACKNOWLEDGMENTS

O N MY FIRST JOURNEY TO CHIAPAS, Mexico, over thirty years ago, I was fascinated by the iron crosses that adorned roofs in San Cristóbal de Las Casas. These rusting talismans, in an array of different styles, cast mystifying silhouettes over the entire sky. While they seemed to confirm the deep spirituality of the Chiapanecos, this artistic expression also was a reminder of the eclectic religious environment in which they lived, one shaped from a rich mosaic of Maya and Hispanic beliefs. As a memento of my introductory visit, I selected a rather garish cross from a display of tourist items in a small shop on Calle Real de Guadalupe in San Cristóbal. Although the cross did not resemble those I had seen on rooftops, it represented the changes that folk art undergoes in response to pressures from external influences and internal economics. On subsequent trips, I haunted stores in search of older examples that more closely resembled those still on roofs, asked friends for permission to photograph their crosses, and then sought out ironworkers who would copy old designs. As the duration of my stays increased over the years, I watched as the number of roof crosses visible from the cobblestone streets slowly diminished.

Thanks to the foresight of Frans Blom, who began collecting iron roof crosses in the early 1950s, many remain on permanent display at his former residence in San Cristóbal, now a regional museum known as La Asociación Cultural Na Bolom or, simply, the Na Bolom museum. When Susanna M. Ekholm, Supervisora del Patrimonio de Na Bolom, invited me to document the Frans Blom Iron Roof Cross Collection, I responded with reserved

enthusiasm. Already aware of the paucity of information on the subject, I wondered if it would be possible to uncover sufficient data to provide some cultural context for the crosses in the collection. However, I accepted the challenge, and thus began the research for what follows. In July 1995, I examined, measured, and, with Robert Guess, photographed the entire collection. This initial information, including copies of photographs of each cross, was deposited in the form of an unpublished manuscript in La Biblioteca Fray Bartolomé de Las Casas at Na Bolom. While these roof crosses formed a large and accessible sample to study variations in design and style, they yielded few clues about the history of the craft or the function of roof crosses in the everyday lives of the local people.

Only after several years of walking the busy avenues of San Cristóbal and the dusty streets of its old barrios in search of roof crosses, asking residents to tell me about their crosses, and watching ironworkers heat and bend metal over their anvils into the cruciform shape, did the full voice of the roof cross tradition emerge. It spoke in terms of aesthetic characteristics but also of the meaning and function the crosses have for those who make them, and for those who use and believe in them. When considering such beliefs, any explanation of this enduring custom can be only speculative, as well as applicable to the region in which it exists. Since my focus is on an area that I know best, Chiapas, what follows is specific to this state rather than a definitive study of roof and house blessing crosses. The goal of this study is to stimulate further investigation into this exceptional and unheralded regional craft.

Although many people contributed information and ideas that are incorporated in the book, any errors in interpretation and conclusions are my own. I wish to extend particular thanks and recognition to historians Andrés Aubry and Jan de Vos, whose meticulous documentation of the history of San Cristóbal and Chiapas provides background for any analytical work in this region; and to the late archivist Angélica Inda and chronicler Manuel Burguete Estrada, who shared with me what they knew and what they did not know about the roof cross tradition in San Cristóbal. Others have contributed in more specific ways. Will and Bethany Ouimet, volunteer assistants in the Archivo Fotográfico de Na Bolom, sorted through thousands of negatives and prints in search of images of iron crosses in the collection.

Will Ouimet provided me with drawings of crosses visible in old photos but no longer in the collection. Librarian Candelaria Moreno of La Biblioteca Fray Bartolomé de Las Casas kept me company during hours of turning tattered pages of guest albums looking for photographs of Na Bolom in which crosses appeared in the background. Señora Beatriz Mijangos Zenteno, who lived at Na Bolom during the years Frans Blom accumulated his collection, shared with me her reminiscences on how he acquired the crosses as well as her interpretation of the various symbols that adorn them. The entire staff of Na Bolom welcomed me daily and allowed me the rare luxury of passing hours undisturbed in the central patio, where I could study the collection and reflect on the meaning of this unusual folk art.

Five local ironworkers, the late Leopoldo Morales Martínez, Guadalupe Hermosillo Escobar, Carlos Hernández, Carmen Penagos Morales, and Enrique Penagos Espinosa, patiently studied photographs of the collection, gave me their impressions of the relative ages of the crosses and their interpretations of the symbols, and then replicated several examples of the old designs so that I could observe the fabrication process. Friends opened their homes and made their private collections available to me so I could examine many older roof crosses. Samuel K. Clark shared his collection of iron crosses from Guatemala and Ecuador as well as the stories of how he came to acquire them. The photographs and observations of Katy and Robert Zappala further enhanced my understanding of roof crosses from Ecuador. Many other friends offered sage advice and relentless encouragement that helped bring focus to this work, including Carol Karasik, Cheryl Rivers, and Rosalind and Richard Perry. My appreciation extends to Licenciado Mario Uvence Rojas, Presidente del Patronato de la Asociación Cultural Na Bolom, and to Fabiola Sánchez Balderas, Director Ejecutivo de Na Bolom, for their permission to reproduce my descriptions and the photographs of the Frans Blom Iron Roof Cross Collection.

Special recognition goes to Mary Wachs, my editor at the Museum of New Mexico Press, who shepherded this book from beginning to end. Thank you, Mary, for your willingness to take a chance on an unknown author writing on an obscure subject from a controversial part of the world. Without the indefatigable support of two others, however, this publication would never have been completed: Susanna Ekholm, who started me

off on this "way of the cross" and offered continual support and assistance; and Robert Guess, who embraced the project with commitment to match my own, accompanying me to photograph every cross from all possible angles with his never-failing willingness to scale "just one more roof" for that optimum view.

I owe the greatest debt, however, to the residents of San Cristóbal de Las Casas, the homeowners who suddenly opened their doors to find a stranger photographing or sketching their roof crosses. Without exception, they welcomed me with courtesy and expressed delight at meeting someone who was interested in an object that had meaning to them and their families. Several invited me into their patios and even to their rooftops so that I could enjoy the best views of their crosses. Their stories and recollections provide much of the information that brings this tradition to life.

INTRODUCTION

UNTIL 1 JANUARY 1994, when the startling news of a rebellion reverberated throughout Mexico and the rest of the world, Chiapas lingered almost forgotten in the southeastern corner of this vast country. Its reputation as the state dotted with magnificent Maya ruins and rich in oil and electric power resources overshadowed the realities of the poverty, illiteracy, and lack of access to basic health and education that engulf over one-fourth of the inhabitants of Chiapas, including many descendants of the ancient Maya who live in rural areas scattered throughout 74,000 square kilometers of land.

Established as a province under the jurisdiction of la Capitanía General de Guatemala shortly after the Spanish conquest, Chiapas did not become a state within the Republic of Mexico until 1824. Only in 1950, when the Pan American Highway finally reached San Cristóbal de Las Casas, were the highlands, home to a large concentration of modern Maya, linked to other parts of Mexico. Until then, isolated and rarely visited except by a few adventuresome travelers, the Indians and Ladinos of Chiapas were left to their own ingenuity to cope with the exigencies of daily life. Here they developed traditions, distinct at first from the rest of Guatemala and later from Mexico, to deal with the unpredictable and often harsh environment in which they lived. These were often visually expressed in their crafts and cleverly veiled in the cloak of Catholicism. These beliefs remain embedded in the hybridized culture that developed, one marked by a strong underlying spirit of unrest that surfaces periodically in local revolts.

Sounds of this rebellious voice echo through the pages of history. It was initially heard from the Chiapanecs, one of the first indigenous groups in this region to resist the Spanish invasion in the early sixteenth century. Later, the Lacandon Maya evaded subjugation for centuries by hiding in the vast expanse of lowland jungles in the eastern part of the state. In 1712, the Tzeltal-speaking Maya rebelled against a Spanish viceroy with an uprising in Cancuc, and then in 1869 the Tzotzil-speaking Maya of San Juan Chamula rose up in another protest against the government. Following the Revolution of 1910, this defiant spirit was somewhat subdued by anti-Christian campaigns throughout Mexico that left a deep imprint in Chiapas, where people witnessed violation of their churches, altars and *santos* (images of saints), along with the expulsion of clerics. With this history of struggle, the 1994 uprising was just one more outcry for the rights of indigenous people and their share in the economic growth and political voice of the Republic of Mexico. Issues in the Indian communities over land rights, autonomy, and religious affiliations continue to plague this state, often resulting in hostile confrontations.

Population growth, political upheavals, armed rebellions, and environmental problems have left immeasurable scars on the landscape of Chiapas, once renowned for its biological diversity and pristine natural habitats shaped by five distinct climatic and geographical zones. These physical contours include the Pacific coastal plain, or Soconusco, with its record of human habitation dating to nearly 3000 B.C. and conquered by the Aztecs in the fifteenth century; the high mountain range of the Sierra Madre de Chiapas that separates the coastal zone from the rest of the state; the Central Depression carved out by the rapid waters of the Río Grijalva, first inhabited by the ancestors of the Zoques around 1000 B.C. and settled later in A.D. 500 by the Chiapanec; the Mesa Central, or Chiapas Plateau, formed by the lofty mountains of the highlands, home to the descendants of the ancient Maya; and the vast lowland tropical rain forests, where archaeological ruins testify to the past grandeur of the Maya civilization dating from 200 B.C. to A.D. 1200. In each of these varied zones, often separated by impenetrable natural barriers, human populations lived for centuries prior to conquest in a delicate balance with their environment. Once a sparsely

ROOF CROSSES IN CHIAPAS

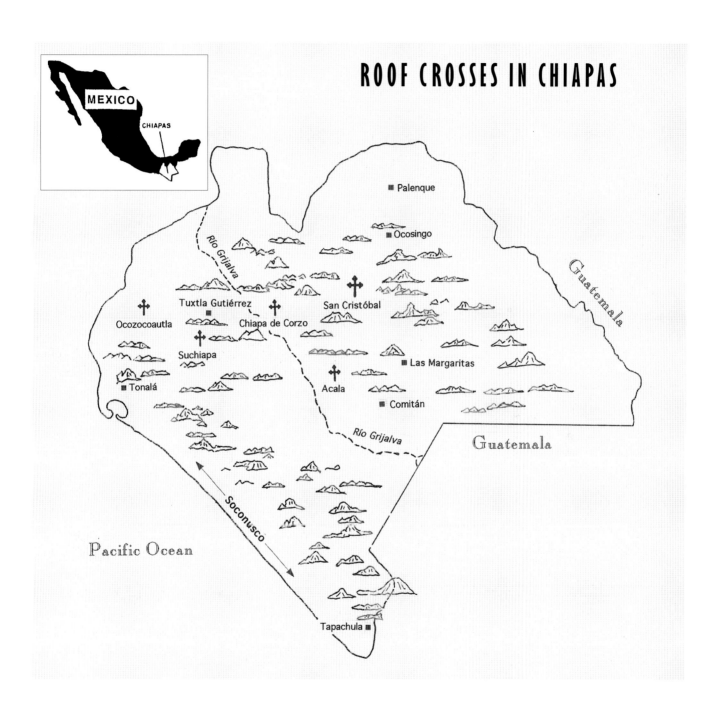

populated region, the number of inhabitants has increased rapidly from a million and a half in 1970 to over four million at the beginning of the third millennium.

In spite of the changes brought about at the hands of humankind, however, the natural beauty of Chiapas endures. In the highlands, inhabited by nearly one million Indians and a large population of Ladinos, traditions and local customs persist amid forest-draped mountains and open skies. Billows of pure-white clouds continue to punctuate the azure sky as they float along their familiar course from the Caribbean Sea to the Pacific Ocean. Driven by Mother Wind, the Maya term of respect for this invisible breath of nature, during the rainy season the clouds darken and drop their moist elixir that nourishes the *milpas* to the accompaniment of thunderclaps and jagged bolts of lightning. The vast sky, illuminated by day with light from Father Sun, and at night with the glow from the stars and changing phases of the moon, fascinated the ancient Maya, who peopled their cosmos with deities and spirits. We find today, jutting upward from tiled roofs into this infinite space, crosses carefully installed to protect the houses and their inhabitants from the unpredictable whims of nature and other quixotic forces. This custom of roof crosses, passed from one generation to the next, is just one more vestige of the spiritual heritage that characterizes the state, a potpourri of folk beliefs blended with the dogmas of Catholicism.

All too frequently we take for granted such familiar objects until they begin to disappear, a point at which their history and original function may be long forgotten. The iron roof crosses of San Cristóbal may not have yet reached this critical stage, but it is not far in the future. With the passing of an older generation of ironworkers and a new emphasis on creating souvenirs for travelers who flock to this colonial city, contemporary artisans now produce iron crosses in a stereotypical style sold almost exclusively as a tourist craft. These modern souvenirs adumbrate the older, more imaginative crosses that were popular in the late-nineteenth and early-twentieth centuries. Fortunately, a sufficient number of these remain in Chiapas to piece together the development of this folk art.

The evolution of the ironwork craft in San Cristóbal reflects the distinction Nelson Graburn makes between folk art and tourist art in *Ethnic*

and Tourist Arts: Cultural Expressions from the Fourth World, defining folk art as objects created by craftsmen without formal training to fill the needs of their community and tourist art as items made for commercial profit in keeping with the aesthetic values of the buyers, not necessarily those of the craftsmen.[1] Such changes occur in the wake of cultural contacts, notably soon after a region opens up to tourism as it did in Chiapas in the 1960s.[2] Today, in San Cristóbal the few practicing ironworkers recall the traditional styles of roof crosses but prefer making crosses designed for the more lucrative tourist market. Moreover, residents who still want to follow the custom are now inclined to purchase a ready-made cross rather than commission one in a more traditional style from an ironworker.

What follows traces the evolution of this folk art in Chiapas as it developed into tourist art. Part 1 consists of a history and interpretation of the custom of installing roof crosses on private homes in Chiapas in a cultural and religious context. It reconstructs how this local craft developed over the last few centuries in Chiapas and concludes with an overview of the custom as it exists in several Latin American countries. Part 2 describes a collection of thirty-two iron roof crosses on public display at the Na Bolom regional museum in San Cristóbal—the Frans Blom Iron Roof Cross Collection. Each cross is classified according to a scheme of styles that I developed as a result of analyzing the features of these crosses as well as from surveying extant crosses still visible on roofs and in private collections. Part 3 provides a walking tour through the old barrios of San Cristóbal to view iron crosses still visible on roofs. Included are maps to locate the crosses and suggestions for examining and appreciating this almost forgotten genre of ironwork, a craft that adds to the rich artistic heritage of Mexico.

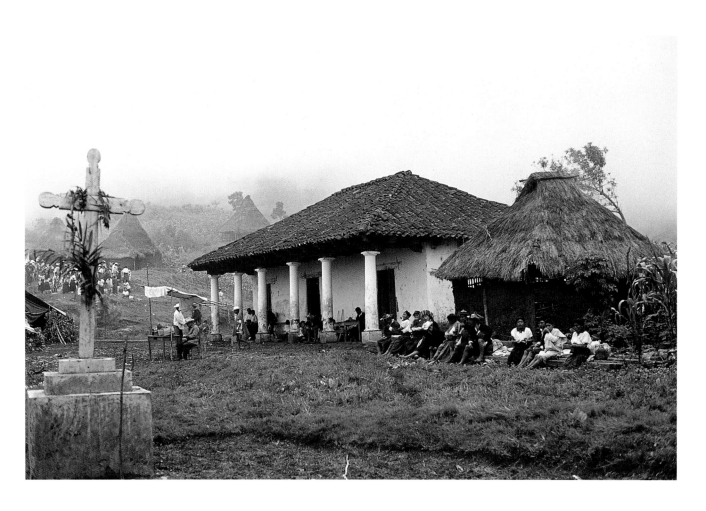

ENTRANCE CROSS.
A wooden cross draped with
bromeliads and mounted in a
cement base marking the entry
to the Tzotzil community of
Santiago in highland Chiapas.

THE CROSS IN THE NEW WORLD

MANY SURPRISES AWAITED THE SPANISH *conquistadores* in the sixteenth century when they first ventured ashore in the New World, for they encountered a people with their own history of conquest who had amassed considerable wealth at the expense of their subjects and who also shared with them a common symbol. Amazed when he spotted a cross on the shores of the newly discovered land, Hernán Cortés presumed that this part of the world had been visited centuries before by missionaries dispersed to spread Christianity throughout the world, even though no evidence existed for this premise or his conclusion that this was the same Christian cross depicted on his banner of conquest. As a result, the conquering Spaniards never truly comprehended the meaning of the cross to inhabitants of the New World, a misinterpretation Christian missionaries were to intentionally exploit in their widespread evangelization.[3]

For the indigenous people of the New World, the cross represented the basis of their cosmology, beliefs about the origin and order of their world.[4] Symbolic of their *axis mundi*, it depicted the four sacred directions from which Mother Wind drove the plumes of clouds laden with rain across the vast heavens to nourish the soil. For the Aztecs who first confronted the Europeans, it was the emblem emblazoned on the forehead and fiery cloak of their old god Quetzalcoatl, an association that led to their confusion between this lost deity and the Spaniards, ultimately contributing to their defeat. To the ancient Maya, the cross represented the god of maize, as well as the sacred ceiba tree that linked the celestial sphere with the mysterious underworld, the home of their ancestors. It stood as a

guardian of their water sources and sacred gateway to their settlements, allowing them to secretly practice their own traditions within the framework of Christian dogma and iconography as preached by the missionaries with their crosses.

The cross, as one of the most ancient symbols known to humankind, far predates Christianity. It appears in Paleolithic cave art of the Old World and as a motif woven into fabrics and carved on stone sculptures throughout the Americas. Its intersecting lines, arranged in various patterns with a wide range of meanings, can be used as written signs or as gestures. Political, humanitarian, and religious groups have adopted various cruciforms as emblems of both war and peaceful causes. Artists have employed it to create masterpieces in paintings and sculpture. Further, this symbol is so ingrained in daily life that often without even thinking we cross our fingers in hopes of good fortune, cross our hearts in promise of secrecy, and cross ourselves in a sign of faith. Today, in many regions throughout Mexico and Latin America, people still cross themselves or loved ones for good luck as they leave the security of their homes or embark on a long journey, and bless themselves as a sign of respect when passing a church.

In Christian history, although the Latin cross, shaped like the one used in the Crucifixion, was always a sign of faith, it was not until the early part of the fourth century that it was adopted as a universal symbol of Christianity. It was then that Empress Helena, the mother of the Holy Roman Emperor Constantine, discovered in Jerusalem the cross believed to have been used in the Crucifixion. At first, Christians preferred an unembellished cross as their standard, or occasionally one with the head of Christ painted at the top where the arms and upright joined. However, by the fifth century, they were adorning the cross with a full-figure image of Christ either carved or painted, like the crucifix now favored by Roman Catholics.[5] Following this modification, the Crucifixion became a common theme in the artistic expression of the Middle Ages, while the cross itself appeared on banners under which the Crusades were fought. Moreover, the armies of Spain selected the imprint of the cross as their standard in the battle to free their homeland on the Iberian Peninsula from the Islamic influence of the Moors, a centuries-old struggle that ended in 1492.

Fresh from this military victory, the Spaniards came to the New World in the early 1500s under the same flag with a strong commitment to spread Christianity throughout the world. Thus the symbol of the cross became the link between two spiritual worlds, Christian monotheism and the indigenous polytheism firmly established in the Americas. The fragile coexistence of Catholic tenets with native rituals, of so-called orthodoxy and paganism, eventually developed into orthodox Catholicism and Indian Catholicism.[6] The Spaniards further added to the mixture of traditions when, in addition to introducing to the New World the official dogmas of Catholicism as directed from the Papacy in Rome, they also brought many customs of folk Catholicism, including processions, folk saints, home altars, and *cofradías*, sixteenth-century Spanish special societies to care for images of the saints, or *santos*. Today, these religious expressions still play an important role in the folk Catholicism of many parts of Latin America. It is the constant interaction among these various aspects of Catholicism, along with additional innovations, that gives the religion practiced in these Latin countries its individuality, although the cross remains a unifying symbol.

VISITING SANTOS.
Statues of saints leaving the Church of Magdalenas in highland Chiapas bundled in straw for the journey to visit saints in nearby Santa Marta.

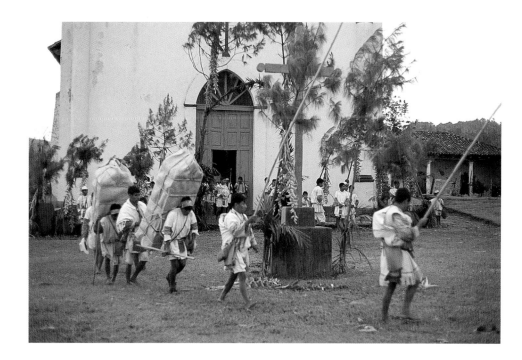

The dichotomy of orthodox and Indian Catholicism continues to this day in parts of Mexico with large numbers of Indians who still speak their native languages, live in autonomous communities, and follow traditional ways, or *costumbres*, such as wearing characteristic clothing, participating in ceremonies to honor *santos*, performing music and dances at fiestas, employing medical lore in healing, and producing crafts for daily use. The cross plays a role in many of these *costumbres*. In the states of Oaxaca and Chiapas, which have the largest indigenous populations in Mexico, crosses are omnipresent. The Zapotecs of Oaxaca, for example, place rustic crosses adorned with flowers in cornfields, near water sources, along roadsides, on mountain peaks, and in locations marking cardinal points and boundaries.[7] This strong presence of the cross exists throughout Chiapas, especially in the highland region, where many modern Maya continue to live. Chiapas, still considered the "backyard" of Mexico, even referred to by urbanized Mexicans as a "province," remains the least-developed region of the country. Here, wooden crosses dot the countryside near communities of the modern Maya, while iron crosses mark the homes of Catholic Ladinos in the adjacent towns. Consequently, Chiapas may offer one of the best opportunities to examine how ancient indigenous beliefs related to the cross have merged and coexist with orthodox Catholic dogma.

CONQUEST OF CHIAPAS

When the Spaniards arrived in what today comprises the state of Chiapas, they confronted an indigenous population that spoke several different languages. Except for the Zoques, who inhabited the western part of the territory, and the Chiapanecs, who lived in the southern section of the Central Depression along the Río Grijalva, most of the inhabitants spoke a Mayan language. Originally, indigenous inhabitants were identified by the community in which they lived, but recently, the more accepted way to distinguish them is by the language they speak.[8] The territory of the Maya, rich in diversity with a long history of settlement, included then as now the lowland jungles of the Lacandones and the Ch'oles and the highlands, or Central Plateau, settled by the Tzotziles, Tzeltales, and Tojolabales. In addition, a stretch of coastal plain edged by the Pacific Ocean and separated from the

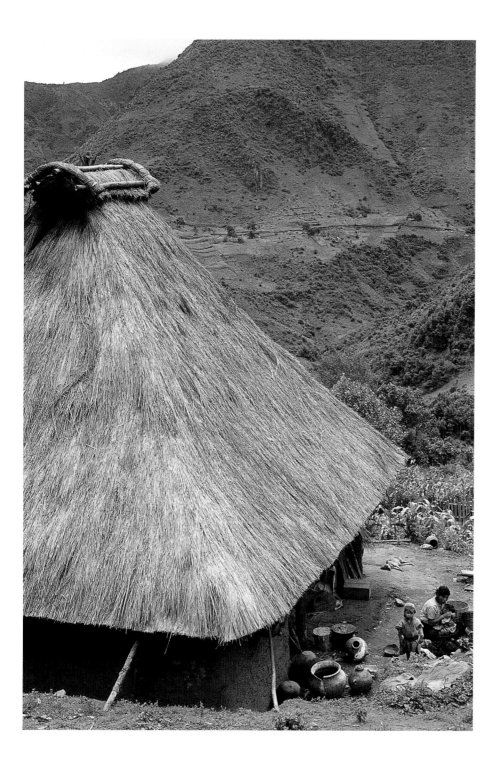

ROOF CROSS.
A tiny wooden roof cross on the peaked thatch roof of a traditional-style house in the municipality of San Juan Chamula.

Central Plateau by the Sierra Madre de Chiapas, was occupied in pre-Hispanic times to serve as a major trade route extending from the Valley of Mexico into Central America. This region, known as the Soconusco, together with the territory of Chiapa, for a brief period after the initial conquest was part of New Spain with its center of power in Mexico City.

Although Capitán Luís Marín led the Spanish vanguard into Chiapas in 1524, it was another four years before Capitán Diego de Mazariegos arrived to establish permanent Spanish settlements. In March 1528, after subduing the Chiapanecs, who controlled the territory around the Río Grijalva, and their Zoque neighbors to the northwest, he laid out the settlement of Chiapa de los Indios, later known as Chiapa de Corzo. He then proceeded with his troops into the highlands, where he encountered another Spanish military leader who also intended to claim the region. Dispute over this territory, located at the periphery of two centers of political power, la Capitanía General de Guatemala under Pedro de Alvarado and New Spain to the north commanded by Hernán Cortés, complicated conquest. Control over what is today Central America was a prize that the conquerors of the New World raced to claim: a strategic strip of land bridging two continents, as well as the narrowest point of land between two oceans. Somewhere near Huixtán, Mazariegos, dispatched by Cortés from the Valley of Mexico with his contingency of troops from Mexico and Oaxaca, met Pedro de Portocarrero, the emissary of Alvarado who had come north from Guatemala with his army. The two military leaders agreed that Mazariegos, not Portocarrero, would proceed to the Valley of Hueyzacatlán to establish a major Spanish settlement in the highlands. Some of the indigenous troops from Guatemala went with Mazariegos to the site of what would eventually become San Cristóbal de Las Casas.[9]

Here, on 31 March 1528, Mazariegos founded a town for the Spaniards, initially referred to as Chiapa de los Españoles to distinguish it from Chiapa de los Indios, which had been established earlier in the same month for the Zoques who lived in the Central Depression. Some suggest that the state's name of Chiapas evolved from the designation for these two early settlements, or the two Chiapa, and that the first province was referred to as "la Provincia de los dos Chiapa." Others purport, however, that the name Chiapas comes from the designation for the Province of Chiapa plus that

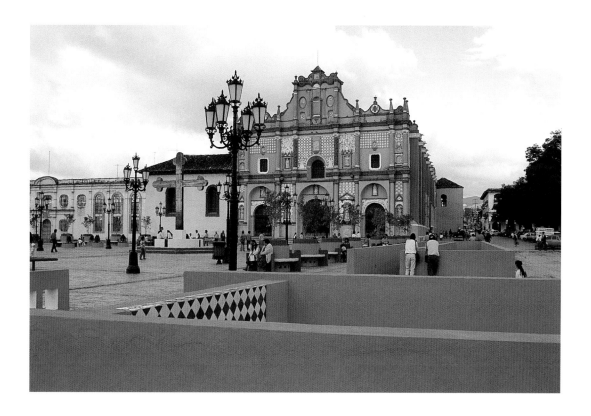

CATHEDRAL OF SAN CRISTÓBAL DE LAS CASAS. Repainted in 1993, the cathedral reflects a color scheme similar to that of the colonial period in San Cristóbal de Las Casas.

for the Province of Soconusco, both included in the domain of el Reino de Guatemala. The latter explanation seems more plausible since the name of Chiapa de los Españoles was changed to Villa Real de Chiapa in 1528. The town underwent many further name changes during the next five hundred years until adopting in 1943, by presidential decree, the present name of San Cristóbal de Las Casas,[10] one that honors both the patron saint San Cristóbal (Saint Christopher) and the renowned advocate for indigenous rights Fray Bartolomé de Las Casas.

The initial layout of this town, characterized by distinct barrios, closely resembled the European urban plan, according to which tradesmen and artisans lived and worked in designated sections.[11] At first, the districts were created to accommodate the various native troops recruited by Mazariegos, who were assigned to separate linguistic and cultural districts apart from the Spaniards, who built their houses around the Plaza Central.[12] The indigenous recruits who had come from the Valley of Mexico,

Tlaxcala, and Oaxaca settled in Barrio de los Mexicanos, Barrio de Tlaxcala, and Barrio de San Antonio on the west side of town. Those who had accompanied Portocarrero from Guatemala and opted to join Mazariegos set up communities in Barrio de San Diego and Barrio de Cuxtitali on the eastern edge. The servants in the houses of the Spaniards resided closer to the center in Barrio de la Merced. Rather than building a town fortified by a protective wall, these six districts functioned as a defensive zone around the main plaza, where the Spaniards lived. Most of the early construction was accomplished through the forced labor of the conquered Tzotzil- and Tzeltal-speaking Maya. When such slavery was banned in 1549 due to the efforts of Bartolomé de Las Casas, the first bishop of the new territory to set foot on the land, many of these Indians who chose to remain rather than return to their native communities settled in a district created especially for them, Barrio del Cerrillo.[13]

Spain's settlement of the New World had many stages, causing some confusion over the names of the different regions. Originally, the entire territory was referred to as New Spain to distinguish it from the lands claimed by Portugal, which today consist mostly of Brazil. To maintain control over this vast area, which included parts of North America extending to the tip of South America, however, the government in Spain soon divided up the regions into various viceroyalties and *audiencias*. The original viceroyalties were New Spain and Peru, with the boundary in Central America with present-day Panama in the Viceroyalty of Peru.[14] The Spanish Crown, however, kept Central America, because of its important position between the two major viceroyalties of New Spain and Peru, directly dependent on the king of Spain.[15] As a first step in this process, la Capitanía General de Guatemala, la Audiencia de los Confines, was created in 1544, a region that included all of Central America with the exception of Panama plus the present state of Chiapas. By 1560, this *audiencia* was officially separated from the Viceroyalty of New Spain and referred to as el Reino de Guatemala, the Kingdom of Guatemala.[16] As a result, the two provinces of Chiapa and Soconusco shared more with the early history of Guatemala than with the territory of New Spain to the north. In both situations, however, these provinces remained isolated from the center of power, and a provincial way of life developed in San Cristóbal de Las Casas, far from the more cosmo-

politan influences of Antigua, the first capital of el Reino de Guatemala. During this era and up to 1821 when New Spain and Guatemala gained independence from Spain, the Catholic church was the most powerful institution in the Americas. However, this power shifted with the formation of independent countries and different systems of governing. In 1824, the Province of Chiapa became a state in the Republic of Mexico, with San Cristóbal de Las Casas as the first capital. In 1842, the Province of Soconusco also was annexed to Mexico, and by 1882 combined with Chiapa to make up the present territory and state of Chiapas. San Cristóbal remained the capital until 1892, when the state's government was transferred to Tuxtla Gutiérrez.

Remnants of the nearly three-hundred-year association with Guatemala are still evident in Chiapas, where a social and cultural milieu developed that distinguishes it from the other states of Mexico reflected especially in the colonial architecture, the selection of favored saints, and other local customs. The physiography of the land has had a significant impact on the type of culture that emerged here. Isolated by high mountains, swept by fierce storms, and lacking consistent communication with the central government in Antigua, the population developed its own identity distinct from other parts of el Reino de Guatemala. Moreover, the unpredictable and occasionally violent weather in the state even influenced the custom of roof crosses.

As early chronicles of the city verify, the valley that encapsulates San Cristóbal, known for the thunder and lightning tempests that precede seasonal torrential downpours, has a long history of flooding, frequently resulting in casualties and the destruction of entire barrios. During the rainy months from June to October, large fluffy clouds creep across the eastern sky to settle over the languid valley. In the early afternoon, they darken as their ominous presence blots out the sun's rays. While thunderclaps shatter the stillness, lightning bolts that soon streak across the sky fleetingly illuminate the earth below. Then the clouds release raindrops that tattoo the earth. As their pace quickens, water surges downwards from the nearby mountains to collect in the narrow streets, while streams rush into the two rivers that course through the town. When caught in the sudden downpour, residents, accustomed to the heavy rainfall, huddle in the shelter

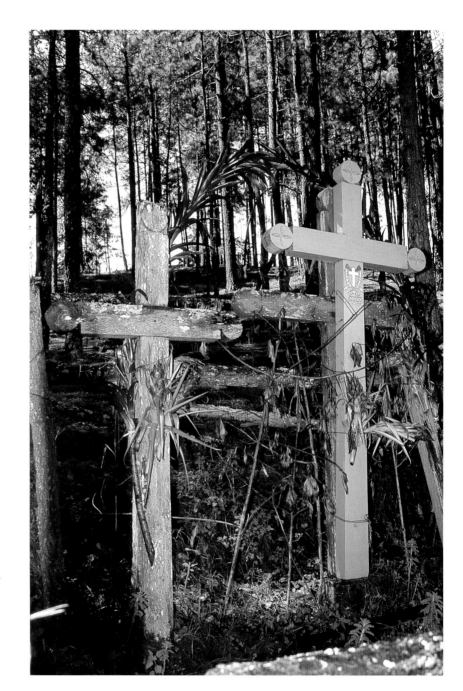

WATER SOURCE.
Wooden crosses festooned with epiphytic bromeliads marking the site of a spring in highland Chiapas.

of doorways waiting for it to stop. Indians, working in their fields or returning to their hamlets from market, pause along the muddy paths to take cover under bright-colored sheets of plastic carried for such protection. As the clouds slowly drift apart to allow the sun's light to again filter through, pedestrians return to the streets, and the Indians tuck their plastic sheets into their net bags for the next day's downpour and retreat to their fields. The normal pace of life returns for these highland people, long acquainted with the fury of such storms, a population that has evolved from a mixture of roots that both reach back to the ancient Maya civilization and across a vast ocean to European culture.

THE CROSS IN CHIAPAS

It is no surprise that a strong devotion to the cross developed in the region around San Cristóbal de Las Casas, with its aura of superstition and a large indigenous Maya population coexisting with devout Catholic Ladinos. Since the sixteenth century, three distinct cultures have intermingled here, each with its own customs. Heirs to these cultures shape the social environment of the highlands: the modern Maya, whose ancestors once dominated the region, maintain their *costumbres* and practice an Indian Catholicism that integrates their pre-Hispanic rites with the Catholic liturgy; the Coletos, longtime residents of San Cristóbal, still follow an orthodox form of Catholicism; and the Ladinos, a genetic and cultural blend of both heritages, practice Catholicism tinged with folk beliefs.

Although Cortés and his soldiers started the military conquest of the New World, Catholicism was the vehicle for the spiritual conquest of the original inhabitants. Just as Cortés depended on Indian recruits to help with the assault on the Aztecs in the Valley of Mexico, the few Catholic friars who followed his military advances into Chiapas had to use their own creativity to convert a large and dispersed population to Christianity.

A small band of Catholic missionaries, representatives of three European monastic orders—the Mercedarians, Franciscans, and Dominicans— arrived in the highlands of Chiapas in the 1530s to begin their task of conversion. The Dominicans left their architectural mark in the form of impressive churches and large *conventos* that provided dwellings for the

priests, constructing colonial churches throughout el Reino de Guatemala connecting the westernmost provinces of Chiapa and Soconusco with Antigua. It was under the aegis of the Dominicans that the true evangelization of the region took place.[17] Because of the few Dominican missionaries and a dispersed congregation, the majority of the population had minimal contact with the missionaries and were only taught basic articles of the Christian faith, including such prayers as the Our Father, Hail Mary, and the Apostles' Creed, along with the Ten Commandments and the primary precepts of the Catholic church.[18] In their evangelization, the friars encouraged the Indians to form *cofradías*, organizations patterned after European religious brotherhoods and led by *mayordomos*, who assumed the role of religious leaders in the remote indigenous communities. In such societies, the surviving Maya were secretly able to maintain many of their own religious traditions, remnants of which are still evident in the religion practiced by both the modern Maya and the Ladinos in barrios of San Cristóbal, where *santos* are cared for in private homes, serenaded in churches, and during festivals carried in processions through the streets.

The cross was a familiar symbol employed by the first friars of the region, but whereas the Christian cross was usually adorned with a representation of the crucified Christ, the early missionaries in Chiapas rarely enjoyed the luxury of carved imagery and substituted a plain wooden cross, a cruciform already familiar to the Maya. In keeping with the European custom of placing a stone cross in the marketplace, where crowds would gather to hear the message of the Gospel, the friars erected wooden crosses in the plazas in front of newly constructed churches in the New World.[19] Here, under the shadow of the cross, the Indians received instruction in its new meaning, one associated with redemption, resurrection, and the eternal life promised by Christianity.

Today, the main route that connects Tuxtla Gutiérrez, the capital of Chiapas, to San Cristóbal climbs eighty kilometers upwards through damp layers of mist generated by low-hanging clouds. Above eighteen hundred meters, remnants of once lofty pine and oak forests cling to the steep hillsides and deep valleys that flank the narrow, two-lane Pan American Highway on its tortuous ascent. Clusters of adobe houses covered with tile roofs dot the scenery, inhabited by descendants of the Maya, who continue to

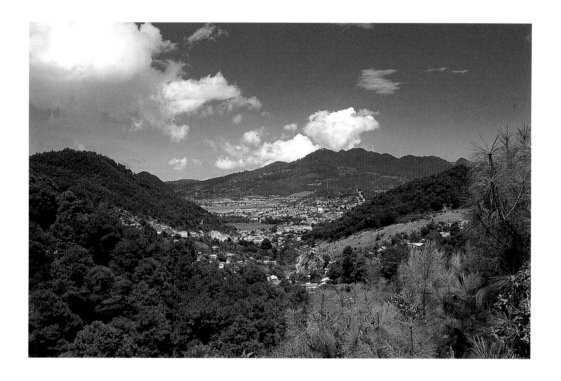

cultivate nearby *milpas* as they have for centuries. As their dwellings come into focus, faint outlines of small wooden crosses appear against the misty backdrop. Covered with moss nourished by seasonal rains, carved with floral designs, the crosses sit low along the center ridges of pitched roofs. Just over the summit of this picturesque road appears the first glimpse of San Cristóbal, nested in a valley at an altitude of twenty-one hundred meters. Known in pre-Columbian time as the Valley of Hueyzacatlán, it was renamed the Valley of Jovel by the Spanish because of the native grass called *jovel* that once covered an ancient lake bed. The town is surrounded by four prominent mountain peaks considered sacred by the Maya, who have inhabited this region for nearly two millennia. Revered as home to their deities and ancestors, the peaks of Cerro Huitepec to the west, Cerro Moxviquil at the north, Cerro Ecatepec to the south, and Cerro Tzontehuitz in the east hover over the town like guardians of the four corners of the world. Only the adobe bell towers of the many colonial churches designed by European friars and built by the Indians compete with these lofty peaks.

SAN CRISTÓBAL DE LAS CASAS. View looking west towards Cerro Huitepec.

ROOF CONSTRUCTION. Traditional roof style in San Cristóbal de Las Casas: courses of tile are laid down on a wooden framework, with some cemented in place to prevent slipping.

The basic city plan remains today much the same as when the first Spaniards settled here, with outlying barrios clustered around a central zone. The residents of these separate districts, each with its own church dedicated to a patron saint, maintain a sense of community fueled by an annual festival to celebrate the saint's day. In addition to a few wooden crosses similar to those seen on roofs in the nearby country-side, iron roof crosses also appear on houses in the long-established barrios. Some of these, reaching up to a meter tall and each uniquely decorated, crown the roofs of many older dwellings constructed with the local roof style where courses of *tejas* (tiles) are placed over wooden beams.

In the nearly five hundred years since the founding of this colonial town, the handprint of humankind has fallen heavily on the surrounding landscape. As the town has mushroomed in size after the turn of the twentieth century from a population of under ten thousand to more than one hundred thousand in 2000, the forests that once blanketed the flanks of the surrounding mountains are slowly being covered by *colonias*, or suburbs, that cling to their sides like the moss that once covered the fallen trees, and now when the heavy morning mists disappear, a sea of buildings can be seen spreading across the valley floor once carpeted with the *jovel* that the Indians used as roofing material. Among the changes that have altered the countenance of the town, is the gradual disappearance of the iron roof crosses that formerly accented the roofs in the old barrios. Whatever its beginning—the folk beliefs that have developed to control the violent weather plaguing the region or religious beliefs—this house blessing tradition was once a common practice, remembered by many older residents as a time "when the sky was filled with crosses." Today, only a few cast their silhouettes in the sky.

The distinctive social and spiritual atmosphere in which the roof cross custom developed reflected layers of tradition superimposed on existing ways and was characterized by a dependency on the spiritual world to influence the many unpredictable forces of nature. Much like the ancient

Maya marked their calendars with favored deities, the residents dedicate most days to special saints, some of which are mythical characters not found on the liturgical calendar of the Catholic church but belonging to a folk pantheon, while others have been canonized by the Catholic church. Residents often prefer to pray to the local *santos* before private altars in their homes rather than attend services in the beautiful colonial churches that reflect the town's Spanish past. In this conservative milieu, life thrives behind house walls and pulsates to a rhythm of private religious celebrations.

Further, the ominous environment of Chiapas, where natural disasters are common, as are the legends, superstitions, and customs that have evolved as a means of coping with these uncontrollable acts of nature, has also influenced religious customs, including the use of roof crosses. Because earthquakes, volcanic eruptions, floods, and especially lightning storms have damaged colonial structures and leveled entire barrios throughout the centuries, the custom of roof crosses was woven into the religious fabric to protect houses and their inhabitants from such malevolent forces, and as a sign of Christian faith. Of all the tales that persist about how the custom started, one chronicler of San Cristóbal, Manuel Burguete Estrada, perhaps offers one of the more credible accounts.[20] On reviewing the town records that date as far back as the late 1500s, he noted stories of severe storms when lightning seemed to penetrate the walls of the churches to destroy altars and beautifully carved *retablos* that held the statues and paintings of the saints. Confronted with these disasters, the panic-stricken citizens invoked the protection of a new patroness. In 1775, a statue of *La Virgen de la Nieve* (Our Lady of the Snow), one of several advocations of the Virgin Mary as Queen of the Heavens, was installed in the cathedral, then later replaced by a statue of *Nuestra Señora del Rayo* (Our Lady of Lightning), representing a devotion thought to have originated in the late eighteenth century near Guadalajara in the state of Jalisco, and still practiced each year in San Cristóbal on 18 August.[21]

Further, Burguete Estrada suggests that the custom of placing crosses on roofs to guard houses developed out of a widespread fear of lightning storms and torrential rains. Since the severity of such storms has recently

HOME ALTAR.
An elaborate private altar in Barrio de Guadalupe celebrates the feast day of El Señor de Esquipulas, 15 January.

diminished due to meteorological changes and deforestation in the highlands, he concludes that the need for protective crosses on homes has decreased along with the devotion to *Nuestra Señora del Rayo*.[22]

His hypothesis was substantiated on several occasions when residents explained their roof crosses as a way to protect their houses from the *rayos*, or lightning bolts. One of my more poignant encounters with an owner of a roof cross confirmed this strong belief in its protective power. Late one afternoon in Barrio de San Ramón I discovered a series of brightly painted adobe houses with old tile roofs near the barrio church. On one of these, an interesting old carved wooden cross caught my eye. As I paused in the plaza across the narrow street from the house to sketch the cross, an elderly Ladina, her matronly shape covered by a gingham apron and her hair tightly contained in a scarf, appeared in the doorway. While wiping her hands on the front of her apron, her gaze steadily met mine. Aware that I had invaded her private space, I closed my sketchbook and slowly crossed the street to explain my intrusion. Glancing upwards to the old cross, I expressed my admiration and inquired about it. Words suddenly spilled from her mouth as the stern expression on her face softened. She told me of her husband long gone, how he had carved the cross himself and placed it on the roof of their first home over fifty years ago. He had assured her then that it would always protect their home from the severe lightning storms that occurred periodically. "*Los rayos*," her voice trailed off. A chasm of time and experiences separated our views of the world. Steeped in tradition, she depended on customs based on superstition to ward off the effects of natural events, while I sought more logical, historical explanations for such customs. But in spite of the cultural gulf between us, we did not judge each other. And while she had been able to indulge in long-forgotten memories, the encounter had allowed me to pursue the connection between roof crosses and the fear of lightning.

Many homeowners who provided me with information regarding their roof crosses explained their devotion to both *Nuestra Señora del Rayo* and *Santa Cruz* as well as their faith in the protective powers of the cross itself. Even though today in San Cristóbal *Nuestra Señora del Rayo* is considered the patroness of the electrical trade and her powers against light-

ning storms appear nearly forgotten, the faithful still believe in her ability to intercede in such circumstances, along with *Santa Cruz*. Further, this association is reflected in the familiar novena pamphlets with prayers to *Nuestra Señora del Rayo* and to *Santa Cruz*, one of the major ways that Catholic friars introduced and maintained devotions to the saints. Still favored as a means of disseminating religious information and readily available in churches and shops that sell religious paraphernalia, these pamphlets include a brief description of the devotion as well as a series of prayers to be said on nine consecutive days. In such a leaflet entitled *Novena a Nuestra Señora del Rayo*, it is related how Christ was distressed by the wickedness of people on earth and in retribution threatened to cover the sky with relentless lightning to punish the inhabitants. In defense of the faithful, the Virgin interceded successfully to avoid the calamity and thus became exalted as patroness of the sky.[23] In another pamphlet, one dedicated to *Santa Cruz*, to the faithful who honor this image of the cross, and recite the prescribed prayers, a promise is given that their houses will be spared from the dangers of lightning.[24]

Although the use of roof crosses is most evident in the highlands of Chiapas, especially in San Cristóbal and its environs, the custom is also followed in other parts of the state. Roof crosses continue to be seen in several towns and adjacent rural areas in the Central Depression, such as Villa de Acala, Chiapa de Corzo, Suchiapa, and Ocozocoautla. The practice was also documented by Donald Bush Cordry and Dorothy M. Cordry in their landmark work among the Zoque of western Chiapas, including the present capital of the state, Tuxtla Gutiérrez.[25] While few crosses remain on roofs of houses in this modern city, the residents of neighboring rural communities preserve the custom. In each of these towns, the roof cross has a unique style that identifies its place of origin. However, it is in San Cristóbal, where the use of roof crosses has persisted the longest, that a guild of ironworkers developed the distinctive iron roof crosses now associated with Chiapas.

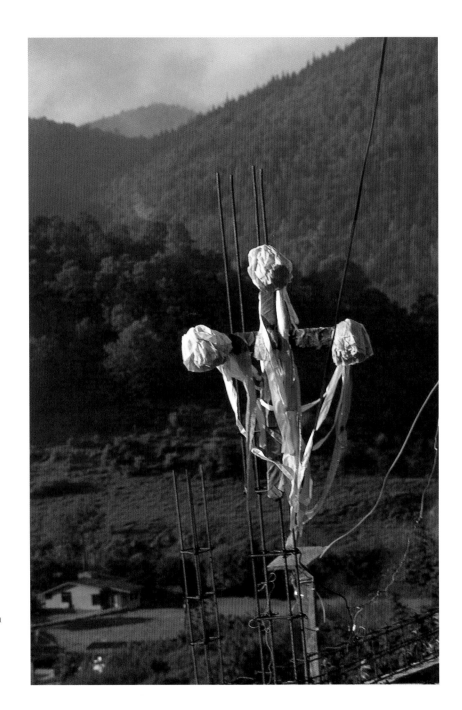

CONSTRUCTION CROSS.
Albañiles install a crude wooden
cross on a construction site.

Santa Cruz and the Roof Cross Tradition

From the initial emphasis on the cross in colonial times, emerged one of the strongest religious devotions that exists throughout Mexico and Latin America, referred to simply as *Santa Cruz*, the Holy Cross. The custom of installing crosses on roofs of houses as signs of faith, protective talismans, or blessings may also be a manifestation of the devotion to Santa Cruz. Santa Cruz is celebrated throughout Mexico on 3 May. Although assigned the same day on the Catholic calendar that honors Empress Helena's discovery of what was purported to be the cross on which Christ was crucified, Santa Cruz represents a fervent belief in the inherent protective powers of the cross itself rather than the more specific commemoration of the cross used in the Crucifixion. Santa Cruz is not represented by a crucifix but rather by a tall unadorned Latin cross, occasionally painted green or swathed in cloth. Such a cross often leans against a wall amidst an assemblage of traditional *santos* in old colonial churches in the highlands of Chiapas. On the day set aside to honor this image, the faithful often "dress" the cross in new clothes, wrapping it entirely in shiny white cloth or in traditional Indian attire, then further decorating it with ribbons and flowers before moving it to a prominent spot in the church, where devotees scatter pine needles around its base, light candles, burn incense, and pray. Only on Good Friday does Santa Cruz appear with the image of the crucified Christ, when in the remote Indian village churches of Chiapas the *mayordomo* responsible for the care of Santa Cruz carries the tall cross to the front of the church, where it becomes the focal point for the reenactment of the Crucifixion. The faithful remove the statue of El Señor Sepultado, a reclining statue of the entombed Christ, which throughout the year reposes in a glass coffin-like box, and affix it to Santa Cruz in commemoration of the final scene of the Crucifixion.

Santa Cruz is also the advocate chosen by *albañiles*, stonemasons and construction workers, who often express their devotion to this symbol by erecting a temporary wooden cross of scrap lumber on buildings under construction.[26] In Chiapas, many *albañiles* do not consider a house complete until they have scratched a small simple cross on the *culata del canal*, the end of the cement canal of a roof ridge, a signature that appears whether or not the homeowner decides to erect an iron or wooden cross on the

roof. Most *albañiles* cannot account for this strong association of the cross with their craft, other than to say that they have always worked under this sign. One explanation for the craft's connection with this devotion, however, relates to Empress Helena's search for the cross of the Crucifixion. According to legend, Helena, exhausted from her quest, was prepared to admit failure when her workers approached her with a request, agreeing to work without pay if she would persist in the exploration for one more day. On this last day, they uncovered what they believed was the cross on which Christ was crucified.[27]

The devotion to Santa Cruz is likely related to the custom of installing roof crosses on houses in municipalities and environs of Chiapas, with the Indians using wooden crosses and the Ladinos preferring wrought-iron crosses. Often on 3 May, in towns or in the countryside, homeowners decorate their roof crosses with flowers, greenery, or paper streamers to honor Santa Cruz and, in rural areas especially, in anticipation of preparation of the *milpas* for the planting of the corn to begin a new agricultural cycle.

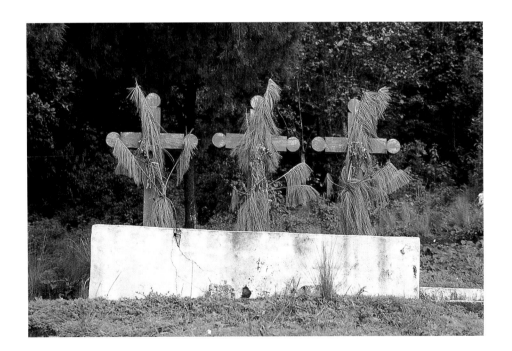

SHRINE CROSSES.
Three wooden crosses adorned with pine boughs at a sacred site near Nachig, a Tzotzil village along the Pan American Highway a few kilometers west of San Cristóbal de Las Casas.

When asked why they place a cross on their roof, most residents of San Cristóbal appear puzzled, since for them this practice is not mysterious but simply a custom of their family for generations. Their answers, however, provide a few clues about the practice: "To protect the house," "because of the lightning," "as a sign of our faith," "we are Catholics," "it is the custom," "it belonged to my grandmother," or, "it honors Santa Cruz." Whatever the origin of the roof cross and its possible connection with the devotion to Santa Cruz, the custom is adapted to changing superstitions and dangers as the following story illustrates.

According to a resident, in Barrio de los Mexicanos, one of the oldest barrios in San Cristóbal, a rumor spread like a brewing storm through the narrow streets. No one knew exactly where it started, but most pointed to Doña Margarita as the logical source of such a tale. For years, this elderly street vendor had operated the taco stall under a tree on the corner near the small barrio church. Every day beneath an aging tar-paper roof she dispensed advice and news along with her delicious concoctions of fried meat and thinly sliced onions splashed with spicy salsa and wrapped in warm corn tortillas. Her customers were familiar with her incessant chatter and usually just nodded their heads in response as they gulped down their tacos and hurried on their way. But this time many lingered to listen to her reassuring words that spread calm throughout the neighborhood, where there had reportedly been a recent sighting of the mysterious *chupacabra* (vampire-like creature) that had terrorized the residents.

Early in 1996 the fame of this nocturnal vampire-like creature had circulated throughout Mexico and into immigrant enclaves in the United States.[28, 29] Sordid stories passed from town to town and across international borders of the mischief caused by this elusive mythical monster as it stalked the streets by night. According to Doña Margarita, however, the residents of San Cristóbal did not need to worry. Here they venerated Santa Cruz and displayed crosses on their roofs as a sign of their faith. No *chupacabra* would dare to harm those who lived under this protective talisman. With such assurance, life continued its normal pace, the residents secure in the belief of the extraordinary power of their roof crosses.[30]

Such expressions of folk belief reflect the lenient form of Catholicism that persists in Chiapas. It is not uncommon even today to meander through

STONE CROSS.
Boundary cross, near the ruins of Moxviquil, marking the borders between the municipalities of San Juan Chamula and San Cristóbal de Las Casas.

the narrow streets of San Cristóbal and hear the high-pitched monotone of a *rezadora* as she leads a prayer for a small group of devotees in a Ladino home where a statue of a favored saint is tended at a private altar beautifully bedecked with floral arrangements and candles surrounding the image. These *santos* may represent saints officially recognized by the Catholic church or folk saints, such as the enigmatic Santa Cruz. It is rare but also possible to witness both Catholic and folk rituals occurring simultaneously in the cathedral of this colonial town. As the bishop of the diocese officiates at solemn High Mass at the main altar before the congregation, an Indian *curandera* may be performing a curing ceremony on the floor in front of a nearby side altar, offering candles, food, and drink, including *posh* (corn liquor), to appease the deities and heal her client. This continues to be one of the few states in Mexico where the indigenous people prefer rituals that integrate their pre-Hispanic deities with Catholic images. They dress statues of saints in layers of traditional Indian clothing, laden them with jewelry and mirrors, escort the images on visits to other saints in nearby communities, and use them to enact rituals important in the Catholic church during the Easter and Christmas seasons.[31, 32] Such dichotomies testify to the prevailing sense of spirituality that dominates the coexisting cultures, whose stewards tenaciously preserve many aspects of their traditions.

To give visual expression to these beliefs, various forms of folk art developed with the cross a unifying motif. Crosses are sculpted in stone, poured in cement, carved in wood, wrought in iron, and etched in concrete. Although throughout Mexico crosses are visible along roadsides as

commemorative shrines to those killed in traffic accidents, atop colonial churches, on buildings under construction, and on the walls and roofs of private homes, in the state of Chiapas they appear to be integrated in the landscape and sky, with the roof cross epitomizing such integration.

In Chiapas where two worldviews collided—resulting in a majority of Ladinos who practice folk Catholicism and the modern Maya with their Indian Catholicism—a tacit compromise seems to exist that permits a flexible interpretation. It is evident that the Catholic clergy who serve this community today, just as their predecessors did in the colonial period, accept a mixture of symbols and rites as long as they believe it benefits the Church. Thus although roof crosses in San Cristóbal may be symbolic of different concepts for various residents, those who practice this custom often share a common goal: to manipulate or live in harmony with supernatural or natural elements they can neither explain nor control.

Uses of the Cross in Chiapas

The multiple use of the cross in Chiapas, apparently due to the fusion of pre-Columbian concepts of the world with tenets of Catholicism, blurs the actual meaning behind the custom of roof crosses, especially as followed by modern Maya.

While to Christians the cross represents one meaning—the Crucifixion of Christ and the sacrifice and redemption it implies—to the ancient Maya the cross has multiple meanings related to various deities and rituals. They often held annual rites near tall crosses erected on the peaks of sacred mountains to petition for rain to nourish their crops or to bless their corn seeds before planting, their only recourse to influence natural forces.

In many parts of Chiapas, crosses fulfill specific functions in the ritual life of the modern Maya, who use them to mark important sites, such as a spring, cave, or entry to a household compound; to denote boundaries of communal lands; to designate dangerous crossings on footpaths or roads; or as focal points in shrines or other locations where rituals are performed.[33] Often the Maya erect a trio of crosses to represent metaphoric gateways and the three levels of their universe: the upper world of the sky, where the deities dwell; the earthly world, where the living are found; and the underworld realm of the dead.[34]

ROMERILLO.
A row of tall crosses erected on a
hillside overlooking a cemetery
for Tzotziles in highland Chiapas.

The Zinacantecs and Chamulas, both Tzotzil-speaking Maya with ceremonial centers in *municipios*, or municipalities, adjacent to San Cristóbal, utilize towering wooden crosses as symbolic entrances to significant arenas of their social space, and smaller ones within the private spaces of their homes. In *Tortillas for the Gods*, Evon Vogt describes three important rituals that Zinacantecs perform to compensate the Earth Lord for materials used in house construction: the sacrifice of a chicken, which is buried under the center of the floor; the placement of a household cross in the patio to communicate with the Earth Lord and the ancestral deities; and the installation of a wooden roof cross to protect the house.[35] Such small roof crosses may appear to have less importance to the modern Maya than the larger ones that mark other significant spots in their natural environment, but when children of these indigenous communities are asked to draw pictures of their houses, the drawing often contains a simple cross along the roof line, indicating how the belief is inculcated in the young.[36]

In the repertoire of symbols they used, the ancient Maya showed a preference for the cruciform identified today as a Greek cross, with its four arms of equal length, rather than the Latin cross, with its arms joining above the midpoint of the upright. The former appeared as a motif in ceremonial garments still preserved on finely carved monuments that adorned their temples and palaces.[37] The world tree, another important symbol in their cosmology, represented the center of the Maya universe with its roots tapping into the underworld and its branches reaching into the heavens.[38] It was depicted in full foliage with the celestial bird perched on top as a sign of the heavenly realm. As this symbol merged with the cruciform symbol, the cross and the tree came to have the same meaning. The foliated cross of Palenque, a well-known Maya sculpture that represents the corn plant and its related deity, illustrates the fusion of these symbols.[39]

Related symbolism is reflected in the decoration of contemporary Maya crosses since both the large wooden ones that mark important sites and small ones used on roofs are often painted green or blue and decorated with pine boughs and colorful flowers to give the impression of a living tree. Further, some are distinctly carved with five four-petaled flowers, each filling a circle and then placed at the ends of the arms, the apex of the upright, the axis where the arms and upright join, and along the upright

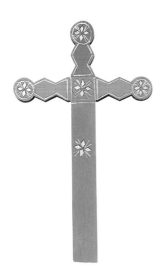

WOODEN ROOF CROSS. This style of cross, painted and etched with floral or astronomical designs, is typically seen in the municipality of San Juan Chamula.

near the base to suggest the crosses are trees in bloom.[40] Although some modern Maya today interpret these four-petaled designs as stars rather than flowers, such symbols apparently reflect the continued connection with their ancient cosmological beliefs despite the fact that no clear documentation survives as to how the indigenous population used the cruciform prior to the conquest. Moreover, that such an extensive use of wooden crosses persists suggests a link with the pre-Hispanic past since iron was introduced by the Spaniards and thus the iron roof cross tradition is clearly a post-conquest custom.

Roof Cross Tradition

Although wrought-iron crosses as ornamental features and funereal objects are common throughout the Old World, decorating Christian churches, marking grave sites, commemorating accidental deaths along roadsides, and adorning wayside shrines, the origin of roof crosses is more problematic to document. While the practice of installing roof crosses on private dwellings may have existed in other regions of the world, it does not appear to have been necessarily widespread or conspicuous enough to have been noted. Such adornments made of straw occasionally appear on thatched roofs in Ireland, where straw roof crosses were recorded as far back as 1689.[41] Their more widespread use in iron and wood for private dwellings, however, persists in certain areas of the New World, all conquered by Spain, subjected to spiritual conquest by Catholic friars, and all with strong ties to pre-Columbian cultures. In most regions where the custom flourishes, so does a large population of indigenous people who maintain many of their *costumbres*.

In the artistic decor that the Spanish transported to the New World, the friars used iron crosses to embellish the roofs of their churches and bell towers. In addition, they frequently erected large wooden or stone crosses in the atria that set aside a sacred place in front of the churches for religious instruction as well as services. Although there seems to be no indication of a widespread roof cross tradition in Spain or in other European countries prior to the conquest and during the colonial period, it is clear that most of the cruciform shapes and floral motifs that appear on the finials of iron roof crosses can be traced to European art styles.[42] George M. Foster, in *Culture*

and Conquest: America's Spanish Heritage, examines with meticulous care the cultural connection between Spain and New Spain resulting from the conquest.[43] He describes the custom in Spain of placing a cross along the highway at the site of a violent death as well as the celebration on 3 May to honor *Santa Cruz* in Andalusia and Extramadura. However, he does not document any location in Spain where the tradition of roof crosses on houses exists,[44] although I found an illustration of architecture from Old Spain depicting a house in the countryside of the Province of Valencia with two wooden crosses at the front and back peaks of a roof thatched with straw.[45]

It is probable that roof crosses were used during the colonial period in Guatemala, which included Chiapas, and it has been documented that wooden roof crosses resembling the crosses attached to tile roofs in Chiapas were once mounted in the thatch along roof ridges on houses in indigenous communities of rural Guatemala.[46] However, despite the fact that roof crosses were used in the colonial period in Guatemala as well as in Ecuador and Peru, I could find no specific evidence to link the practices in these countries. Variation exists even between Guatemala and present-day Chiapas, as well as within Chiapas itself. For example, among the Zoques who once dominated the western half of Chiapas, including the Central Depression, the custom persists in and around Suchiapa, Villa de Acala, and Ocozocoautla. Here in these towns with Zoque descendants, evidence of an older house blessing tradition, once common in the region, can still be found. Residents hold a ceremony to mark the installation of their roof cross using a special *teja* (clay tile) that has a hollow base to hold a wooden cross. Decorated with small figures, the *teja* is often etched with the date of the ceremony. The owner is customarily assisted by a *madrina* or *padrino* (sponsor), who provides the wooden cross on the day the house is inaugurated. Guests add to the festivity of the occasion by bringing roof tiles decorated with modeled figures, which are placed along the roof ridge to form elaborate scenes at both sides of the elevated cross.[47] A modification of this custom occurs in situations where the homeowner delivers *tejas* to friends as invitations to attend a celebration for completion of a house. After decorating them with colorful paper and cutouts of popular figures, the invited guests come on the day of the festivities to adorn the roof.[48] Because the figures on the clay tiles are very fragile, they usually deteriorate within a

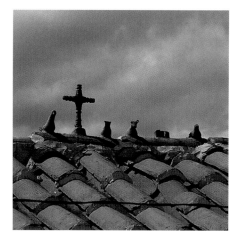

SUCHIAPA.
A wooden cross flanked by clay figures on a roof ridge marking the completion of a new house.

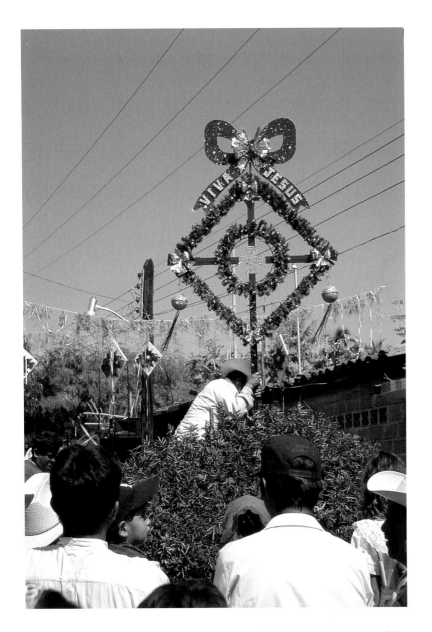

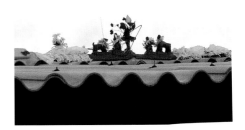

OCOZOCOAUTLA.
Assemblage of figures around a
roof cross as a blessing on the
new roof.

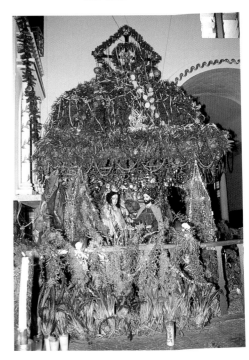

NOCHE BUENA IN VILLA DE
ACALA. Townspeople gathering
to cover a roof with bromeliads
and install a symbolic roof cross
at the peak.

CHRISTMAS IN VILLA DE
ACALA. The *nacimiento* in the
colonial church during the
Christmas season.

few years, leaving the wooden cross embedded in the central *teja*. The fact that I have noted several of these specially made tiles in various states of deterioration in towns of the Central Depression of Chiapas suggests the custom persists. Since they require special molds or must be shaped by hand, not all tile makers produce these decorated *tejas*, which usually must be commissioned from an artisan, such as a potter from Suchiapa who still makes them.[49]

On a few occasions, roof crosses also appear in a symbolic form during important ceremonial events. One such example occurs annually in Villa de Acala, a community in the once Chiapanec-controlled territory of the Central Depression along the Río Grijalva. Here residents celebrate *Noche Buena* by constructing a *casita* in preparation for the arrival of the Christ Child, decorating the roof of the *nacimiento* with thousands of brilliant red bromeliads, all of the same genus and species, *Tillandsia guatemalensis*. Several days prior to this day, young men from Acala set out for the highlands, over one hundred kilometers away, to gather the plants from their forest habitats and then return to drape them over the wooden framework of the roof.[50] Finally, a wooden cross decorated with green foliage is placed at the roof's peak, replicating the local custom of installing a roof cross on a newly completed house as a blessing, indicating that the house for the Christ Child is ready to be moved in a solemn procession to the church, where the *nacimiento* will be assembled.

The roof cross tradition is further evident in the colonial town of Chiapa de Corzo, sixty kilometers west of San Cristóbal, although in a cursory survey of the oldest barrios, I located less than fifty crosses, significantly fewer than the number extant in San Cristóbal. Of these, the majority were carved from wood, and, as in most of the original Zoque-dominated areas of the Central Depression, were plain with straight flat ends on the arms and upright. These finials contrast with the wooden crosses carved in San Juan Chamula, where the ends are characteristically lobed. Iron-wrought roof crosses from Chiapa de Corzo also have a different style from those fashioned in San Cristóbal. They are Latin crosses in a solid design, a design with no space between elements that yields a silhouette, and highly embellished with scroll- or fret-like features attached to the upright and

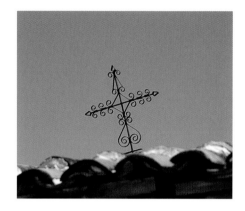

CHIAPA DE CORZO.
Ornate scrolls and spirals embellish the roof crosses of this town in the Central Depression of Chiapas.

transverse arms. Often the metal of such scrollwork is turned on edge, creating an ornate two-dimensional motif which becomes the only ornamentation on the cross. Ironworkers of Chiapa de Corzo employ this same pattern on crosses that mark graves in the main *panteón*. These roof crosses are relatively small with minimal variation, no more than forty centimeters high, and not as conspicuous as those on roofs in San Cristóbal.

Specific dates for iron roof crosses are difficult to ascertain except for an occasional date on a cross or when a family member recalls when a house was constructed and the cross installed or passes a story on to the next generation so that eventually it becomes part of the family lore. I did note the year 1973 formed in thin metal and barely visible at the base of one cross in Chiapa de Corzo. Moreover, a resident of this town whose family has lived for generations in a colonial house near the barrio church of San Jacinto claims that his roof cross dates to the early nineteenth century and could be nearly two hundred years old.[51] This small iron cross, approximately thirty-five centimeters tall with fluted arm finials, has only a tiny ornamental banner at one side of the upright. Its size and decorative motif are significantly different from other roof crosses in Chiapa de Corzo, suggesting that indeed it could be several hundred years old. In addition, Jorge Ramos Aguilar of San Cristóbal provided a date for when his grandparents installed a roof cross on a new house constructed the same year that an earthquake destroyed their former residence. When I visited him one day in Barrio de Guadalupe with the late afternoon sun streaming into his patio surrounded on three sides by single-story rooms, he lifted his arm in a sweeping gesture aimed at the impressive roof cross highlighted by the sunlight, emerging from the central ridge of the peaked roof formed by a framework of wooden beams over which were laid courses of tiles. He proudly related how his grandfather had built this house at the turn of the twentieth century after the family home was destroyed in an earthquake. Installed in 1905, the roof cross was a final blessing to protect the new house and its occupants from other disasters. It has remained here for three generations, verifying that the tradition of roof crosses is at least one hundred years old. The cross, over a meter tall with a wide apical circle from which project rays surrounded by a scalloped corona, represents one of the older and more unusual styles of roof crosses.[52]

Although roof crosses of iron rarely are found on houses in the indigenous communities of the modern Maya, approximately 40 percent of the existing roof crosses in San Cristóbal are carved in wood. Because of their simplicity, these attract less attention than the more dramatic and larger ones wrought in iron. Possibilities for individualizing a wooden cross are few when compared to the myriad of options available to skilled iron-workers. Carved in pine that is readily available in the highlands, they are susceptible to weathering and thus less permanent than their iron counter-parts. Additionally, the wood itself limits design possibilities. The carver may round, square, or shape the ends in lobes; arrange the arms and uprights in different cruciforms and paint or incise the wood with floral or geometric designs; perhaps even carve out the centers of the arms and upright, a tedious task that, however, results in a graceful product. A significant difference occurs between wooden crosses used in the Maya communities and those found on houses in San Cristóbal. The Maya prefer crosses that are more apt to be painted and carved with floral or star-like patterns, whereas those in town are rarely painted or decorated with incised motifs.

Descriptions of iron crosses crafted by *herreros* from San Cristóbal only occasionally appear in print. Two examples, described as "seventeenth-century iron house crosses from the state of Chiapas," are illustrated in an exhibition catalog from the Museum of International Folk Art in Santa Fe, New Mexico, where they remain in the permanent collection but not on display.[53] Similarly, although photographs of iron crosses can sometimes be found in illustrated books on arts and crafts of Mexico and Latin America, authors of such books rarely include any contextual information or description to accompany these examples.[54, 55] One exception is Carlos Navarrete, who elaborates on the custom in his work on colonial architecture of Chiapa de Corzo, suggesting that local ironworkers found inspiration for roof crosses in the cruciform openings that decorate the spiral staircase of the sixteenth-century fountain in the central plaza.[56] The design that he describes, a Latin cross mounted on a sphere to symbolize the domination of Christianity over the world, nevertheless does not appear on any of the extant roof crosses in either Chiapa de Corzo or in San Cristóbal. Since he provides sketches of roof crosses depicting the motif, it is possible

TOWER OF THE FOUNTAIN.
The window-like opening, shaped
in a cruciform and orb motif, is
part of the staircase winding along
the turreted tower of this fountain
in Chiapa de Corzo.

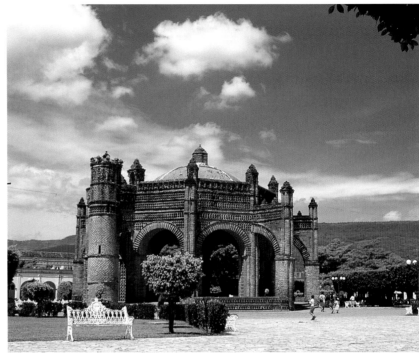

FOUNTAIN IN CHIAPA DE
CORZO. One of Chiapas's most
impressive colonial monuments
dating to the late sixteenth century.

that this symbol was popular in other regions, perhaps in Guatemala, where the custom once prevailed.

Although it is difficult to ascertain the precise origin of the roof crosses of San Cristóbal, the nascence of the roof cross tradition in Chiapas appears to have preceded the shift in devotional locus from the church domain to family-oriented rites held in private homes that resulted from the anticlerical movements of the late nineteenth and early twentieth centuries. During this period, churches were closed by governmental decree, religious art banned from public view, and many Catholic priests exiled. This also led to the demise of most roof crosses. Once the ban was lifted, local craftsmen, no longer limited by the liturgical standards imposed by the Catholic church, became the purveyors of devotional objects commissioned now for the home rather than for the church. As the source of their inspiration, they often copied the old wrought-iron ornaments that still adorned the many colonial churches as well as those roof crosses that the faithful had stowed away during the time of the persecution.

WROUGHT-IRON CROSSES

Although no records exist to confirm the material of the first roof crosses, the use of wood most likely preceded iron. Once the tradition of protecting or blessing a house with a cross became popular, the next logical step was to fashion them of more durable material that would allow for greater creativity of design. As the craft of ironwork developed, so did the skills of the artisans, who used their own imaginative ideas to fuel interest in the custom.

It is in iron that roof crosses attained their peak of artistic expression as folk art, individually designed and crafted for domestic use in keeping with an established regional custom. With the passing of time and an increased regard for these talismans, talented ironworkers produced an array of roof crosses but generally on common themes.

Although wrought-iron work is not a craft native to Mexico or Guatemala,[57, 58] following its introduction into the New World by Europeans at the time of the conquest, it has been used by *mestizos* throughout the course of its history in the Americas. The Indians, already skilled in working with gold, silver, and copper, had to learn from the Spaniards how to craft iron metal, and then later the methods to process it. At the time of the conquest, the iron mines of Spain were renowned throughout Europe, but the true development of Spanish ironwork did not begin until the second half of the fifteenth century.[59] In the initial settlement of the New World, Hernán Cortés transported *herreros* along with their tools and the metal from Spain and Portugal to forge items necessary for conquering the Aztecs and establishing dominion over the new territory. They first produced iron implements, mainly weapons, horseshoes, and military trappings. Once these needs were met, then items for decorating churches took precedence over household and other utilitarian objects.

The first ornamental products from ironwork shops in the Americas furnished churches, chapels, and cathedrals with elaborate railings, screens, and pulpits. Much of this ornate work reflected the Moorish style that prevailed on the Iberian Peninsula up to the fifteenth century, first influenced by Renaissance and then by baroque styles from the continent. From European craftsmen, lured by tales of New World riches and dreams of elevating their status from worker to master, native apprentices learned how to work

iron and a variety of artistic styles to employ in ornamentation. As the apprentices of the European maestros, the indigenous people undoubtedly influenced some of the design elements on the earliest wrought iron as well as in later work.[60] While the earliest *herrerías* were in Mexico City, the site of the first school for indigenous *herreros* in New Spain was in the state of Michoacán. Later in the colonial period other centers were established. Not until the twentieth century, however, was San Cristóbal in the new state of Chiapas recognized as a site of notable ironwork production.[61]

Archival evidence indicates that by 1650 blacksmiths in the Province of Soconusco were forging utilitarian objects such as iron nails, household cutlery, and horseshoes.[62] When iron ore was finally extracted and processed in the New World, iron products became more affordable, and thus accessible, to a greater number of people. Although the initial ironwork was produced by indigenous artisans under the tutelage of European masters, subsequently the craft was controlled for centuries by the *mestizos*, who created distinct products. The resulting style, which Pál Keleman refers to as "Folk Baroque in Mexico," fuses Christian iconography and baroque influences from the Iberian Peninsula with native materials and creative skills of New World artisans.[63] Only in the last few years, however, have a few Maya artisans of Chiapas once again been empowered to create their own work in iron.

The earliest source in Spain of the artistic ideas that influenced the fabrication of New World iron crosses may have been the Province of Catalonia. In an extensive collection of Spanish ironwork illustrated in *Hierros artísticos españoles de los siglos XII al XVIII*, Luis Pérez Bueno describes an art style exclusive to Catalonia that developed in the thirteenth century and lasted until the end of the seventeenth century.[64] His illustrations of these early examples suggest that religious symbols, including implements of the Passion, were being attached to crosses made from hammered, crude iron pieces. Although these items did not function as roof crosses, the assemblages of figures that adorn them resemble the ornate style of cross from San Cristóbal, STYLE VIII (see Part 2). An exception to these decorative features, however, is that sun and moon do not appear on these early pieces. In addition to the similarity in ornamentation, Pérez Bueno includes a sixteenth-century cross similar to another style currently being crafted in

STYLE VIII

Chiapa de Corzo.[65] Heavily decorated in scrollwork of volutes and swirls, these crosses lack additional symbolic or representational figures. Such examples suggest a possible link between Spanish artistic influence and New World products, specifically roof crosses made by the artisans of Chiapas.

It is difficult to make comparisons between various iron crosses either in the Old World or the New World for several reasons. In the study of decorative arts, iron crosses have received minimal attention in comparison to other iron objects produced in the Americas during the colonial and post-colonial periods, except for processional crosses used in the sixteenth- and seventeenth-century churches of Chiapas, items of exceptional workmanship, in silver and embossed with figures depicting religious allegories.[66, 67]

However, in searching for other associations between New World and Old World iron crosses, not specifically those installed on roofs, I did find one group of nearly eighty iron grave crosses documented in North Dakota, forged with similar methods and ranging from simple, unadorned designs to elaborate open ones. The craft was brought by German-Russian immigrants to this area from their homeland in the Ukraine and the Black Sea regions to the United States in the late nineteenth century.[68] They settled in an agricultural area of North Dakota, where blacksmiths made equipment necessary for their farm work. Isolated from their country of origin and free from other artistic influences, these craftsmen used their skills to create their own style of fanciful crosses with elaborate ornamentation to mark the graves of their dead. This ironwork tradition brought by Ukrainian immigrants to North Dakota may be associated with the ancient Lithuanian folk art of wooden poles and wooden crosses topped by ornate iron pieces, some in the shape of a cross. These ubiquitous commemorative markers that predate Christian influences in the Baltic region are scattered about the countryside, where the early inhabitants had strong animistic beliefs and reverence for natural phenomena.[69] Familiar astronomical signs of the sun, moon, stars, and flora motifs were incorporated into their ironwork and wood carvings, then later with the introduction of Christianity, these indigenous signs merged with Christian symbols. Further, the roadside poles topped with iron crosses decorated with such symbols as radiating suns and crescent moons were transformed into shrines to house images of Christian saints. Traces of these shrines, dating from the eighteenth through

early twentieth centuries, remain throughout Lithuania. Although the custom of iron crosses on roofs is not documented for this vast region, the shrine cruciforms suggest how a craft along with designs and artistic motifs can be transported to another part of the world. Whereas similar European influences occur in ironwork from Chiapas and parts of South America, the installation of iron crosses on roofs of private homes remains a New World tradition. Why such a custom developed in some areas of the Americas and not in others is speculative. Where it does occur, one common denominator is a large indigenous population with a strong will to sustain local culture and widespread practice of the Catholic faith. Where evangelists have attracted large numbers of followers, roof crosses, with their overt association to Catholic iconography, are notably absent. For example, in the highlands of Chiapas, it is possible to identify evangelical enclaves by the absence of wooden roof crosses, as well as by biblical names given to such communities as Belem, el Jardín de Eden, Nueva Palestina, and Betania.

Iron Workshops in San Cristóbal de Las Casas

Crosses that originate from the ironworkers of San Cristóbal de Las Casas have distinct styles, themes, and symbols that continue to reflect strong Hispanic, as well as indigenous Maya, influences. A glance into an ironworker's shop in San Cristóbal is a glimpse back into medieval times as the tools and techniques have changed little throughout the history of the craft. The mastery of iron is truly a cottage industry where the work requires minimal space and equipment: a shallow brick-lined fire pit for a charcoal-fed fire fanned by a hand-driven bellows to deliver oxygen and to control the temperature; an assortment of tools; a heavy wooden table; and a shed-like structure, perhaps three meters wide to four meters long, usually darkened from the soot and ashes of constant fires. Once the metal softens, the *herrero* shapes it on an anvil using hammers, chisels, and punches. Of all the implements, the *cincel* (chisel) is the key to his work. He often makes his own *cinceles* in various sizes and with different motifs at the tips to decorate the metal, which occasionally become his "signature" on a piece, a means of identifying his work. His is a solitary craft, as he works perhaps with only a young apprentice who tends the flame to maintain the temperature required to heat the metal and learns the craft from the maestro.

Although his range of artistic expression is limited by the color and properties of metal, variation can be attained from his ability to manipulate the iron and decorate it with familiar symbols that speak the visual language of his culture. Such a decorative vocabulary developed in San Cristóbal, most likely in the late seventeenth century. By then *herreros* had established workshops in Barrio del Cerrillo, located in the shadow of the magnificent façade of the colonial Church of Santo Domingo.[70] Here they first forged implements needed to till the land, and then later decorative items, such as iron grills, locks, latches, keys, hinges, and, eventually, roof crosses.

Most of the contemporary ironworkers in San Cristóbal come from a long line of artisans who have learned their craft from their fathers or served as apprentices under a maestro. Carmen Penagos and his son, Enrique, represent a typical ironworker's family, in which the father teaches his son the trade, thus continuing the workshop into another generation. Their *herrería* is part of a family compound located in Barrio del Cerrillo, one of the oldest barrios of San Cristóbal, dating from the mid-1500s. Although this area was for several centuries the hub of the ironwork trade where most craftsmen worked in their home-based *herrerías*, today only a

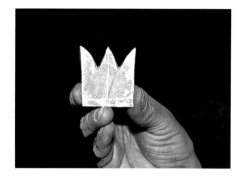

FINIAL.
Design being traced and cut from thin metal.

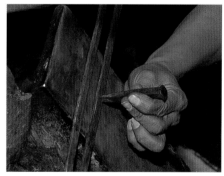

DECORATING THE IRON.
Ironworker imprinting metal with ornate designs.

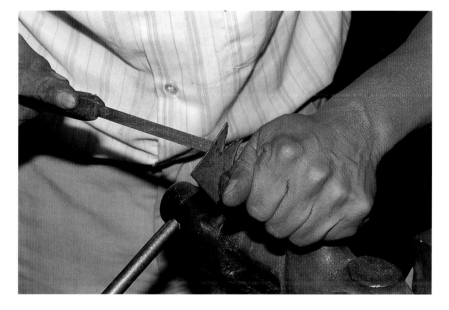

BENDING IRON.
Enrique Penagos shapes a roof cross.

SANTO DOMINGO.
Santa Domingo as seen from
Barrio del Cerrillo.

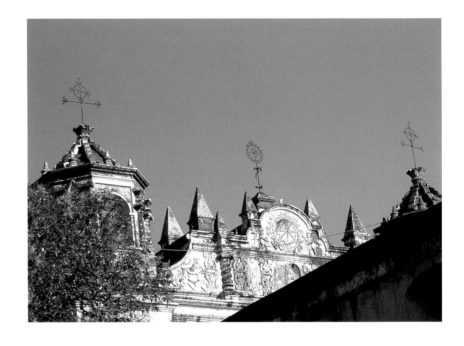

SANTO DOMINGO.
Five weather vanes on the towers
of Santo Domingo Church that
separates Barrio del Cerrillo and
Barrio de los Mexicanos.

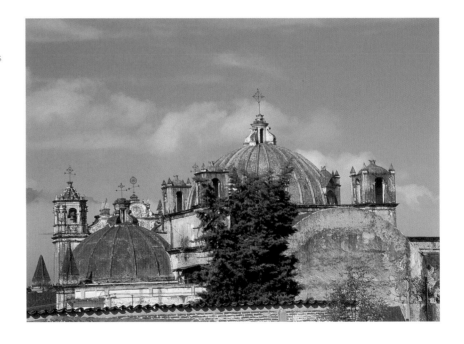

few of these artisans remain. The Penagos family compound houses members of the extended family, each with private rooms off a central patio, with the workshop to the rear of the property. Although Don Carmen is approaching his retirement years and leaves much of the work to Enrique, he maintains control over the business—greeting new clients, taking the orders, determining when the work will be completed, and setting prices. The father and son work on a fixed-order basis, require a deposit, which is usually one-half of the agreed upon price, and have no finished products on display in their workshop. Thus customers must approach these master craftsmen with a basic concept of what they desire. The family has been in the trade for nearly forty years and has established a reputation for fine workmanship.

On entering the patio of the compound, a cacophony of sounds from the cages of some fifty fighting cocks greets a client. Leaving more of the work at the forge to Enrique these days, Don Carmen can often be found sitting on a low chair stroking one of his favorite roosters or tending to the wounds of another. If engaged in conversation, he recollects about the history of his craft, his eyes, reddened from years spent over the smoky fire of the forge, drifting toward the impressive profile of the nearby colonial Church of Santo Domingo, with its five iron weather vanes still crowning the façade and apse, likely installed at the beginning of the seventeenth century shortly after completion of the church. Continuing to reflect, Don Carmen wonders how many early styles for the iron roof crosses of San Cristóbal de Las Casas were inspired by these fine examples of ironwork.[71] A cross was often incorporated into the overall design of a weather vane to add a religious dimension to their practical function, and thus making them more appropriate ornaments for church roofs. Today, these weather vanes atop Santo Domingo, stilled by the corrosive sediments that have accumulated over the centuries, no longer rotate in response to the changes in wind direction, but they clearly show some of the patterns on older roof crosses visible today in San Cristóbal.

Don Carmen's recollections are verified in Manuel Toussaint's account of Mexican colonial art. Toussaint notes that the cupolas of most colonial churches had large iron crosses with cutouts of roosters that revolved

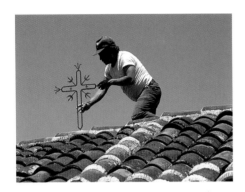

INSTALLATION OF ROOF CROSS. *Albañil* Juan Hernández Gómez secures an iron cross to a new roof.

around the shaft to indicate wind direction. Such weather vane crosses, after iron grills and railings, were the most decorative element of wrought iron in colonial architecture.[72] Since it was during the eighteenth and nineteenth centuries that iron roof crosses reached their artistic peak in San Cristóbal, it is probable that the custom of placing iron roof crosses on private homes was inspired by these weather vanes. In adapting the roof crosses for private houses, the ironworker elongated the end of the upright to a sharp point so that the resultant spike could be set in cement at the center of the roof. Here, a small section of a roof tile is chiseled out, approximately ten centimeters in depth, the point of the cross placed in this space and then covered with a bed of cement to secure it.

Several factors have contributed to the decline of this labor-intensive craft: changes in the fabrication of ironwork and decrease in the demand for nonutilitarian items linked to local customs. First, the development of advanced techniques of iron smelting and casting during the industrial revolution resulted in mass-produced objects cast in iron eventually replacing most hand-wrought work first in Europe and then later throughout the Americas. As ironworkers had to confront the decline in requests for their handcrafted products, only a few small *herrerías* survived to carry on the artistic tradition. Second, the iron roof cross craft was adversely impacted by antireligious movements that engulfed Mexico in the late 1800s and early 1900s resulting in the closing of churches, the destruction of religious objects, the banning of displays of Christian symbols, the expulsion of Catholic clerics from the country, and the separation of powers of the Catholic Church and state. During the 1910 Revolution, the political influence of the Catholic Church eroded even further until in the 1930s the government once again permitted churches to open. Such religious strife, however, lingered in Chiapas and neighboring Tabasco, where residents endured the continued persecution by the government so graphically described in Graham Greene's account of his visit to these states in 1938.[73] During these years, many roof crosses disappeared from houses in San Cristóbal, some exported to foreign collectors and others recycled into other products. With over 90 percent of the Mexican population Catholic, however, the government could not sustain such strict censorship and eventually maintained a peaceful coexistence with the church in Chiapas.

BALCONERÍA.
Sign on a shop indicating that the ironworker uses soldering and more up-to-date equipment.

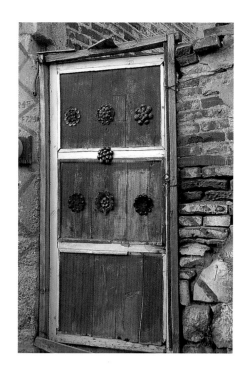

IRONWORKER'S DOOR.
In Barrio del Cerrillo, an ironworker advertises his craft by placing ornaments on his door.

By the 1940s, nevertheless, an entire generation of ironworkers had died, and with their demise went many traditional styles of roof crosses. After these tumultuous years, the use of roof crosses never again regained its former popularity. Due to this lack of interest coupled with the introduction of new smelting methods, such as welding, the sons and apprentices of traditional *herreros* started new business ventures in ironwork. Today, the majority of metalwork in San Cristóbal is produced in their shops, referred to as *balconerías*. The few ironworkers who still maintain their *herrerías* and continue to use forges and hand tools rather than welding torches in their trade live in several older barrios or new *colonias* on the periphery of the town, no longer residing exclusively in Barrio del Cerrillo. Wherever they are located, the only indication of their trade may be a display of various iron ornaments attached to the doors to distinguish their front entrances from those of their neighbors. Their reputation spreads by word of mouth, and since there are no ready-made objects for sale in these simple but effective workshops, clients come with specific orders for household fixtures, perhaps a door knocker and an occasional roof cross.

The demand for the latter becomes less each year in San Cristóbal as flat roofs of cement and other signs of modernization blend with the remnants of colonial architecture. Such new roofs, lacking the distinct ridge line of the traditional two- or four-shed tile roofs, offer no place for roof crosses. Furthermore, as second stories are added to older houses to accommodate the growth in population, the roofs are often peaked to follow the architectural style of the city but are of cement covered with a thin veneer of tiles. Moreover, television antennas or satellite dishes often adorn these roofs rather than iron crosses, leaving only a few ornate examples as testimony to this once important custom. However, these extant examples of a disappearing folk art still intrigue visitors to San Cristóbal, whose enthusiasm supports a viable market for the craft.

REPRESENTATIVE FIGURES. Two horses adorn this wall cross; from the collection of Nancy and Percy Wood in San Cristóbal de Las Casas.

From Folk Art to Tourist Art

The folk art of Mexico has fascinated international travelers and collectors for over a century. Vivid colors, whimsical designs, autochthonous images, and a creative blend of Old World and New World artistic techniques lure a steady stream of visitors to popular tourist destinations as well as to the more remote areas, where they seek out artisans who employ the simplest tools and materials to create coveted art objects. Adventure-

some travelers in search of crafts and out-of-the-way locations only arrived in Chiapas in greater numbers when the Pan American Highway reached the capital and ultimately the highlands in 1950. Today, a new airport allows travelers to fly directly from Mexico City to San Cristóbal de Las Casas, where they are greeted in the waiting room of this modern facility by a group of iron crosses. An outline of a small ornate iron cross even frequently appears next to San Cristóbal on tourist maps of Mexico, a testimony to the status of the state as a center for crafts, especially wrought-iron crosses.[74] As such, it has acquired national recognition among other states whose locations on such maps are distinguished by colorful sketches of pottery, lacquerware, textiles, and masks, testimony to the variety of artisans' works throughout this country.

Evidence suggests that modifications of crosses that fit the criteria of STYLE VII, crosses modestly ornamented with religious imagery (see Part 2) may have been the first attempt by ironworkers to make decorative crosses for sale to tourists and collectors rather than for roofs. A few of these examples dating from the late 1960s and early 1970s remain in private collections and on display in several hotels in San Cristóbal. All are tall, some over two meters, have no points for attachments on roofs, and have ornaments arranged so that they can be hung on walls. Although these crosses made impressive wall decorations, their size as well as lack of a dominant theme appealed to a limited clientele.

It was not until the middle of the 1970s, when a new wave of tourism to Chiapas brought momentum to the ironwork trade, that a more distinctive style of decorative cross appeared in local shops and proved economically successful. It was then that several ironworkers in San Cristóbal supplemented the work commissioned by local townspeople with mass-produced items for sale in tourist shops where door knockers and iron crosses were sought after by travelers wanting regional souvenirs. Although for this new market artisans made minimal changes in door knockers, they demonstrated inventiveness and technical expertise by modifying the roof cross for faster production and easier transport, creating a style based on traditional roof crosses but distinctive in design and ornamentation. Such crosses did not have a tapered point so that they could be more easily transported and later displayed on a wall, and some were fashioned with a built-in

STYLE VII

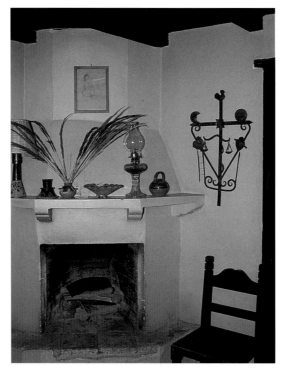

STYLE VIII.
Popular style from the 1970s; from the collection of Virginia and Robert Guess in San Cristóbal de Las Casas.

stand, enabling their use as a table ornament. Although ironworkers fabricated them in various sizes, all followed a similar style with elaborate ornamentation, representing implements of the Passion and the Crucifixion along with other religious symbols, a feature distinguishing them from more traditional roof crosses. These decorative elements rather than the cross itself became the new focal point, as described in examples of STYLE VIII (see Part 2).

On these new decorative crosses, the large array of ornaments, arranged so they can only be appreciated from a frontal view, mostly represent objects used during the Passion and the Crucifixion: the lance that pierced the side of Christ; the hammer, nails, and pincers used to nail Christ to the cross; the sponge at the end of a sword utilized to wet Christ's lips; a crown of thorns made for him to wear; the dice used in casting lots for Christ's clothing; the rooster that announced Peter's denial of Christ; and the pitcher Pontius Pilate used to wash his hands of Christ's death.

Because in predominantly Catholic Mexico travelers expect extensive use of religious motifs on regional crafts, such iron crosses illustrate Nelson Graburn's description of tourist art, where the buyer's expectations are fulfilled by the artisan.[75] Other decorative items on these iron crosses crafted for tourists are, however, less easily interpreted. The sun and moon, or a serpent and butterfly, for example, may be remnants of pre-Hispanic motifs but with simultaneous significance in Christian iconography.

Elizabeth Weismann traces the history of the early use of the instruments of the Passion in Christian iconography to the eleventh century but concludes that they did not become important in Spanish art until the fifteenth and sixteenth centuries and that the symbols seem to be more prevalent in New World art.[76] She further comments that sun and moon figures were not usually included as part of the instruments of the Passion motif but were represented occasionally in Crucifixion scenes. In her opinion, the frequency with which they appear in New World crafts implies acculturation in that

> . . . symbols which are used in both religions (or arts) gain more importance when the two are brought together. For the Christians, sun and moon were acceptable furniture; for the Indian, they were representations of important cosmic concepts; hence their ubiquity in Mexican decoration.[77]

In the tourist-style crosses fabricated in San Cristóbal, these symbols are deliberately merged. Such crosses are produced in traditional workshops, where multiple copies of pieces used for cruciforms and ornaments are shaped by the master *herrero* then laid out in an assembly-line fashion and welded by assistants into patterns established by the maestro as prototypes. The welding process, which takes less time and effort than the joining of the individual pieces with rivets, facilitates production. Any number of crosses can be made in this way and sold as wall ornaments for display.

The creations of the few ironworkers who have applied their entrepreneurial skills to the new market created by tourists exemplify the modernization of a popular craft and its incorporation into the national economy in which products are sold both locally and exported. Guadalupe Hermosillo represents this new breed of ironworker, an artisan as well as a businessman

who does not wait for commissions, but seeks markets for his work, at tourist centers throughout Mexico. One of his specialties is a type of souvenir iron cross modified into a wall hanging, an item that has become almost synonymous with San Cristóbal de Las Casas, which he offers in sizes ranging from ten centimeters up to over a meter and a half tall.

His workshop is also different from those of more traditional ironworkers, such as the Penagos workshop. Nevertheless, it is still an integral part of his home, which is located in a new *colonia* at the periphery of San Cristóbal marked by a contemporary neighborhood of cement-block structures with flat cement roofs. The entry to the house, which he shares with his wife and children, is through his workshop. In the main room are samples of his work for sale, including door knockers, hinges, locks and keys, candleholders, and even a wrought-iron depiction of the Last Supper— offerings not customarily seen in the workshops of more traditional ironworkers. He also has a notebook of hand-drawn sketches of objects in more traditional styles, for clients commissioning work, including several sketches of iron roof crosses copied from the Frans Blom Iron Roof Cross Collection at Na Bolom. Hermosillo's tools hang neatly along one wall opposite a long work table. His forge, constructed of a metal drum to hold hot charcoal, is driven by an electric motor that fans the coal to create the intense heat needed to soften the iron. Hermosillo does the designing and shaping of all the iron, but he depends on his few unskilled workers to assemble the parts. They may simultaneously assemble up to thirty crosses in the same style on the dirt floor of the workshop following a pattern that he has laid out for them. Such ornate crosses, the stereotypical style made for the tourist market, decorate walls of elegant homes from Mexico City to Los Angeles and New York City. I even discovered a cross from an ironworker's shop in San Cristóbal on the remote island of Santa Cruz, one of the four Northern Channel Islands off the coast of southern California. It hung on an outside wall of a small farm building, probably placed there to commemorate the island's name.

Ironically, the existence of this distinctive regional craft may ultimately be affected by its widespread popularity. Propelled by the momentum from requests of collectors for the finest craftsmanship, international entrepreneurs are taking examples of ironwork from Chiapas to well-

known ironwork centers in other states of Mexico, such as Michoacán and Puebla, to be copied by skilled artisans, who likely will add their own innovations to alter the regional style. A photograph in a popular travel and culture magazine of Mexico demonstrates how such a change can occur.[78] It depicts a tourist-style cross, typical of those fabricated in San Cristóbal, but with the cross and ornaments brightly painted and up to thirty ornaments, twice the number that appear on even the most ornate cross from San Cristóbal. Further, while the *herreros* of San Cristóbal are selective in their use of symbols, ironworkers from other regions may include all symbols of the Passion and the Crucifixion. Fortunately, those interested in the history of the craft and with the desire to procure a more authentic replica can still find a few traditional ironworkers in Chiapas.

The Legacy of Traditional Ironworkers

With some effort, it is possible to bypass the ready-made iron crosses in the tourist shops of San Cristóbal de Las Casas and find an aging *herrero* who will copy a design of an old roof cross, with skills nearly forgotten due to the introduction of modern methods of cast iron and smelting techniques. A cluster of elaborate iron figures on a wooden door as samples of his work may be the only indication of his *herrería*. When you lay out the drawing of the object you want made, the *herrero* will scrutinize it through eyes clouded with smoke from years spent over his forge and strain to hear your words with ears deafened from damage caused by the constant noise from metal striking against metal. As the negotiations proceed, he will quietly nod his head in recognition as he studies the sketch of a cross from his past or calls a son or an apprentice to consult with him on the cost of the work. The younger man, who has no doubt learned the craft from this maestro, may be the craftsman who completes most of the work. After settling on a price and date on which the cross will be ready, you leave an *anticipo*, advance, and depart the workshop, wondering about the outcome of this casually made agreement. But when you return in four to seven days, you will be assured that the craft has not yet been forgotten.

As you study the completed cross, however, you will identify the differences between an older cross and your newly acquired replica. While the artisan may have produced a near-perfect copy, you will note that the iron

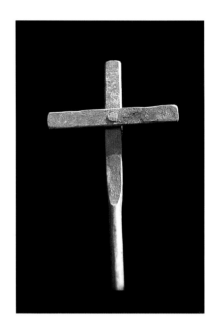

SOLDERING TECHNIQUE.
Solder rather than rivets were
used in fashioning this cross.

CROSS DETAILS.
An ornament riveted on to a
lateral extension.

of the basic cruciform is smooth because it is fashioned from machine-made pieces of iron. The adornments may be attached by *soldadura*, soldering, rather than the older method of *remache*, riveting. The iron itself may even be a bit thinner and lack the occasional flaws inherent in the hand-shaping process needed to attain the desired form. The end product, nevertheless, is a cross distinguished by its originality and not one of the ready-made items sold in local shops.

Until recently, you might have found your way to Don Polo's workshop in Barrio de los Mexicanos, one of the better-known artisans of San Cristóbal, who has spent most of his life making wrought-iron roof crosses for several generations of clients. As a testimony of his skill, a sample of his work appears in an exhibition of local crafts at the Regional Museum of San Cristóbal de Las Casas. His long days in the workshop, however, are coming to an end, and having neither sons nor apprentices to benefit from his experience, so is the tradition of his creative work. I was reminded of this as well as the tenuous position of the craft on a recent visit with him. When Don Polo opened the heavy door that muffles the traffic noise of the busy street, I knew that something had changed. His short, stocky torso

leaned heavily on a wooden stick he held firmly against his right leg, and instead of his usual cheerful countenance he was grimacing in pain. As we exchanged greetings, he glanced at the old iron cross I had brought him to copy and his eyes misted in a light veil of tears. Shaking his head slowly, he replied in his customary manner of few but meaningful words: *"No lo puedo."*

As he was telling me that he no longer could do the work, I glanced behind him to see the tightly closed door to his workshop, a refuge where I had spent many hours over the years in negotiations with this quiet, but always gentle, artisan. I soon learned that beyond the locked door his forge no longer generated the heat to work iron, and his tools, smoothed with the patina from age and use, were stilled. Since there was no one to keep the *herrería* open during his recent illness, he had been forced to refuse the orders that once served as his livelihood. When we said a reluctant farewell, I watched the door close quietly behind me, heavily ornamented with small hand-wrought iron images. From the street I could also see a large iron cross weathered from age but still erect at the center of his roof, another example of Don Polo's craftsmanship. Of the twenty-five roof crosses still remaining on houses in the barrio in which he lives, his is by far the most ornate, as if he had added a sample of all possible ornaments he once was able to offer clients. Sadly, soon after, Don Polo's *herrería* closed permanently, as he did not live to greet the new millennium.

Don Polo was my most reliable source of information on the craft of ironwork in San Cristóbal. It was to him I went in 1996 with a design of a cross I first saw on the Island of Santa Cruz, off the coast of California. Although the design was somewhat different from those made in Chiapas, it did have several characteristics that resembled them. When Don Polo looked at my sketch, however, he immediately identified it as coming from another place and only reluctantly agreed to copy the image. After three attempts, he finally came close to the original pattern but never appeared pleased to be fabricating an object that was not in his familiar repertory of designs. I needed this example for several reasons. First, I wanted to determine if indeed the styles of roof crosses in San Cristóbal were as established as I had predicted. Second, I wanted to include this cross among the samples I planned to use with other *herreros* when asking them to arrange a

number of crosses chronologically from older to newer styles. Of the several *herreros* I had worked with over the years, I chose Don Polo for my unusual request, trusting that he would produce the best replica possible.

Although his passing, along with the deaths of several of his contemporary *herreros*, ends an era of this craft, a ray of hope exists for the continuation of hand-wrought ironwork in San Cristóbal. Six Tzotzil-speaking artisans from the indigenous highland Maya community of Magdalenas are now producing fine examples of the tourist-style cross for sale in San Cristóbal and are ultimately planning to distribute their work to markets outside the country.[79] Under the aegis of a nonprofit organization established to develop free-trade products to benefit the economy of autonomous people in Chiapas, these craftsmen trained by Ladinos fabricate iron crosses combining Christian and Maya symbols following the decorative features of STYLE VIII,

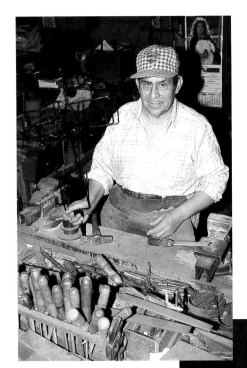

TRADITIONAL *HERRERÍA*.
The late Leopoldo Morales Martínez, Don Polo, with the tools he used in his workshop located in Barrio de los Mexicanos of San Cristóbal de Las Casas.

CONTEMPORARY IRONWORKERS.
The Santiz brothers, Miguel and Manuel, Tzotziles from Magdalenas, forge crosses and other metal products in Barrio de San Ramón of San Cristóbal de Las Casas for the tourist trade.

TABLE CROSS.
Crafted in STYLE VIII by the Santiz brothers for sale in local shops in San Cristóbal de Las Casas.

a sun and moon in combination with many implements of the Passion and the Crucifixion (see Part 2). These meticulously crafted crosses, forged of heavy metal from heat produced by charcoal fires of pine wood, take eight to sixteen hours to complete, depending on the size, with a cross thirty centimeters tall requiring a full day's labor.

These young artisans received part of their initial training in a center established in San Cristóbal to revive and preserve the arts and crafts of highland Chiapas. Opened in 1997, it is a place where students can enroll in courses to learn techniques of weaving, jewelry making, and ironwork.[80] In the ironwork program, they participate in three six-month courses, in which they first learn how to produce farming implements; then the tools used in an *herrería*, such as special hammers, pincers, and chisels to wrought iron; and finally decorative iron products including iron crosses. One of the goals of the ironwork program is to encourage students to replicate some of the old designs of roof crosses from the Frans Blom Iron Roof Cross Collection at Na Bolom. Thus this craft, introduced into the New World by European craftsmen with indigenous apprentices and then carried on by *mestizo* ironworkers, is once more being practiced by some modern Maya in Chiapas. That these indigenous artisans have entered into a trade formerly practiced by *mestizos* is a sign of changing times. Due to the passing of the last generation of ironworkers and the preference of their apprentices to work in *balconerías*, workshops where welding is used, there are currently many new opportunities for innovative ironworkers, including reviving old designs of roof crosses and offering new fixtures and household items.[81] Whatever direction the craft takes in the future, the symbols and styles of the old crosses most likely will remain a standard. The ornaments on the crosses will likely also endure, as will the controversy over the meaning of these symbols, whether they represent Maya iconography, Christian iconography, or, as I conclude, both. The cross, the sun, and the moon, once important symbols in ancient Maya cosmology as well as in Christianity, continue to be part of the artistic expression. While some may conclude that such motifs persist but lack the original pre-Columbian meaning, I propose that rather they represent symbols that unify two diverse belief systems, and thus provide the common themes in the crafts from the state of Chiapas.

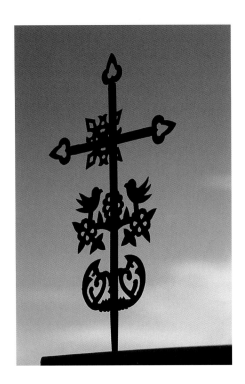

IRON ROOF CROSS FROM ECUADOR.
Whimsical designs rather than religious symbols embellish this roof cross from Cuenca, Ecuador.

ROOF CROSSES IN THE AMERICAS

Looking at the craft of wrought-iron roof crosses of Chiapas from a broader perspective provides a further means of assessing their function and artistry. In general, the works produced by the craftsmen of Mexico and Latin America reflect a strong preoccupation with religious symbols, especially the cross and the instruments of the Passion and the Crucifixion. Patricia La Farge addresses this widespread preference for such symbols, identifying the broad geographic range of the cross as artistic object and describing the different artistic expressions of it in the Americas, including house blessing crosses installed along ridge poles for the protection of the home and family.[82] Although the cruciform appears in many examples of religious folk art, she confirms that the roof cross tradition has been noted in only a few countries. Today, roof crosses are found in two widely separated locales: Chiapas, Mexico, with the highest visibility in San Cristóbal; and in the Altiplano regions of Ecuador, Peru, and Bolivia. They also at one time graced the roofs of homes in Guatemala.

The custom seems to be as popular in and around Cuenca, Ecuador, as it is in Chiapas. In both these regions, residents of the cities prefer an iron cross on their roof, whereas indigenous people in the adjacent countryside use a wooden cross in Chiapas and a cement cross in Ecuador. Ironworkers in Ecuador, as they do in Chiapas, fashion crosses for tourists that replicate those locally used as roof crosses. Where wrought in iron, however, the crosses clearly demonstrate a difference between these two regions, a factor attributed to the *herreros* who produce them. These craftsmen have developed distinctive styles that upon close examination provide clues to the source and provenance of the crosses.

Ecuador

In Cuenca, the preferred cruciform is a Latin cross, adorned at the axis with a distinctive ornament, often in relief, such as a crown of thorns, an elaborate floral motif, or a pierced heart. Ornaments decorate the arms, usually a few implements of the Crucifixion, often including a hammer and pincers. A difference from those crosses produced in Chiapas is the addition of a horizontal bar, equal in length to the arms or slightly longer, fastened at the base. The added projection is adorned with a tableau of figures

and objects, such as a ladder, spear, and sword; or a pitcher, rooster, and church tower; and frequently a local plant or animal.[83] This style of roof cross might have developed from the custom in rural Ecuador of arranging clay figures in a scene along the roof ridge, a practice similar to that noted in the Zoque regions of Chiapas, where a specially decorated tile with a central cross is installed at the center of the roof. Here, as in Chiapas, it is customary for the residents to mark the completion of their house with a celebration that includes the formal installation of a roof cross and a gala party for friends and family. In honor of the event, guests often bring figures molded in clay that are then placed along the roof ridge when the roof cross is ceremoniously installed.

An illustrated article in an Ecuadorian newspaper verifies how residents of the Province of Cañar still follow their tradition of inaugurating a new house with such elaborate festivities. One photograph shows the *madrina* cradling a small cross in her arms as she walks through the streets to the new house, accompanied by musicians who play music on pre-Columbian instruments, such as drums, flutes, and bells, as well as guitars, violins, and

CROSS FROM ECUADOR.
A cement roof cross on a house in the mountains overlooking the Cuenca Valley of Ecuador. Photograph by Katy Zappala, 1996.

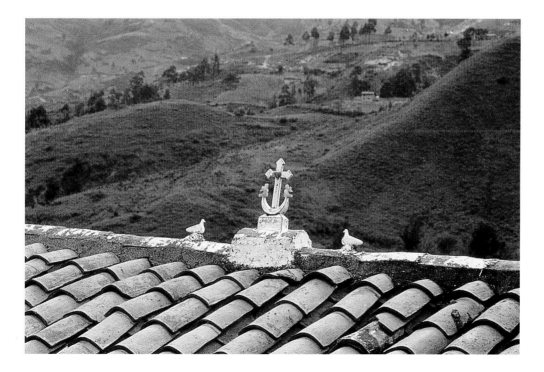

accordions of Hispanic origin. Following the installation of the roof cross, often blessed by the local Catholic priest, friends join the family in the celebration with music, dancing, and a feast. Such an event reflects how the indigenous people of this province maintain their ancestral customs.[84]

In the nearby colonial city of Cuenca, as in San Cristóbal de Las Casas, iron crosses are produced for the tourist market; however, here the style of cross for the commercial trade is not significantly different from the style used on roofs, with only the size modified, resulting in miniature renditions, twenty to twenty-five centimeters tall, of the ones made for houses. In addition, the ironworkers from Cuenca occasionally date their work, whereas the artisans from San Cristóbal do not. A notation of 1889, for example, was reported for such a cross from this region.[85] Another variation is that the ornamental iron figures on both roof crosses and those for sale to tourists are painted in vivid colors, while in Chiapas iron crosses are not generally painted and only occasionally given a protective coat of white or rust color to prevent oxidation of the metal.

Iron crosses fabricated in Quito, the capital of Ecuador, often are more reminiscent of Spanish colonial motifs than those from Cuenca, which tend to display rustic scenes with familiar animal and plant figures. Further, on crosses from Quito the ornate finials and decorations at the axis often are complemented by other adornments on the upright, such as the double-headed eagle adapted from the Hapsburg coat of arms (see page 78, illustration 5). This familiar eagle of the Hapsburg family appears throughout the New World, copied in architectural motifs, ironwork, and textiles. From this European line of royalty that dominated Europe for almost seven hundred years came the Holy Roman Emperor, who also ruled over the Spanish kingdom, accounting for the emblem's presence in the New World. It is likely that the style of cross used traditionally in Ecuador as a roof cross was more readily adapted to a wall ornament, which facilitated the transition of this style from roof cross to smaller tourist cross with minimal change. In Ecuador as well as in Chiapas, however, ironworkers' shops persist as an anachronism in the twenty-first century, still producing hand-wrought utilitarian objects in addition to some decorative wares. The craft is more in danger of disappearing in San Cristóbal, where the use of roof crosses has lost favor among local residents and artisans have had to

depend on outside markets for the sale of their products. In Ecuador, where the custom of roof crosses remains strong, the craftsmen benefit from local demand, in addition to souvenir markets.

Guatemala

Evidence suggests that the roof cross custom was followed at one time in Antigua, Guatemala, where some of the finest colonial architecture and decorative ironwork originated in the colonial period.[86] This first capital of Guatemala, destroyed several times by violent earthquakes and volcanic eruptions, lost much of its rich artistic heritage as a result of these natural catastrophes. Although few, if any, crosses remain on roofs in Antigua, they can be commissioned from ironworkers, who thrive in lucrative businesses providing ornamental iron objects. These crosses, however, are neither ready-made nor available in their shops for purchase as representative crafts. Two examples from a private collection, fabricated in Antigua on special order and copied from a book of old crosses, show a solid design of a Latin cross with simple decorative finials.[87] The first displays the orb motif, a modification of the roof crosses illustrated by Navarrete, where a Latin cross emerges from the terrestrial sphere representative of Christian dominance over the world (see page 78).[88] In the second example, the primary decorative feature is a simple sunburst effect at the axis where the arms and upright join (see page 78). Although Chiapas was included within the territory of el Reino de Guatemala during the colonial period and a possible connection in the roof cross tradition could have existed between the provinces, these illustrations do not resemble any cross produced now in Chiapas.

Peru and Bolivia

Various forms of ornaments appear on roofs in a few areas of Peru and Bolivia. In Ayacucho, Peru, for example, roof crosses are hammered out of tin to copy those made in silver during colonial times.[89] These usually follow a solid design (see page 74) and are heavily embellished with implements of the Crucifixion, including sun and moon figures on the transverse arms. Other religious symbols adorn the cross, such as clusters of grapes, a chalice, angels, and a banner. As a variation, miniature

churches modeled in clay decorate some roofs in Pucará, Department of Puno, while pottery crosses are popular in the northern highlands of Peru and Bolivia. The reasons given for the practice resemble those recorded in Chiapas: to protect the house and the inhabitants from evil as well as a sign of religious belief. Some residents in these countries may install a new roof cross each May on the feast day of Santa Cruz or simply festoon their existing cross with colorful paper streamers and flowers to celebrate the day.

Thus in these geographically unconnected areas, ironworkers employing similar techniques developed a characteristic style of roof cross that is immediately identified with its region of origin. In Chiapas, an open design (see page 74) of a Latin cross, one with space between main design elements, was preferred as a roof ornament, which over time has been modified into a solid design, one without space between main design elements, heavily ornamented with religious symbols but with the characteristic sun and moon figures. In neighboring Guatemala, the design once created appears to have been a solid Latin cross emerging from an orb with floral and geometric motifs but lacking additional religious symbols as ornaments. Here, however, the custom no longer prevails. Farther removed from these regions, a roof cross tradition persists in Peru and Bolivia, where the designs and styles vary as do the materials. In Ecuador, a solid Latin cross decorated with religious motifs combined with representational figures is favored both for the local and souvenir markets. In the regions where the practice is still maintained, the indigenous people who populate the rural areas prefer a roof cross made from a less costly and more readily available material.

Several cultural similarities do occur throughout the regions of the Americas where roof crosses exist. One unifying theme is the ardent devotion to the cross, which is overtly expressed on 3 May with the commemoration of Santa Cruz. On this day, crosses are customarily decorated, and celebrations are held in private homes as well as in entire communities, with *albañiles* having a holiday from their work.[90] These laborers still erect makeshift wooden crosses on building sites where they work daily and scratch the outline of a cross somewhere on the structure as a signature of, or a blessing on, their work. The survival of this devotion may be associated with the importance given the symbol of the cross in pre-Hispanic

times and the utilization of this familiar sign by the Spanish friars who introduced Catholicism into the New World. In Mexico, *el día de la Santa Cruz* is officially recognized in more towns and cities than most other religious feast days with the exception of 12 December, the day to honor the patroness of the country, Our Lady of Guadalupe.[91] However, although the ironwork of countless crosses on cathedrals and churches throughout Europe, Mexico, Guatemala, and South America, and in cemeteries around the world, is reminiscent of that from Chiapas, the styles and motifs of the iron roof crosses crafted in San Cristóbal remain distinct, demonstrating how regional styles develop from techniques with indigenous influences, resulting in a local custom.

The origin of the roof cross custom, whether the cross is of iron, wood, or cement, remains a conundrum. In attempting to find links among these various countries, I uncovered no irrefutable evidence that connects the practice or a definitive source from other parts of the world. Although Dominican friars spread Catholicism during the colonial period into most of Latin America where the tradition persists, to attribute the source of the custom to them would be spurious since due to the large dispersed congregations and few friars at the time, the majority of the population had minimal contact with the missionaries. However, no matter what their origin, iron roof crosses continue to have significant meaning and function to the people who use and admire them. To most Catholic Ladinos they remain as signs of their Christian faith, while to many others they have a more obscure meaning embedded in folk beliefs pertaining to gaining a modicum of control over the ephemeral forces of the spiritual and natural realms.

JAGUAR.
Insignia associated with the
house of Frans Blom: Tzotzil
word for house, *na*, and for
jaguar, *bolom*.

THE FRANS BLOM IRON ROOF CROSS COLLECTION

ALTHOUGH THE TRADITION OF ROOF CROSSES continues throughout the highlands of Chiapas as well as in a few smaller towns of the Central Depression, where specific features readily identify the cross with its place of origin, it is in San Cristóbal de Las Casas that the greatest variation in styles occurs, where the practice has persisted longest, and where more crosses remain on roofs. Thanks to the foresight of the late Frans Blom, a Danish archaeologist-explorer who began collecting iron roof crosses of the region in the 1950s, many of the old designs have been preserved. Examples in his collection, which includes both traditional and more contemporary styles, offer an opportunity to better appreciate how this regional folk art has changed over time. The history of the collection is intertwined with Blom's passion for establishing a research center in San Cristóbal, today the nonprofit public trust La Asociación Cultural Na Bolom where his collection remains on permanent display.

THE HOUSE OF THE JAGUAR

Although Frans Blom (1893–1963) first visited Chiapas in 1922 as a representative of a large petroleum company exploring new sources of oil, it was the ruins of the ancient Maya sites of this unexplored state that captivated his interest and led him into the field of archaeology.[92] In 1925, when he returned for a brief visit, he fell under the spell of San Cristóbal de Las Casas, where he had a few days of respite from his arduous travels through

the uncharted Maya territory as co-leader with Oliver La Farge of a Tulane University archaeological expedition.[93] Although his stay was cut short by the demands of his work, it was long enough for him to become captivated by the natural beauty of the pine-forested region and the richness of the many indigenous cultures that thrived in the highlands. Nearly a quarter of a century of professional mishaps and personal travails passed before he realized his self-made promise to return.[94]

Finally in 1950, using proceeds from a small family inheritance, he purchased the house at Avenida Vicente Guerrero #33 that is now the location of La Asociación Cultural Na Bolom. When he first heard of this abandoned adobe structure, originally designed as a seminary with its own chapel and surrounded by a large orchard, he immediately envisioned a home for himself and his wife, Gertrude Duby Blom (1901–1993). The couple, who first met in Chiapas in 1943, each brought their own talents and interests to the life partnership they were to forge. His were in archaeology

CENTRAL PATIO OF NA BOLOM. Iron roof crosses collected by Frans Blom decorate the corridors of the inner courtyard.

and ethnography, while hers were in journalism, photography, and horti-
culture. Together they shared an interest in preserving the culture of the
Lacandon Maya, who lived in the lowland jungles of Chiapas. Later in her
life Gertrude Blom (usually called "Trudi" or rarely by the Spanish
"Gertrudis") became strongly committed to bringing worldwide attention
to the destruction of this tropical rainforest, the home of the Lacandones.[95]
Frans Blom's ultimate goal was to establish his house as a scientific institute
that would provide a base of operations for scholars engaged in archaeolog-
ical and ethnographical studies. A number of years of hard work ensued
before this dream materialized. When completed, the house was christened
Na Bolom, meaning "House of the Jaguar" in the local Tzotzil language, as
well as being a play on Blom's name.

At the time of his death, Frans Blom had accumulated a research library
of over ten thousand volumes, built modest quarters for visiting researchers,
and set aside rooms to display his collections of colonial religious art,
regional folk art, ethnographic objects from the Lacandon jungle, and
archaeological artifacts from Moxviquil, a preclassic to postclassic Maya site
at the north side of the valley overlooking San Cristóbal. Today, these
objects remain on exhibit for the more than twenty thousand visitors a year
who travel from around the world to view this distinguished collection and
to get a glimpse of the place where Frans and Gertrude Blom once lived
and worked.

A simple wooden sign marks the house as the Na Bolom museum.
Above the main entrance, the year of construction, "Año de 1891," is
carved into the neoclassic façade. Several colored inlaid tiles of a jaguar, the
hallmark of the house, decorate the front of this tall building. The wrought-
iron knocker, polished to a smooth patina by the hands of the many guests
who have stayed here, is also shaped like a jaguar, an example of one of the
few remaining crafts in San Cristóbal. Once admitted, visitors pass through
the *zaguán*, the broad passageway that leads from the street to the central
patio. Brilliant magenta blooms of bougainvillea and delicate yellow flowers
from the climbing vines of Lady Banks roses, remnants of Gertrude Blom's
ardor for gardening, abound in the large courtyard. A wide covered corri-
dor surrounds the four sides of the patio. On the east and west walls hang
most of Blom's collection of hand-wrought iron roof crosses.

NA BOLOM.
Former residence of Frans Blom
in San Cristóbal de Las Casas,
now a regional museum and
location of the Frans Blom Iron
Roof Cross Collection.

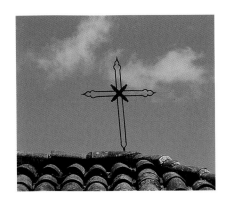

REPLICA OF CROSS 6.
Copy of a cross made in the
1960s by Wally and Francese
Franklin (page 104) for a roof on
one of their guest cottages at the
Hotel Molino de la Alborada.

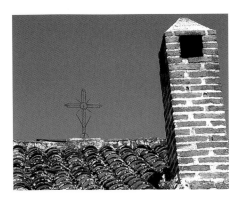

REPLICA OF CROSS 3.
An almost exact replica of Cross 3
(page 101) on a house owned in
the 1960s by the late Edna and
Roswell E. Franklin.

When Blom started this collection in the early 1950s, he merely hoped to salvage a few examples and use them to decorate the walls of the house, not anticipating the significance it would ultimately have on the iron-workers and the craft itself. Soon after the Bloms moved into the house, Frans let the townspeople know of his interest in regional arts and crafts. Subsequently, entrepreneurs such as Señora Narcisa Narváez and Señor Artemio Trujillo provided him with a steady supply of religious objects, including iron roof crosses.[96] They visited various barrios of San Cristóbal offering to buy any pieces from residents, then sold them to Frans, whose only limitation was available funds. As his interest grew, Blom became increasingly aware of the degree to which this old ironwork was being exported or melted down for raw material. This potential loss motivated him to become more diligent in his acquisitions, a foresight which resulted in the largest collection of old iron roof crosses on public view in Chiapas.

The impact of Blom's interest in local ironwork may have extended well beyond the roof crosses he acquired and ultimately left in trust to the people of Chiapas. As a prominent figure in San Cristóbal, his fascination with these familiar objects may have even played an indirect role in the sur-vival of the craft. While some residents found him a willing buyer for their family roof crosses, others became interested enough in reviving the tradi-tion to seek out retired artisans who still remembered the old designs. The collection also served as a source of inspiration for young ironworkers, who often came to Na Bolom to examine and sketch the crosses to expand their repertoire of styles. Some of these drawings, yellowed with age and stained with the charcoal fingerprints of the artisans, are even today provided as patterns to assist clients in selecting a design. In addition, several crosses that still can be seen on roofs in San Cristóbal are exact copies of those in Blom's collection. These replicas represent the generosity of Frans and Gertrude Blom, who graciously accommodated many requests from friends to borrow a cross from the collection to make their own copy.

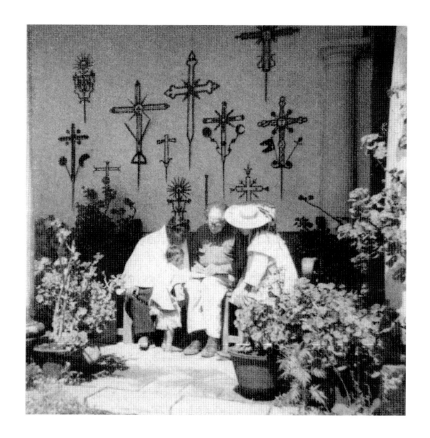

FRANS BLOM IN 1957.
On the patio at Na Bolom with a
Zinacanteco family seated in
front of iron roof crosses from
the museum's collection. Photo
by Mark R. Harrington, courtesy
Southwest Museum, Los Angeles.

DOCUMENTATION OF THE COLLECTION

Unfortunately, there are few records of the collection's evolution. Up to the time of this study, the Frans Blom Iron Roof Cross Collection had been inventoried as part of the general contents of the museum but never described separately as an important documentation of a regional craft. Only recently has some information on the collection appeared in a publication from Mexico.[97] Although numerous articles about the Bloms' efforts to preserve the cultural and environmental integrity of Chiapas often included a photograph of the well-known couple taken at Na Bolom that occasionally showed roof crosses in the background, as do a few old photographs of former guests in the annual scrapbooks maintained at Na Bolom, the collection rarely received any attention except an anecdotal comment.[98]

The Frans Blom Iron Roof Cross Collection begins on page 99.

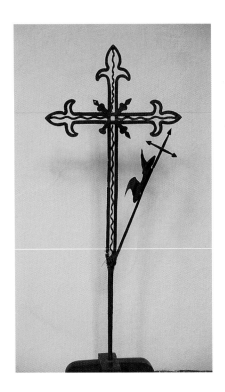

CROSS 30.
Exceptionally well-crafted example of Style V mounted on a wooden base.

The first published account with such a photo appeared in 1958, written by Mark R. Harrington, a former curator of the Southwest Museum in Los Angeles, California. In a brief note in that museum's publication, he described meeting the Bloms in San Cristóbal de Las Casas and included a photograph of Frans sitting in the patio of Na Bolom in front of a display of eleven crosses:

> Speaking of historical exhibits, there was, on the patio wall outside our room, a collection of beautiful wrought-iron crosses, torn from buildings during an anti-religious campaign and rescued by Don Pancho [Frans Blom].[99]

After Frans's death in 1963, Gertrude continued to add to the collection. Frequent inquiries made by guests about the roof crosses resulted in the following description in the booklet *The Story of Na-Bolom*, which she wrote in the 1970s:

> In the old days it was fashionable in San Cristóbal to grace the roof of one's home with an iron cross, and neighborly rivalry produced a rich variety of beautiful designs. With the confiscation of Church property in the last century, a law was enacted forbidding the display of these religious symbols, and people stored them away. In the early 1950's local blacksmiths were buying them by the pound as scrap metal, and Frans offered twice the going price to save those valuable examples of early local art for future generations. Fortunately, the crosses are now again being made by local artisans and can be bought in town.[100]

In July 1995, I examined, measured, and photographed each of the thirty-two crosses in the Frans Blom Iron Roof Cross Collection, assigning them a number arbitrarily based on their location in Na Bolom at that time. Crosses 1 through 27, for example, hang on the west and east walls of the corridors that surround the central patio. Crosses 28 through 30 are situated in interior rooms: Cross 28 decorates the chimney of the fireplace in the *comedor*; Cross 29 hangs in a guest room named "Mitontic"; and Cross 30 is mounted on a wooden stand that sits on the fireplace mantel in the library. Cross 31, believed to have been once part of the collection, was

recently discovered in storage, and Cross 32 was returned to the collection in 1997. The latter two may one day be hung again on the corridor walls.

Further, to trace the history of the collection, I and two assistants in the Photographic Archives at Na Bolom reviewed all negatives and prints of photographs taken in the central patio and inner rooms of the house from the early 1950s up to the present. This provided estimated acquisition dates for each cross in the collection.

These documentary photos also indicate that four crosses once in the collection are now missing. While the location of the crosses remains unknown, there is detailed documentation of the style of two of these crosses. A photograph of one of these appeared on an inventory card bearing no date but with a notation, probably from 1957 when Blom made the acquisition, that reads: "2 cruzes [sic] de fierro [sic] forjado. $50.00 por los 2" ("2 wrought-iron crosses. Fifty pesos for the two"). The image of the missing cross shows a solid cruciform having an apical circle with twelve radiating projections and an inner Latin cross, as well as two conical-shaped towers capped with orbs on each arm near the finials. Two sets of S-curved extensions, one atop the other, project outward from the upright to hold figures of two water pitchers and leafy branches. A stylized lotus, at the center of the arms, supports the upper section of the upright and the apical circle. This cross, part of the collection until January 1959, also appears in a photograph taken by M. R. Harrington on his visit to Na Bolom in 1958.[101] It can be seen in the upper left corner of this image along with ten other crosses, including Cross 18, that are still part of the collection.

An almost exact copy of a second cross missing from the collection remains on a building in the compound once known as the Harvard Ranch, within a half kilometer of Na Bolom. It is composed of a solid design with a prominent four-petaled flower attached to the axis where the arms intersect with the upright. The Harvard Ranch served as living quarters and research center from 1961 to 1981 for the senior staff of the Harvard Chiapas Project, directed by Professor Evon Z. Vogt. The project, designed to document cultural changes in the Tzeltal and Tzotzil communities in the highlands of Chiapas, started in 1957 and lasted nearly thirty-five years.[102] In keeping with the roof cross tradition, each roof on the four major buildings at Harvard Ranch has an iron cross. In addition to the above-mentioned replica, a

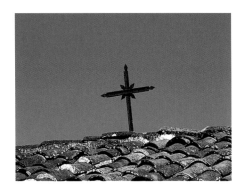

ROOF CROSS AT HARVARD RANCH. Replica of a cross documented in Frans Blom's collection in the 1950s.

second cross installed on one of these buildings is an exact duplicate of Cross 13 still in the collection at Na Bolom. Evon Vogt's acquaintance with Blom, as well as his interest in the roof cross tradition, may explain this coincidence. Vogt further extended the purview of the Frans Blom Iron Roof Cross Collection by presenting yet another copy of Cross 13 to the owners of Los Baños Mercedarios, a family-operated guest house in Barrio de la Merced of San Cristóbal. He made this gift in the 1970s in appreciation for the service the family rendered to the Harvard Chiapas Project by providing lodging for many students who came to study in the indigenous communities during the summer months. The owners installed the iron cross directly behind an existing wooden cross that had been on the roof when they purchased the property in 1955.[103] The two replicas of Cross 13, decorated in a celestial motif with a sun, a last-quarter crescent moon, and stars, have been on roofs at Harvard Ranch and Los Baños Mercedarios for some twenty-five years. Since both remain in good condition, the time span indicates the durability of roof crosses made in this style.

The annual scrapbooks of Na Bolom dating from 1954 to 1988 provide additional information about the roof crosses in the collection. These books contain memorabilia, including photographs of guests and visitors that occasionally show the crosses in the background hanging on a patio wall. Another document, a 1991 inventory list, verifies that all the pieces described in this catalog were part of the collection in that year, with the exception of Cross 14, which was added in 1995, the recently recovered Cross 31, and Cross 32. Regarding Cross 32, in 1963, a few months prior to his death, Blom presented it to Señora Beatriz Mijangos, his and Gertrude's "adopted daughter," then in 1997 Doña Bety returned it to the collection so it could remain on permanent exhibition.

The crosses in the collection, ranging in height from a half meter to a meter and a half including the tapered end, share certain characteristics. All are hand-wrought iron with adornments secured by rivets using the *remache* method, which involves attaching two segments of iron by rounding a small piece of iron into a rivet-like shape and then hammering it through a hole created with a chisel. Only Cross 25 shows indications of the more recent technique of soldering, where a few minor repairs have been made to prevent further deterioration. Several other crosses are impressed with a

variety of geometric patterns, a technique some ironworkers use to embellish the upright and arms of the cross. The thickness of iron used in the basic cruciform ranges from three to five millimeters. When the cruciform is an open design (see page 74), the space between the parallel bars of the arms and upright varies from one to three and a half centimeters. The number of pieces and rivets gives some indication of the degree of complexity and the amount of time needed for the fabrication of each cross. Since the size and bulk of the cross determine the shape of the point, a cross made of thick metal and with heavier ornaments requires a more substantial point for attachment to a roof. Since iron is susceptible to rusting, all the crosses show remnants of black paint at one time applied to retard corrosion. However, in spite of the paint, most have at least some rust on the surfaces.

Since craftsmen were known to copy crosses, designs and styles alone are not always indicators of age. Nevertheless, by comparing older crosses in the collection with those made during the last twenty-five years, certain differences can be noted. The older examples are made in an open design, with the center chiseled from a solid piece of iron to form the parallel bars of the upright and arms. Often the tapered point and upright are formed from a single metal piece. The rough edges have imprints left by the chisel, unlike the smooth edges on crosses made from the machine-formed iron used in more recently made crosses. No production dates or names of craftsmen appear on any cross in the collection, although some unusual small impressed cruciforms on the front of the central circle of Cross 17 may have been one ironworker's mark to identify his work. There is no obvious similarity between any of the crosses in the collection to suggest that two or more came from the same workshop. By contrast, when studying a larger number of crosses, for example those that are still on roofs in certain barrios of San Cristóbal, it is often possible to see such likenesses in distinct finials or particular groupings of adornments, indicating they originated in the same *herrería*.

BASIC DESIGNS

SOLID OPEN

ILLUSTRATION 1.
Designs of roof crosses.

ILLUSTRATION 2.
Basic cruciforms.

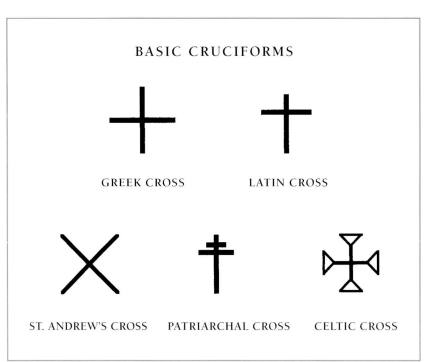

BASIC CRUCIFORMS

GREEK CROSS LATIN CROSS

ST. ANDREW'S CROSS PATRIARCHAL CROSS CELTIC CROSS

VARIATION IN STYLES AND THEMES OF ROOF CROSSES

The crosses in the collection, hanging in clusters against the walls of the corridors, depict a variety of themes and styles that suggest how the patterns that distinguish them evolved and offer the best opportunity to appreciate the variation found in roof crosses in general. One approach in examining each cross is to identify the dominant theme, which indicates its style. By applying this method, the evolution of the craft is discernible as it changed from the simple unadorned style of Cross 22 to the more recent heavily ornamented crosses made specifically for the tourist market, Cross 11 and Cross 29.

As indicated in Part 1, roof crosses are wrought in one of two basic designs, solid or open, on which the ironworker adds decorative or symbolic motifs and ornaments, all of which determine the specific style. A cruciform in a solid design consists of two iron bars usually two to four centimeters wide joined by a rivet just above the midpoint of the upright to

form a Latin cross (see iIllustration 1). The oldest iron roof crosses most likely were fashioned in this manner without additional ornamentation, resembling a plain wooden cross. This design has a decided advantage of being easy to produce, requiring only one central rivet and the cutting of two pieces of iron. Since it has only a few surfaces on which to attach ornaments other than aligning them one above another, however, it does not meet the needs of ironworkers who want to fashion more individualized roof crosses for their clients. By contrast, a cruciform in an open design consists of thin iron bars spaced approximately two to four centimeters apart outlining the shape, with the open space between the bars usually embellished. Often this inner space is filled with undulating lines in a serpentine motif, along with decorative pieces extending from the bars, taking full advantage of the open areas. This design requires more time to fashion but provides more options for creative adornment. The roof cross attained its peak aesthetically with this more versatile open design. Both open and solid designs are formed as a Latin cross in which the upright or vertical bar is longer than the arms, with the two intersecting at an axis above the midpoint of the upright (illustration 2).

Since ironworkers are not in the habit of identifying their work, the variation in designs, styles, and themes offers one of the only clues to the relative age of a style as well as to the changes that have occurred over time within the craft. In the old days, neighbors living within the same barrio of San Cristóbal de Las Casas often vied with one another to have the most unusual or dramatic cross to adorn their roof, resulting in a great variety of these crosses. The ironworker, in displaying his inventiveness and technical expertise through the motifs and ornaments he selected to decorate these two basic designs, inadvertently, or possibly intentionally, created a dominant theme or style that distinguished one group of crosses from another or indicated a time period.

As noted in Part 1, dating roof crosses with any degree of accuracy, without the aid of sophisticated laboratory equipment, is nearly impossible, a problem that is further complicated by the prolonged exposure of these objects to changing weather conditions. The only opportunity to authenticate the age is when a family member recalls when a house was constructed and the cross installed. Usually homeowners associate the roof cross with a

significant event in the family or a catastrophic occurrence that becomes a history marker.

In surveying these extant older crosses, it is the variation in styles within a basic design that immediately identifies them as originating from San Cristóbal de Las Casas. In marked contrast, the contemporary crosses produced as wall or table ornaments for the tourist market show minimal variation other than in size. This stereotypic style, however, also suggests the provenance of the cross. Just as homogeneity is a desirable trait for souvenirs, so tourists can associate them with a specific locale, heterogeneity is preferable to the local residents who commission crosses for installation on their roofs. Yet despite the clients' desire to display unique crosses, iron-workers nevertheless keep certain elements the same. Many of the features on the crosses as well as the cruciforms themselves, for example, can be traced to the medieval art of heraldry. This artistic tradition developed out of the need to distinguish the familial shields of European nobility partici-pating in the Crusades. The cross, used on banners carried into battle during these so-called "Holy Wars" waged between Christians and the Sara-cens from A.D. 1000 to 1200, appeared in many creative decorative pat-terns.[104] These heraldic displays generated a variety of cross shapes and decorative motifs, as well as the vocabulary to describe them.[105] Of these many types of cruciforms, the Greek cross, with four arms of equal length, and the Latin cross, with arms shorter than the upright and intersecting above the midpoint of the upright, appear most frequently in roof crosses. Occasionally, crosses carved in wood are shaped like a patriarchal cross, which resembles a Latin cross but with an additional smaller arm that intersects the upright above the main arm. Axial ornaments on a roof cross are even, in a few instances, arranged in the form of a St. Andrew's cross, a diagonal pattern in the shape of a large "X" (illustration 2).

Four dominant themes distinguish the roof cross tradition developed by the ironworkers in San Cristóbal: floral motifs taken from the art of European heraldry and reminiscent of the baroque period, a solar and lunar motif with roots in pre-Columbian cosmology and Catholic iconogra-phy, a conquest and Church authority motif, and a Christian motif involv-ing the implements of the Passion and the Crucifixion. These four themes

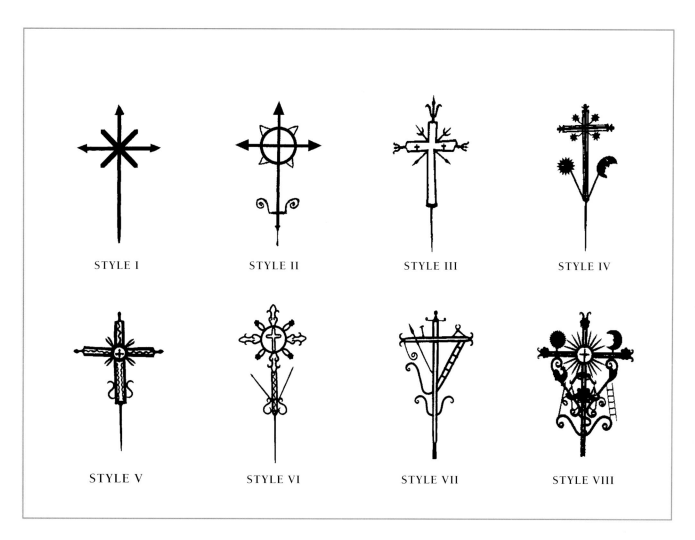

ILLUSTRATION 3.
Cross styles.

ILLUSTRATION 4.
Major features of a roof cross.

ILLUSTRATION 5.
Roof cross, Ecuador.

ILLUSTRATION 6.
Roof cross, Antigua, Guatemala.

ILLUSTRATION 7.
Roof cross, Antigua, Guatemala.

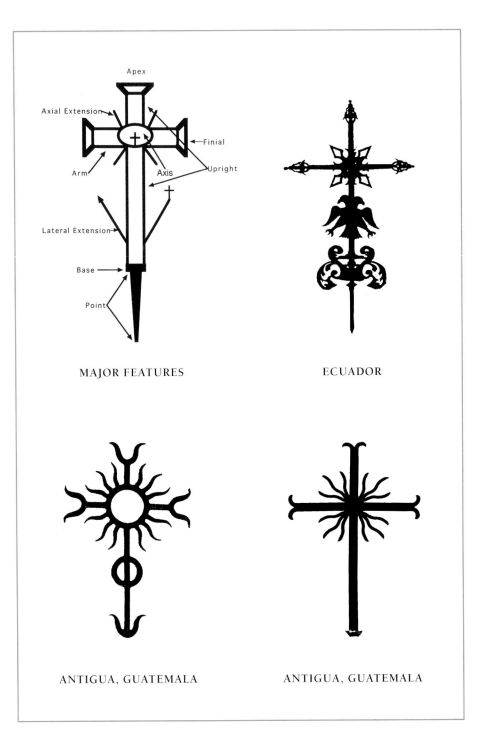

MAJOR FEATURES

ECUADOR

ANTIGUA, GUATEMALA

ANTIGUA, GUATEMALA

applied to the basic cruciform shape with its tapered point serve as indicators of changes in the craft over time. For example, when asked to arrange photographs of locally produced roof crosses in a sequence from oldest to most recent, contemporary ironworkers of San Cristóbal unanimously agreed on which were the oldest styles, choosing crosses in both solid and open designs but only those with simple finials and few decorative elements. None of their selections included crosses decorated with implements of the Passion and the Crucifixion, a motif they identified as the most recent innovation, one that has occurred in the last thirty to thirty-five years. Considering their explanations about the design elements on the crosses, I developed a scheme of eight styles based on an examination of over 350 iron roof crosses, including those still visible on roofs today, in private collections, for sale in artisan shops, and in the Frans Blom Iron Roof Cross Collection at Na Bolom (illustration 3). Of these, 251, including examples of all the eight styles, can be seen from the streets of the old barrios of San Cristóbal and along roads in the outlying areas surrounding the city proper. The 32 crosses in the collection at Na Bolom represent all the styles, with the exception of STYLE II.

Although the eight styles described here appear to be arranged from the earliest to the most recent, an exact chronology cannot be verified. The composite motifs offer only clues to the relative age of the style but not of the cross itself. For example, implements of the Passion and the Crucifixion do not appear in early styles, while symbols of Catholic church authority, such as the spear with a banner, may have been the first ornaments used to decorate roof crosses. As such, these figures are apt to also appear in more recently made crosses. However, as in any craft subject to the creative whims of craftsmen and their clients, the various decorative elements on roof crosses do not always fit into obvious categories, with some features overlapping categories to suggest a transition from one style to the next, a variation on a particular theme, or simply a preference of the artisan. This is especially apparent in the more recent STYLE VII and STYLE VIII. Whereas much variation exists within STYLE VII, which represents a period of experimentation and change from crosses made specifically for roofs to those made to appeal to collectors as wall hangings, within STYLE VIII decorative elements are more fixed, designed for a certain clientele.

STYLE I.
One of twelve similar crosses in STYLE I adorning roofs in a small section of Barrio de San Ramón.

STYLE I.
A solid cruciform with simple arrow-like finials from Barrio de Cuxtitali.

Thus, due to the ironworkers' practice of copying or modifying various crosses to meet their clients' desire for an individualized piece, no section of San Cristóbal has a significant number of crosses in any one style, except in Barrio de San Ramón, where twelve recently constructed houses have roof crosses identical in style, design, and size with even the same decorative imprints on the arms and upright. The crosses, all examples of STYLE I, are installed on roofs of houses with similar architecture that share a common wall, and most likely were constructed by the same builder. The greatest variation in styles occurs in Barrio del Cerrillo, the original center for the ironwork craft, where one can view over fifty crosses, rarely two alike, on roofs, more than twice as many found in any other barrio.

European Motifs (Styles I, II, and III)

The style of cross that ironworkers identify as the earliest reflects the European influences on craftsmanship and motifs. Such elements can be observed in the architectural detail of colonial churches, as well as on the façades of later neoclassic buildings in Chiapas. The following are just a few examples of these features that inspired the early ironworkers: the cross atop a sphere in relief on the façade of the Church of San Felipe Ecatepec from 1550; the crowned bell towers of La Caridad Church, constructed around 1715; and the iron weather vanes on the seventeenth-century Church of Santo Domingo in San Cristóbal de Las Casas.[106] Local artisans used these European aesthetic elements, first in the architecture of colonial churches and later in their ornamental ironwork.

The basic cross design categorized here as STYLE I is a solid cruciform shape either with minimal or no adornment (illustration 3). Decorative details, if present, occur on the finials, at the axis where the arms and upright meet, or as attachments to the upright. The finials are either blunt, tapered to a sharp point, or stylized flowers. The axis may be plain, surrounded or covered by a four-petaled motif, or intersected by two representational objects, such as spears or nails. If an ornament is affixed at the axis, it takes the form of an "X" in the shape of a St. Andrew's cross. Ladders, banners, lances, or scrolls occasionally project from the upright, either singularly or as pairs. Fifty-nine crosses, or 24 percent of the total observed in

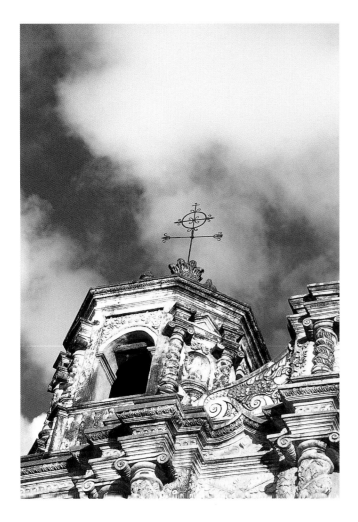

WEATHER VANE.
A design on a tower of Santo Domingo frequently incorporated into roof crosses of STYLE II.

San Cristóbal, fall into this category, the identifying features of which are simplicity and a solid cruciform design.

A solid cruciform fashioned in a weather vane motif is the dominant model for STYLE II (illustration 3). Inspired by the ornate weather vanes that crown the domes and façades of the churches of Santo Domingo, La Caridad, and El Calvario in San Cristóbal, the roof crosses in this category have a large open circle at or near the apex that is intersected by a solid

ORNATE FAÇADE.
Decorative stucco designs, such as this fleur-de-lis, on façades of many neoclassic buildings in San Cristóbal de Las Casas resemble floral finials on iron roof crosses.

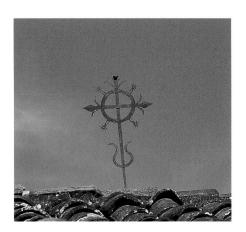

STYLE II.
A weather vane motif with the central circle divided into four equal parts to form a Greek cross; Barrio de la Merced.

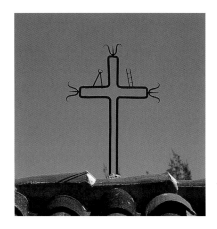

STYLE III.
An open cruciform with floral finials; Barrio del Cerrillo.

Greek cross, dividing the circle into four equal parts. This element resembles the solar wheel design found on ritual stones dating to the Stone Age.[107] The finials of the crosses in this style are most often shaped as arrows or fleurs-de-lis. An additional decorative horizontal piece of metal may project from the solid upright between the circle and the base in the form of a lotus or a fixed arrow. The latter ornament is attached to the upright in a way reminiscent of the movable pointer on a true weather vane that is affected by changing wind direction. Although only seventeen roof crosses in San Cristóbal, or 7 percent of the total, have this weather vane motif, the style is sufficiently distinctive to warrant a separate category.

Crosses grouped in STYLE III are fashioned in an open design with floral finials or representational finials with a coronal motif (illustration 3). Attention is often drawn to the axis of the cross by angular extensions that project outward from the center, a symmetrical floral feature, or the absence of any ornamental figure. Since the spaces between the bars that form the cruciform outline are usually unembellished, the hallmark of STYLE III is an open design. A curvilinear extension sometimes adds a graceful transition where the bars of the upright merge at the base to form the tapered point. Forty-eight crosses, or 19 percent of those still on roofs, meet the criteria of this category.

Pre-Columbian Motifs (Style IV)

Crosses having an open design with a dominant celestial motif characterized by a last-quarter crescent moon, a full-faced sun with clearly defined facial features, several stars, and occasional angel figures, are examples of STYLE IV (illustration 3). Figures of the sun and moon are common artistic motifs of many crafts from Chiapas and also a theme that was important in ancient Maya aesthetics. This motif on roof crosses, habitually placed on lateral extensions that project from the lower section of the upright, indicates a probable link to pre-Columbian cosmology and also immediately identifies the provenance of such crosses as San Cristóbal de Las Casas. This use contrasts with that of a later style (STYLE VIII) in which the sun and moon are integrated with Christian symbols and placed on the arms of the cross, an arrangement that persisted in Christian art until the

eleventh century. Further, in Christian iconography artists often depicted the sun placed to the right and the moon to the left of the image of Christ on the cross to symbolize his dominion over the day and the night.[108, 109] When the sun and moon appear without Christian symbols, these are more apt to have origins in pre-Columbian traditions, for the sun and moon rarely, if ever, stand alone in Christian art but are incorporated into a melange of symbols or are used to represent certain aspects of Christ, the Blessed Mother, or the saints. In this specific style of roof cross, STYLE IV, the sun and moon symbols stand alone as they do in representations of the Maya deities of the sun and the moon.

Whether the sun and the crescent moon are pre-Columbian symbols that were employed in colonial art of the New World, where indigenous craftsmen may have introduced them, or whether they are Judeo-Christian tradition symbols continues to be strongly debated. Sidney David Markman asserts that these are Christian symbols that represent the Church and the Synagogue with no pre-Columbian connection.[110] However, Leopoldo Castedo supports the opposing view that in spite of conquest by the dominant Christian European world, the indigenous people of the Americas covertly resisted acceptance of Christian iconography,[111] simply reinterpreting Christian symbols and rites in terms of their own religious and artistic vocabulary and thus maintaining many of their own spiritual traditions. The similarity between many Christian and pre-Columbian rituals, such as the use of incense, candles, songs, images, and prayers, facilitated this hybridization of spiritual expressions.

Other distinguishing features of this style are the symmetrically arranged projections that draw attention to an open quadrilateral space at the axis. In addition to the lack of any clearly defined Christian symbols, other than the cross itself, ornaments are often cut from thin strips of metal, making them less able to withstand variable climatic conditions. Although very few crosses of this style can be seen on roofs throughout the city, four examples remain in the Frans Blom Iron Roof Cross Collection. This comparatively high percentage in the collection may be due to the relatively protected environment provided the crosses at the museum. Only four, or 1 percent, remain on roofs today, all in various states of deterioration.

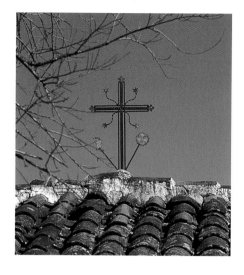

STYLE IV.
A copy of Cross 13 from the collection at Na Bolom: sun and moon ornaments placed on lateral extensions; on the property of the former Harvard Ranch.

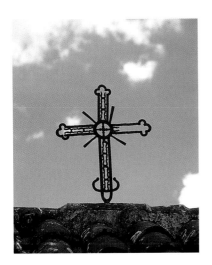

STYLE V.
An open cruciform with serpentine lines coursing through the spaces of the upright and arms; from Barrio de Santa Lucía.

STYLE VI.
Roof cross competes with a television aerial and satellite dish in Barrio de Santa Lucía.

Motifs of Conquest and Church Authority (Styles V and VI)

Banners, swords, and a small cross mounted on a staff are examples of symbols of conquest and the imposition of Catholic church authority in the New World that appear as dominant ornaments on roof crosses designated as STYLE V and STYLE VI. Notable in these two styles is the absence of sun and moon figures. STYLE V is differentiated by an ornate open design with serpentine lines that fill the space between the bars of the upright and transverse arms and elaborate finials (illustration 3). Part of the total pattern usually, but not always, includes a distinctive central circle, often embellished with serrations, projecting rays, or swirls. A small interior Latin cross dominates the circle with lateral extensions that project outward, giving a sunburst effect. The usual pattern of ornamentation includes an axial circle, decorative finials of either elaborate fleurs-de-lis or spear points, and ecclesiastical symbols on the lateral extensions that project from the upright bars. This style shows considerable variation, with some crosses lacking the central circle and others with fewer ornaments added to the arms and upright. The decorative elements that fill the inner space between the bars of the arms and upright are the distinctive features of STYLE V. The fact that fifty-six crosses, 22 percent of the total still on roofs, belong to this style suggests a strong preference for these motifs as well as the durability of the style.

An apical circle and the absence of a distinct overall cruciform distinguish roof crosses belonging to STYLE VI (illustration 3). The characteristic circle is adorned with projecting iron rays, floral motifs, or an additional outer scalloped corona. Most often a small Latin cross partially fills the inner space, in contrast to the Greek cross that distinguishes STYLE II. The cross is supported by a tall, either solid or open, upright. Lateral extensions usually project outward from the upright to enhance the ornate appearance that characterizes this style. Fourteen crosses, or 6 percent of the number on roofs in San Cristóbal de Las Casas, belong to this style.

Christian Motifs (Styles VII and VIII)

Preference for using Christian symbols is a distinguishing feature of STYLES VII and VIII, a more recent phenomenon perhaps starting in the 1940s when the ban on the public display of religious imagery was lifted. This may have motivated the ironworkers to emphasize symbols that were

STYLE VII.
Lotus-like motifs decorating
an upright; from Barrio del
Cerrillo.

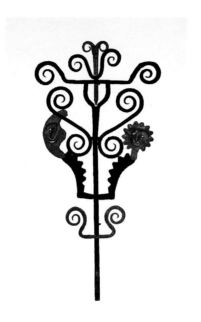

STYLE VII IN TRANSITION.
Wall cross without religious
symbols; from the collection
of the late Ralph Hilt in San
Cristóbal de Las Casas.

once prohibited, as well as to employ them as indicators of a renewed sense of religious freedom. STYLE VII has few of such Christian ornaments, while STYLE VIII has many.

Crosses of STYLE VII have graceful, scroll-like swirls that project outward from the upright (illustration 3). The design can be either open or solid, modestly ornamented with simple finials, often with two to four implements of the Crucifixion as decorative elements and occasionally sun and moon figures. This style represents a transitional stage in the shift to a preference for a solid design with an increased number of small ornaments. Some of the decorations are representational and easily identified: domestic animals, household utensils, flowers, a few implements of the Crucifixion, and sun and moon figures. Thirty-one roof crosses, or 12 percent of the total still visible from streets in San Cristóbal de Las Casas, are of this style. In the 1960s and early 1970s, ironworkers began experimenting with variations of STYLE VII by deleting points from the roof crosses and making them larger, some up to two meters tall, for sale to local collectors as wall decorations. Examples of such crosses are on display in a few hotels in San Cristóbal, as well as in private homes. Although this was not the style that

STYLE VIII.
A tourist-style cross without a point sitting low on a roof ridge; from Barrio de Guadalupe.

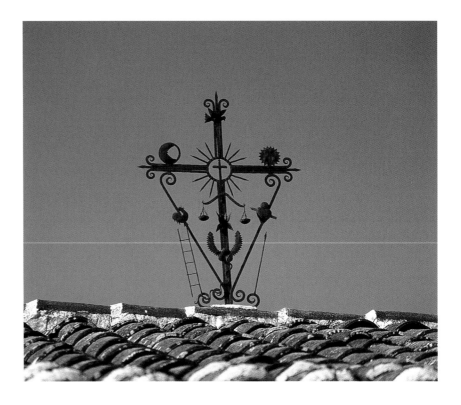

ultimately became the popular souvenir or tourist item, this early experimentation may explain the greater variation within STYLE VII in comparison to the other styles.

STYLE VIII, the most recent style of cross made primarily for the tourist market and modified as a wall or table ornament without a tapered point, incorporates many motifs already described. The basic cruciform, either solid or open, serves as the framework for the stereotypical decorative features that distinguish this style from the others: a sun and a moon in combination with many implements of the Passion and the Crucifixion (illustration 3). The number of these symbols ranges from six to twelve depending on the overall dimensions of the cross, which can vary in height from thirty centimeters to two meters or more. A sun and a moon, always used as an integral part of the overall decorative motif, are placed on the arms of the cross, rather than on lateral extensions as they appear on crosses belonging to STYLE IV. If an open design is used in crosses of STYLE VIII, the

bars of the upright and arms are closely spaced to eliminate any inner decoration. Such an arrangement of these bars offers additional support in larger crosses that reach well over a meter in height. These, at a distance, appear almost as solid pieces. In examples with an open design, a circle with a small interior cross and projecting rays form the axis. In one of a solid design, a rosette disguises the rivet that attaches the arms to the upright.

Crosses in this style, although not constructed for use on roofs, often are adapted for such use because they are readily available in local shops, and thus do not necessitate commissioning an ironworker. Since they have no point for attachment to a roof, they sit lower along the ridgeline than crosses representative of other styles. With their numerous ornaments, most of which are too small to be appreciated from below, either at street level or from an inner courtyard, these crosses lack the graceful lines of older styles. In addition, when crosses over a meter and a half high are placed on roofs, the added height causes them to sway precariously in strong winds. That several of these crosses do appear on roofs throughout the city, however, suggests that residents of San Cristóbal are willing to buy ready-made crosses and use them as roof ornaments. Twenty-two such crosses, or 9 percent of the total, can be seen on roofs today.

INTERPRETATION OF ROOF CROSS SYMBOLS

Determining the meaning of the objects that decorate roof crosses is sometimes difficult because many of the figures have no inherent meaning but are purely decorative and even those that appear clearly to be symbolic can be interpreted differently.

The Frans Blom Iron Roof Cross Collection at Na Bolom gave me the opportunity to decipher the meanings of some of these ornaments. To Doña Bety, who lived in the house throughout her youth and watched as Frans Blom collected the crosses, there was no mystery about the meaning of roof cross symbols.[112] One day she escorted me around the patio at Na Bolom, stopping in front of each cross to explain what various features meant to her and which ones were simply *adornos* (objects used as decoration). She first learned about the meaning of roof crosses from her grandmother in Barrio del Cerrillo, whom she frequently accompanied to church as well as

SAN FELIPE ECATEPEC.
Stucco relief above a portal of the
colonial Church San Felipe
Ecatepec in San Cristóbal de Las
Casas resembling a motif that
often appears on roof crosses.

to many private rituals held in front of home altars. Doña Bety recalls hearing about the time when roof crosses had to be removed because of a governmental decree designating them as religious objects. While to her, and to most individuals who have maintained the custom for generations, the various symbols can be explained only from a religious perspective based on Catholicism, others, including several of the ironworkers, identify pre-Columbian or indigenous influences.

Despite such variation of opinion on the meaning of the decorations, most agree that a roof cross is a religious symbol that the owner displays as a sign to bless his home or protect his house. In the following discussion, cross numbers refer to illustrated items in the Frans Blom Iron Roof Cross Collection.

Floral and Geometric Motifs

Some of the floral and geometric motifs that accent cross finials, softening the blunt ends of the iron bars, have symbolic meaning, while others are purely decorative. Most of the floral motifs come from heraldry, including a *botonée* design with button-like ends, as in Cross 6; a *pattée* pattern, in which the arms narrow at the center and then flair outwards at the ends, as in Cross 30; and the *moline* design, which resembles the rynd of a millstone, as in Cross 16. The fleur-de-lis, however, may have additional significance related to the strong influence the Dominicans had in colonial Chiapas. Sidney David Markman, in his work on the early architecture of the state, notes that this order of friars had a monopoly on evangelizing the indigenous population of the territory during the sixteenth century, and that the founder, Santo Domingo de Guzmán (Saint Dominic), was also a popular saint in the New World.[113] In the iconography associated with his image, Santo Domingo is often depicted holding a lily as a symbol of purity, which may partially explain why the fleur-de-lis was frequently preferred in local decorative arts. Roses are another common floral motif appearing as finials. When depicted as a rosette in the shape of a wheel of petals, the rose can be interpreted as a solar symbol.[114] In addition, roses often represent the Virgin Mary. Floral motifs on crosses, in general, may be reminiscent of the foliated cross of the ancient Maya, with flowers draping the arms of the cross to imitate a living tree, a custom that persists with the

modern Maya of Chiapas, who often hang live plants on their large wooden cross or smaller crosses that mark their shrines.

A common geometric motif is the use of arrows as finials, suggesting spiritual weapons, an association dating to the Greco-Roman period when natural disasters were thought to result from Apollo's arrows. Arrows are also attributes of the martyr San Sebastián (Saint Sebastian), an advocate against plagues.[115] This saint, depicted in Christian art as a young man whose body is pierced by arrows, was one of the first images that the Spanish friars introduced to Chiapas, a region where devastating epidemics occurred frequently during the colonial period. The utilization of arrows to represent rays of the sun also reflects a pre-Columbian belief that sunbeams were considered projectiles shot from above to the earth below.[116]

Religious and Ecclesiastical Motifs

Since in ancient Maya iconography the cross often represents a living tree, rarely do the modern Maya use an iron cross on the roofs of their houses, instead preferring wooden crosses, often decorated with floral or star-like designs and without any representational Christian symbols. By contrast, to Catholic Ladinos the cross represents the Passion of Christ, atonement for the sins of humankind, and resurrection of Christ in triumph over death. In Christian iconography, the cross with a figure of Christ affixed becomes a crucifix, the identifying symbol of Christianity. Although no roof cross in San Cristóbal de Las Casas yet bears a human figure, such a symbol may be incorporated eventually into a new style as contemporary artisans become increasingly innovative.

There is a great variety of religious symbols used on roof crosses in San Cristóbal. A cluster of grapes suspended from a vine represents the sacramental wine or blood of Christ, whereas a pruned vine stands for the crucified Christ. A circle, placed at the axis, where the arms and upright join, can be a metaphor for eternity as well as for God or the sun. When a small, inner Latin cross is added to the circle, it could be interpreted as a monstrance, the ornate receptacle in which the consecrated host is exposed on the altar of a Catholic church for veneration, or even the host itself, the flat, round wafer of unleavened bread that the priest consecrates during Catholic Mass.

Further, when extensions project outwards from the periphery of the circle to produce a sunburst effect, the number of these rays may have additional meaning. Twelve, for example, can represent the original Apostles who followed Christ; or seven the sorrows experienced by the Blessed Mother, one of which was the death of her son on the cross. Where the number of rays varies from eight to fifteen or more, the projections are more likely to be decorative rather than symbolic. If the cross has been on a roof for many years, however, some of the projections may have broken off, making it difficult to determine any association. In general, the aureole, or field of splendor, created by rays around a circle symbolizes divinity, light, and heavenly power. It also represents the light of the Christian message being introduced into the New World.

Further, a balance indicates the weighing of good and evil at the Last Judgment, as well as justice. A scale, along with a sword held aloft, are the icons that identify San Miguel Arcangel (Saint Michael the Archangel), the winged warrior confronting evil and darkness. Whereas the dove represents the Holy Spirit, the third element in the Catholic Trinity, a generic bird at the top of the cross may be related to the celestial bird prominent in the creation myth of the Maya. Palm branches, a familiar symbol of victory usually depicted as two serrated leaves, remind us of Palm Sunday and Christ's triumphant entry into Jerusalem. Another interpretation of these branches is that of pine boughs, common adornments on private altars in homes of San Cristóbal de Las Casas, where families maintain devotions to Christian saints or honor specific manifestations of Christ. The use of pine branches that decorate large wooden crosses in the Maya communities transforms these ritual markers into symbols of the world tree, as do the green pine needles that customarily carpet the festivity area during Indian and Ladino celebrations.

Some decorative features focus strictly on ecclesiastical themes, such as a waving banner that unfolds from a staff suggesting Catholic church authority. When a cross decorates the banner or is a finial on a staff, it becomes a symbol of Christ's triumph over death or represents the missionaries who carried the teachings of Christianity to the New World. Whereas a single sword is a sign of church victory over evil, a mitre, the tall hat with a crosswise cleft at the top worn by bishops as a sign of authority, repre-

sents the Catholic church and a paternal influence over its followers. A dome, or cupola, is another indicator of dominance of the Catholic church on earth. One or more keys are associated with San Pedro (Saint Peter), the first head of the Catholic church, who received the symbolic keys to the Catholic church as well as to the Kingdom of Heaven.

Celestial Motifs

A sun and moon with clearly defined facial features, always depicted together, frequently adorn crosses. These celestial bodies play prominent roles in both Maya and Christian cosmologies, in which they evoke duality: night and day, darkness and light, or male and female. The location of the sun and moon on a roof cross, either at the ends of two lateral extensions projecting from the upright or attached directly to the arms, may determine their meaning. When these figures appear on such extensions and are accompanied by stars, the arrangement suggests a pre-Columbian rather than a Christian theme. From the earliest period of Christianity, Christ was identified with the sun just as the sun was a major deity in pre-Columbian mythology and the basis for the myth in which its appearance each morning accounted for the daily creation of the world.[117] The depiction of the moon in the last-quarter crescent on crosses belonging to STYLE IV may be relevant to the importance different phases of the moon had to the ancient as well as to the living Maya in the planting and harvesting of crops, especially corn. In ancient Maya cosmology, the sun and moon were considered deities, with the moon being the avatar of the mother goddess or consort of the sun, and the sun representing the maize god.[118] Although these persist as deities in many prayers and legends of the modern Maya, the sun alone is more often depicted on their wooden crosses. It is rather *mestizo* craftsmen who incorporate both symbols into their ironwork. When a sun is depicted alone on crosses, the symbolism probably originates from the pre-Columbian tradition since in Christian iconography sun and moon figures rarely appear alone as primary symbols.

For Christians, the sun and moon do not stand alone as essential symbols of natural elements, and are, therefore, commonly used in conjunction with other symbols. For example, in early European art of the Crucifixion a small sun and full moon occasionally appeared over the right

and left arms of the cross, interpreted in various ways as the twofold nature of Christ, with the sun representing his divine nature and the moon his human nature; or the two parts of the Bible, with the Old Testament as the moon, providing only a faint glimmer of illumination, and the New Testament as the sun bringing into full light the fulfillment of the Scriptures.[119] The legend that the sun and moon stood still in the heavens at the moment of Christ's death adds further meaning to use of these items on Christian crosses. Further, the sun and the moon, either individually or together, are often attributes of the Virgin Mary. While in biblical accounts she is described as a woman clothed in the sun with the moon at her feet, she is associated more frequently with a crescent moon. Many of her titles have an affinity to celestial attributions, such as "Queen of the Heavens," "Queen of the Angels," "Virgin of the Snow," and "Our Lady of Lightning." Similarly, for the ancient Maya the moon was a representation of their mother goddess.

Other notable celestial symbols on roof crosses include stars and lightning bolts. Stars that bring light to the darkness of the night and illuminate the heavens are equated with divine guidance or favor. The ancient Maya, as do their living descendants, believed that lightning was a powerful natural force that affected other astronomical events. Although they also revered whirlwinds and meteors, lightning was the principal deity that controlled other natural phenomena.[120] In their dependence on agriculture for subsistence, they viewed lightning bolts as pathways between the earth and the upper realm of their universe, as well as sources of power to bring rain. The undulating lines between the spaces of the iron bars on crosses of the open design may denote bolts of lightning. According to ironworkers, these sinuous lines can also represent serpents, which have a variety of meanings. To the ancient Maya, serpents symbolized the path their deities traveled from one realm to another as well as the course followed by the planets. The modern Maya also view the serpent as a symbol of fertility, while for Christians the serpent is an emblem of evil and deceit associated with the tempter in the Garden of Eden. Serpents are explicitly portrayed on roof crosses adapted as wall ornaments, often in association with a butterfly, the Christian symbol for the Resurrection of Christ as well as for transformation and renewal.

SANTA CRUZ.
Implements of the Passion and Crucifixion incised on the cross in the Church of Santa Cruz de Cunduacán in Chiapa de Corzo. The cross is festively decorated for the celebration on 3 May.

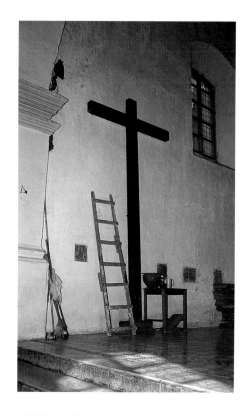

UNADORNED CROSS.
A tall cross representing Santa Cruz leaning against the wall of a side chapel in the Church of La Caridad in San Cristóbal de Las Casas.

Motifs of the Passion and Crucifixion

The initial use of implements of the Passion and the Crucifixion as religious symbols in the New World dates to the first monumental sculpture erected in the Americas when the Spanish friars ordered the carving of graphic objects on the stone crosses that stood outside their churches,[121] employing them in their instruction of the indigenous people in the doctrines of Christianity, including the Passion and Crucifixion. Such implements of the Passion and Crucifixion also appear as decorations on the most recent style of cross produced in San Cristóbal de Las Casas.

Objects on iron crosses relating to the Passion include a crown of thorns, flagellation ropes, a reed like the one placed in Christ's hand as a sceptre and sign of mockery, dice such as those tossed by the soldiers to vie for his robes, a towel as symbol of the one used to wipe his face on the route to Calvary, and a cock representing the one that crowed when Saint Peter denied his association with Christ and reflecting the ideas of vigilance and the dawning of a new day.

Additional commonly used items relating to the Crucifixion that appear frequently include: three nails symbolizing those used to pierce Christ's hands and feet; a hammer like the one used for driving the nails; a lance reflecting the one used to pierce the side of the dying Christ; a sponge at the end of a

reed or spear like the one employed to moisten his lips; pincers like those used to extract the nails; a ladder symbolizing the one utilized to remove his body from the cross[122]; a plaque with or without the Greek letters *INRI*, "Jesus of Nazareth, King of the Jews," at the apex, representing the plaque that was nailed to the top of the cross at the Crucifixion; and a chalice, symbolizing the vessel used for the consecrated water and wine in the Catholic Mass and the spilling of Christ's blood at the Crucifixion.

Despite the apparent straightforward meaning of objects symbolizing the implements of the Passion and Crucifixion, local popular interpretations demonstrate the broad variation in interpretation that exists, as well as how the symbols can be assigned differing meanings that appeal to Christians as well as non-Christians. For example, a 1998 calendar distributed by a prominent business in San Cristóbal featured a color photo of a tourist-style cross, STYLE VIII, perched atop a tiled roof with a text explaining the implements of the Passion and Crucifixion from a secular perspective. According to the interpretation, figures of the moon, sun, stars, and flowers were symbols of natural elements, the ladder represented ascension to a new life, the serpent was an emissary of evil, the rooster was a symbol of daily awakening, the heart was a sign of life, and the scale indicated the equilibrium a person seeks throughout life.

In many churches of Chiapas, a variety of these implements and symbols are painted or carved on large wooden crosses. Adorned in such a way, they more closely resemble how the cross is commemorated on 3 May in the Catholic church as a reminder of the Crucifixion and the discovery of the cross on which Christ died. Where folk tradition has imbued the cross with its own power, as in the ardent devotion to *Santa Cruz* that persists in Chiapas, the presence of these symbols of the Crucifixion is both in harmony with Catholic tenets and the lore associated with the cross by indigenous people.

An example of this coexistence of seemingly two disparate belief systems occurs in the small barrio church of Santa Cruz de Cunduacán in Chiapa de Corzo, where such crosses decorated with implements of the Passion and the Crucifixion are the primary objects of devotion. However, in most churches located in indigenous communities of Chiapas, more distant from Catholic church authority centered in the Archdiocese of San Cristóbal, the large crosses that represent *Santa Cruz* lack such symbols.

For example, those in the Church of San Juan Chamula and in the Church of San Felipe Ecatepec on the western fringe of San Cristóbal are painted green and draped in cloth.

Domestic Motifs

Other embellishments on roof crosses represent common domestic objects and familiar plants and animals, some of which have a double meaning. Although paddles from the *Opunita* cactus, *nopal*, important as a food, probably lack any symbolic meaning, for example, sheep can signify both the sheep cared for by the Good Shepherd and the domestic animals so important to the pastoral people of the highlands of Chiapas. Similarly, a hammer and pincers can be seen either as the emblem of the ironwork trade or as implements of the Crucifixion, while a water pitcher can refer to either a household utensil or the one used by Pontius Pilate to wash his hands of guilt from condemning Christ to death on the cross. Such ornaments with ambivalent associations combined with features suggestive of pre-Columbian symbols broaden the appeal of roof crosses to not only those interested in Christian icons but others seeking ornamental souvenirs without religious connotations.

One specific motif that appears now and then throughout all the styles is an *olla*, a clay cooking vessel outlined near the cross base where the tapered end begins or shown as an additional ornament. A variation on the theme occurs in those crosses mounted directly in ceramic *ollas* at the center of the roof to give the impression that the cross is emerging from the vessel. Over time, the *olla* may break and disintegrate, leaving only a mound of cement that makes it appear as if the roof cross is mounted on a globe. The *olla* motif can be interpreted in various ways. It can stand for the common household utensil used throughout Mexico and hence a symbol of home and hearth. Since the roof cross is usually positioned midway along the ridgeline where the smoke from an interior fire pit would emerge, a cross in an *olla* could be a metaphor for this traditional cooking spot. The *olla* may also represent the earth from which it is formed. Further, it could relate to the symbol of the cross emerging from an orb utilized in the fifteenth and sixteenth centuries as a sign for the domination of Christianity over the world.

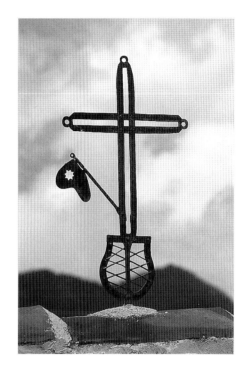

CROSS DETAILS.
What appears to be a banner when viewed from the street becomes the delicate wing of a butterfly that rotates in the wind.

The Cross as Unifying Cultural Symbol

The collision of cultures that occurred throughout the New World in the sixteenth century affected the arts as well as all aspects of daily life. The resultant societies that emerged were a melding of the autochthonous cultures in the Americas before contact with those of the dominant Europeans. The Catholic conquerors, who abhorred the pre-Columbian practices of idolatry and human sacrifice, empowered the clergy to destroy all evidence of these rites. Thus the spiritual conquest of the New World, which involved the obliteration of ideas, was as much a challenge, if not greater, than the physical conquest, for the clergy had to confront stubborn resistance by the indigenous people to preserve their traditions. Often the friars closed their eyes to many of the rituals that the Indians continued to perform, and most likely some eventually accepted a mixture of religious rites and accoutrements as long as they served the Catholic church. Thus it was a Hispanic-American style of religious art, as well as the Catholic religion itself, that developed in the New World, rather than a pure European or Hispanic style. Disagreement continues over the degree of influence from the indigenous cultures in this hybridized religion, as well as in the arts. In the predominantly Maya region of Chiapas, the modern Maya practice a Catholicism blended with their own beliefs. David Friedel et al., who identify the aspects of classic Maya cosmology that survived the conquest and are incorporated into the religion practiced by the descendants of the Maya, point to the cross as a significant symbolic link. They suggest that the ancient symbol of the world tree is

> transformed into and merged with the modern Cross of Christ. . . . for the Maya whom the padres were trying to convert to the new religion, the leap from tree to cross allowed them to embrace the outward forms of Catholicism without losing the cosmological content of their own beliefs.[123]

Similarly, Ladinos, with mixed Indian and European heritage, also practice an eclectic form of Catholicism reflected in their use of roof crosses, which function as religious symbols but also as items associated with superstitions connected with more ancient beliefs. Thus in Chiapas, as

throughout the Americas, when Christianity was superimposed on preexisting indigenous beliefs the boundaries between folk beliefs and Catholic dogma blurred, giving significant symbols, especially the cross, a dual meaning.[124]

In a larger context, in spite of dramatic changes initiated when different cultures clashed in the sixteenth century, traditions will never completely be obliterated. Old traditions are merely altered or temporarily displaced for a time, only to resurface again with a renewed infusion of vitality. For example, in San Cristóbal de Las Casas, such melding gives folk art endurance, making it eternally appreciated by people from all cultures.

In this millennium of technological overload, many people especially are drawn to the worlds of fantasy, superstition, and dreams as expressed in folk art and admire those who produce it. As Peter Beagle notes: "We are raised to honor all the wrong explorers and discoverers. . . . Let us at last praise the colonizers of dreams."[125] The New World presented such a place of discovery for the Spanish *conquistadores* and the missionaries, many of whom have become renowned historical figures and even saints canonized by the Catholic church. Only a few soldiers and clerics who raised their banners and crosses on the soil of the Americas, nevertheless, were altruistic. In their vigorous attempts to replace the indigenous religion with Christianity, the friars destroyed most of the religious patrimony of their converts. They did not succeed, however, in extinguishing the creative spirit of these people and their descendants, many of whom maintained their ability to dream and to express themselves in imaginative ways, creativity reflecting a blend of religious European heritage and indigenous culture. The custom of roof crosses is an important example of such cultural assimilation. With its dual function of protection against harm or evil and display of religious devotion, the custom bridges the gap between folk and religious traditions. It was the *herreros* of San Cristóbal, however, who preserved this custom. By combining symbols of art and religion, they created various styles of roof crosses that encouraged the residents to maintain the practice and thus continue the tradition. The legacy of their artistic expression endures in the collection of roof crosses at Na Balom as well as in those that remain on rooftops today.

CATALOG OF THE COLLECTION

To demonstrate the system of classifying the various roof crosses fabricated in San Cristóbal de Las Casas according to style, it will be applied to each cross in the Frans Blom Iron Roof Cross Collection. The illustration of a generic cross, showing an open design with the major features noted, offers a guide to the terms used in classification of the crosses (Illustration 4). Note that attention is most often focused on the axis, the intersection where the arms of the cross meet. In STYLE VII, however, the addition of scrollwork draws the eye away from the axis to the base, where these embellishments are usually positioned. Because the scrollwork is flat, it blends into the overall design rather than dominating any of the other features. The three finials that cap the arms and upright of the cross are similar, except in STYLE VII and in STYLE VIII, where occasionally a different finial is used to draw attention away from the axis to the apex of the cross. The overall design is generally symmetrical, as are the lateral extensions, with deliberate placement of the ornaments to assure balance. While the point is functional in all the styles, except for STYLE VIII, where it is absent, it can also contribute to the overall aesthetics of the cross. The technique of decorating the iron bars and ornaments with imprints of designs from chisels is more prevalent in the recently made and heavily ornamented crosses. On rare occasions, such marks also appear on older crosses but in fewer number. Note that because many of the crosses from the collection at Na Bolom are old and have been damaged over the years, their flaws appear in the photographs illustrating them.

CROSS 1

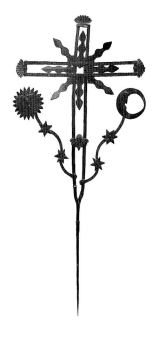

Maximum length: 101 cm
Maximum width at arms: 44 cm
Length of point from base: 36 cm
Number of pieces: 28
Number of rivets: 30

Width of arms: 10 mm
Thickness of arms: 3 mm
Width of upright: 11 mm
Thickness of upright: 4 mm
Space between bars: 2.5–3 cm

Cross 1, an open design decorated with celestial motifs of the sun, moon, and stars, resembles Crosses 13, 21, and 23, all examples of STYLE IV. The dominant position of the solar and lunar ornaments, almost overshadowing the cruciform, illustrates how pre-Columbian artistic themes are integrated with the Christian cross. Cross 1 first appeared in the collection in 1958, when it was displayed with eight other crosses on the corridor wall in the northwest corner of the central patio.

Eight notched extensions, symmetrically arranged at the axis, are other prominent features of this cross. Cut from thin metal, they are more fragile than the finials and other ornaments. A line of impressed dots coursing along the midline adds contour to each extension, which ends in a sharp point to suggest a lightning bolt or radiating beam. Four of the eight extensions project into the open space where the arms and upright meet, leaving a distinct open square at the axis. They also point in the direction of the finials, reminiscent of cockleshells, as if to draw attention to them. These broad, fluted ornaments, riveted at their centers to five centimeter-spacers, terminate the arms and upright. The finials are impressed from the frontal view, giving the notion they are attached backwards.

Two undulating lateral extensions, ending in flattened, thin cutout figures of the sun and moon, project to the left and to the right from near the base where the upright bars join. The last-quarter, crescent moon and full sun are embossed with anthropomorphic features. Two small six-pointed stars decorate each extension. A diminutive figure of the head and upper torso of an angel-like figure is riveted to a spacer that spans the vertical bars of the upright above the two lateral extensions. The left vertical bar of the upright and the point, which is almost round in cross section, are shaped from the same piece of iron, adding stability to the cross. An additional iron piece, seven centimeters long, secures the right vertical bar to the point at the base. An area reinforced with wrapped metal on the tapered point near where the vertical bars join indicates the lower section was either repaired or added at a later date.

CROSS 2

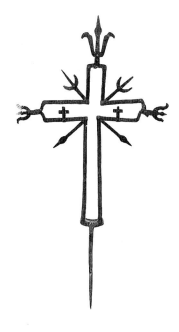

Maximum length: 75 cm
Maximum width at arms: 41 cm
Length of point from base: 21.5 cm
Number of pieces: 23
Number of rivets: 19

Width of arms: 9 mm
Thickness of arms: 4 mm
Width of upright: 10 mm
Thickness of upright: 4 mm
Space between bars: 2.7–4 cm

FIRST DOCUMENTED AS PART OF THE collection in 1957, Cross 2, dramatic in its simplicity, is an example of STYLE III. Since several roof crosses reminiscent of its style and design appear on older houses in San Cristóbal de Las Casas, it once may have been a popular pattern. Noteworthy is the treatment of the finials, which are one and a half millimeters thick. A stylized fleur-de-lis dominates the apex, with the rounded notches on the inner edges of the outer petals seemingly fitting the central apical part as if the flower had emerged full bloom from a bud. Two smaller finials, in similar floral motifs and riveted to the ends of the transverse arms, are extremely fragile. The lower tip of the finial on the right and the upper tip of the left are missing.

The open space is undecorated except for a small Latin cross, three millimeters thick, riveted to the lower bar of each arm. The vertical bars of the upright were joined to the flattened upper end of the squared point by heating, and then the joint was reinforced with two rivets. The use of a chisel in forming the iron pieces is evident from the rough edges of the metal.

Axial extensions, resembling stylized tridents above and spearheads below the arms, project at forty-five-degree angles from each corner of the axis. The trident, a decorative motif, is associated with dominion over the seas as well as being symbolic of storms and lightning.[126] It also may have another connotation in Maya cosmology. Linda Schele, an epigrapher who studied Maya symbolism, identified a similar three-pronged motif on the tips of banners carried during the Carnival Celebration in San Juan Chamula and associated this shape with the blades of spears carried by dancers in war and sacrifice scenes depicted in murals from the Maya classic period.[127]

Maximum length: 117 cm
Maximum width at arms: 70 cm
Length of point from base: 28 cm
Number of pieces: 32
Number of rivets: 33

Width of arms: 15 mm
Thickness of arms: 3.5 mm
Width of upright: 14 mm
Thickness of upright: 3 mm
Space between bars: 3.2 cm

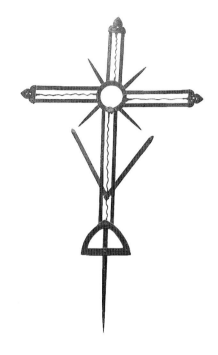

PART OF THE COLLECTION SINCE 1956 and an example of STYLE V, Cross 3 is over a meter tall. The loss of several original ornaments alters its intended appearance, giving it a more modernistic look and causing it to stand out from the other crosses both in terms of its size and profile. It is also distinguished by the slightly unaligned arms and sections of the upright above and below the open circle.

This circle, chiseled from a piece of solid iron, forms the axis where the arms and upright meet. Such a circular motif usually contains a small Latin cross, and undoubtedly this feature was once present since a small fragment of metal remains where the undulating line bisecting the lower section of the upright joins the circle. If so, this combination would symbolize the monstrance used in the Catholic church as a receptacle for the consecrated host. As it is now, the axial circle with four tapered extensions ending in sharp points may represent a crown of thorns rather than a monstrance or the sun's rays. The more common representation of a sun is a series of rays projecting outward in a sunburst effect. Undulating lines created from thick, twisted wire and attached at both ends by small metal sleeves bisect the arms and upright, which terminate in solid arch-like finials resembling pointed or ogee arches. The sinuous lines suggest serpents or lightning bolts. Four perforations, a small oval and three rectangles, decorate each finial.

The two bars that compose the upright project upward from a broad, open triangular base. The point, flat in cross section, is riveted to the top of the base along with the sinuous line that courses through the middle of the upright. The triangular, or handle-like, shape of the base is an unusual motif, one that occasionally appears as a finial on a Celtic cross.[128] The lower triangle, somewhat rounded, could symbolize the Trinity. Two lateral extensions above this triangular base project outward from the line in the center of the upright. Although rivets, visible at the tips of the extensions, indicate that ornaments were once attached, only a small piece of iron from one former ornament remains on the right extension.

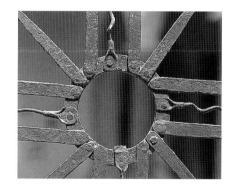

DETAILS OF CROSS 3.
Technique using *remache* to attach multiple pieces.

CROSS 4

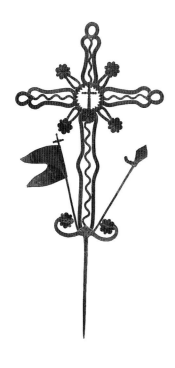

Maximum length: 101 cm
Maximum width at arms: 49 cm
Length of point from base: 32.5 cm
Number of pieces: 40
Number of rivets: 43

Width of arms: 14 mm
Thickness of arms: 3 mm
Width of upright: 13 mm
Thickness of upright: 3 mm
Space between bars: 2–5 cm

SEVEN DAISY-LIKE COROLLAS WITH EIGHT petals balance the open design of this ornate cross, which has been in the collection since 1957. Although the overall design resembles Cross 10 in the collection, two prominent ornaments representing Church authority distinguish Cross 4. Both crosses serve as examples of STYLE V.

Bold wavy lines, terminating at the finials, bisect the bars and attach to an axial circle with a Latin cross secured at the top and bottom. Serrations line the inner circumference of the circle, drawing attention to the small cross with its arms and upper section of the upright ending in trefoil finials. The lobed ends of this inner cross resemble those on traditional wooden crosses that mark shrines in the indigenous communities of Chiapas.[129] The curving upright and transverse arms terminate in ovate finials with broadened ends resembling teardrops. Four matching corollas project outward from the circle on open-designed axial extensions.

Two small incurving extensions, also ending in corollas, form the base of the cruciform, from which two lateral exten-

sions emerge: a banner with a shaft topped with a cross symbolizing Christ's Resurrection and a spear representing Catholic church authority. One side of the upward-curved crossbar below the triangular point of the spear is missing, and the proximal end of the squared, tapered shaft is partially cut through, suggesting at one time attempts were made to sever the cross from its point.

CROSS 5

Maximum length: 50.5 cm
Maximum width at arms: 33 cm
Length of point from base: 17 cm
Number of pieces: 9
Number of rivets: 13

Width of arms: 4 mm
Thickness of arms: 3 mm
Width of upright: 4 mm
Thickness of upright: 3 mm
Space between bars: 1–1.5 cm

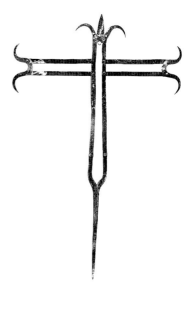

CROSS 5 WAS ONE OF THE FIRST PIECES from the collection photographed on the wall in the northwest corner of the central patio in 1956. An example of STYLE III, this is the smallest cross in the collection and lacks any decorative ornaments except for the lotus-like motifs that act as finials for the double bars forming the open upright and arms. In general, older crosses of this size have little adornment, with the open design making the artistic statement.

A sharply pointed projection completes the apical finial of the upright, giving it a distinct floral appearance. Similar projections are missing from both arm finials, which resemble the leafy base of the apical finial without the central stalk. The right arm finial has a rivet hole where a projection might have been attached, while the left arm lacks any indication of such an addition. Since arm finials are usually symmetrical, the presence of only one rivet hole suggests a change in the ironworker's plan or the use of an iron piece that already had a hole.

The squared point and the two vertical bars that reach up to the axis where the arms join the upright are from one solid piece of metal. Two rivets, one on each bar of the upright, five and a half centimeters from the base, imply that lateral extensions once were present. If so, it is nearly impossible to know the original theme of these ornaments, especially due to the small dimensions of the cross. Scrap pieces with holes already in place may have been used to form the cruciform, indicating that it was never further embellished.

CROSS 6

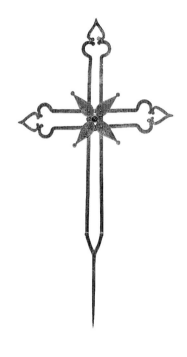

Maximum length: 121.5 cm
Maximum width at arms: 62.5 cm
Length of point from base: 28.5 cm
Number of pieces: 14
Number of rivets: 9

Width of arms: 15 mm
Thickness of arms: 5.5 mm
Width of upright: 15 mm
Thickness of upright: 5.5 mm
Space between bars: 3.5–5 cm

CROSS 6, PART OF THE COLLECTION SINCE 1956 and the second largest, measures over a meter in height. No lateral extensions or basal ornaments compete with the graceful lines of its open design, an example of STYLE III. A four-petaled flower, accented by a raised button-like center, or boss, is made up of five pieces of iron set on a spacer and secured with seven of the nine rivets on the cross. This distinctive quatrefoil motif is the traditional pattern used on the wooden crosses in the Tzotzil community of San Juan Chamula. The Tzotziles often carve five such flowers or stars on their wooden crosses: one at each end of the arms to represent the hands, one at the apex to indicate the head, one near the axis to symbolize the heart, and the fifth near the base to mark the feet.[130] Such symbols infuse life into the cross, personifying it for believers.

The space between the double bars that shape the arms and upright broadens at the ends to form symmetrical protuberances as in a *botonée* motif. These are then capped with ogee, or pointed arches, which have been joined by heating where they meet the bulbous ends of the upright and arms. This is the only cross in the collection that has such prominent parts connected without rivets, although the connection on the apical finial is broken and now held with thin wire. The broadened point and lower sections of the upright are a single piece secured by two rivets to the upper vertical bars slightly above the base.

DETAILS OF CROSS 6.
Anterior view of the floral attachment at the axis.

CROSS 7

Maximum length: 52 cm
Maximum width: 34.5 cm
Number of pieces: 4
Number of rivets: 5
Arms: None

Width of lotus: 15 mm
Thickness of lotus: 4 mm
Width of upright: 2.5 mm
Thickness of upright: 4 mm

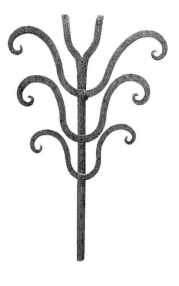

THE UPPERMOST SECTION AND TAPERED point of Cross 7 are absent, with only two rivets left on the forked ends of the upright to indicate where the upper portion was once attached. When a local ironworker examined a photo of what remains, he surmised the missing upper fragment was similar to those of Cross 14 or Cross 18, both examples of STYLE VII.

The lotus motif, the decorative imprinting on the iron, and the use of preformed metal suggest Cross 7 was crafted more recently than the majority of crosses in the collection, perhaps in the early 1960s. Photographs of the central patio document that the cross was part of the collection in 1965. Although the upper section of the cross was intact at that time, details of the photos were insufficient to identify the size, shape, and features of this now missing section. A later photo indicates that only the present section remained in 1982, composed of three consecutive lotus-shaped tiers ending in graceful downward curves. Each tier is attached by rivets to the broad, flat upright and increases in size with the smallest at the bottom. The solid upright is imprinted throughout with a line of small, round punch marks.

CROSS 8

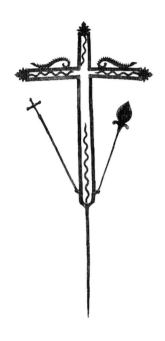

Maximum length: 112 cm
Maximum width at arms: 53.5 cm
Length of point from base: 41 cm
Number of pieces: 25
Number of rivets: 25

Width of arms: 15 mm
Thickness of arms: 4 mm
Width of upright: 15 mm
Thickness of upright: 4 mm
Space between bars: 2–3.5 cm

SIZE, WORKMANSHIP, AND GENERAL condition distinguish Cross 8, an example of STYLE V and part of the collection since 1957. Although segments of the decorative extensions are missing, the remaining elements are well preserved. Whereas some ironworkers have interpreted the free ends of the undulating lines that bisect the upright and arms of this cross as the heads of serpents, and the two uppermost ornaments on the arms of the cross have been interpreted by others variously as *gusanos* (worms), *plumas* (feathers), or *palmas* (palm branches), these features are probably decorative rather than symbolic. Such variations in interpretation, however, verify the difficulty in determining the meaning of some ornaments, especially when the motif has no obvious association.

The identical finials, functioning as spacers between the bars, are shaped as multi-leafed lotuses. The uprights bend at ninety-degree angles to form the arms, which support the two upper serrated scroll-like ornaments. Near the base, two lateral extensions project outward. Rivets on the staff that supports a small cross suggest that a thin metal banner was once attached. Interpretation of the other extension is problematic. Although it could represent a stylized spear with a downward turned crossbar, as the ornament on Cross 4, the end is sufficiently broad to suggest a bishop's mitre on a staff. In either interpretation, the theme of the cross relates to Catholic church authority. The point, thick and square in cross section, flares laterally at the base to support the two bars of the upright.

Maximum length: 83.5 cm
Maximum width at arms: 68.5 cm
Length of point from base: 15 cm
Number of pieces: 41
Number of rivets: 32

Width of arms: 13 mm
Thickness of arms: 4 mm
Width of upright: 14 mm
Thickness of upright: 5 mm
Space between bars: 3–3.5 cm

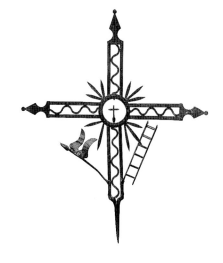

AN EXAMPLE OF STYLE V AND FIRST documented as part of the collection in 1986, Cross 9 is of special interest because of its ornaments reflecting a mixture of themes with various possible meanings. The ladder and the banner that extend outward above the base on either side of the bars that compose the upright serve as examples. The thin metal banner, which rotates on the shaft of a triangular-pointed lance, clearly represents Catholic church authority. However, since it is unusual to have only one implement of the Passion on a roof cross, the ladder, meticulously constructed with rounded rungs fitting on both ends into thick side pieces, may symbolize the bridge between the Catholic church on earth and the Kingdom of Heaven, rather than representing the usual ladder used to remove the body of Christ after the Crucifixion.

The arms and upright of this cross, composed of widely spaced, broad double bars, are bisected by thick serpentine lines, attached at both ends by rivets. Rivets also secure the broad, flattened point at the base. At the axis, the lines lead inward to a circle that is rounded from a single piece of flat iron. A small Latin cross resting on an ovate pedestal projects into the orb, from which four sets of three axial extensions radiate outwards. One of the twelve extensions is missing from the lower left set. The arms and upright terminate in finials resembling the conical roofs topped with spherical caps on the turrets of the Church of San Nicolás in San Cristóbal de Las Casas.

CROSS 10

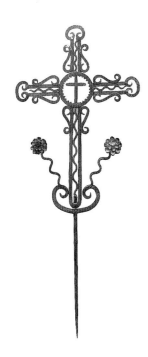

Maximum length: 104 cm
Maximum width at arms: 43 cm
Length of point from base: 41 cm
Number of pieces: 38
Number of rivets: 42

Width of arms: 11 mm
Thickness of arms: 4 mm
Width of upright: 13 mm
Thickness of upright: 4 mm
Space between bars: 1.5–2 cm

CROSS 10, FIRST DOCUMENTED AS PART OF the collection in 1960, remains in very good condition except for minor wear on the rosettes. It is an example of STYLE V with decorative motifs that resemble those of Cross 4. Although heavily decorated, it apparently has no symbolic adornments other than the cruciform. With its elaborate baroque-like ornaments, it has no front or back and thus is equally appreciated from either view.

The two-sided flowers, composed of four thin layers of indented petals, project upward on undulating lateral extensions from the curved ornament at the base. The right lateral extension has a longitudinal groove, located midway between the attachment and the rosette, which is seemingly only decorative. The open space between the bars of the upright and arms is bisected by serpentine lines that lead to the axial circle accented by interior serrations. A solid Latin cross with carefully delineated floral finials is connected to the circle at the top and bottom. Eight identical S-shaped scrolls, attached to the outer sides of the double bars, draw attention to the axis.

The base of the cross rests on a simple upturned piece of metal that ends in graceful swirls. The finials repeat this same motif, only smaller and inverted. The two vertical bars of the upright join at the base, where one bar is riveted to the square, tapered point.

Maximum length: 71 cm
Maximum width at arms: 52 cm
Length of point from base: None
Number of pieces: 72
Number of rivets: 52

Width of arms: 12 mm
Thickness of arms: 3 mm
Width of upright: 12 mm
Thickness of upright: 3 mm
Space between bars: 5 mm

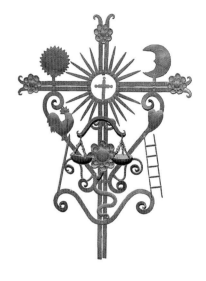

THIS HEAVILY DECORATED CROSS WITHOUT A tapered point, and with all ornaments on the frontal surface, serves as an example of STYLE VIII. Most likely purchased new for the collection (circa 1975), it was never used as a roof cross. While it is an open design, with double bars outlining the upright and arms, these are closely spaced, only five millimeters apart. It is an interesting contrast to Cross 29, which is a solid design composed of a wide upright and a single bar for the transverse arms.

The arms and upright of Cross 11 terminate in gentle backward curves of a stylized lotus, where three rosettes, composed of two nestled layers of petals secured with bosses, accent the ends. A sun and a first-quarter crescent moon with impressed facial features rest on the upper bar of the arms on either side of the axis in keeping with the typical placement of these symbols in Christian iconography. The circle, surrounded by sixteen sharply pointed extensions arranged in four sets of four, supports a small Latin cross with distinct lobes as finials.

Attention, however, turns from the basic cruciform shape to the implements

of the Passion and Crucifixion: a ladder, lance, heart, and a rooster representing the one that heralded St. Peter's denial of Christ. The heart and rooster are attached to two lateral extensions, ornate S-curves projecting from the bars of the upright to the lower bars of the arms. A lotus-shaped base with scrolled ends provides a platform for the lance and ladder.

Scales, representing justice, hang below the axial circle. A serpent, the Christian symbol for evil and betrayal, slithers upward from the base along the bars of the upright. A large rosette, similar to those near the finials, accents the upright below the circle and rests directly above the serpent's mouth. Wavy, fish scale impressions from four different chisel patterns decorate the iron pieces as well as the ornaments. The extensive embellishment and the use of countersunk rivets indicate the cross was created within the last thirty years.

CROSS 12

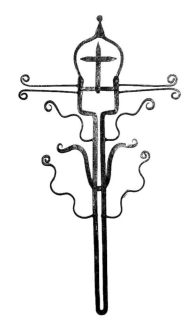

Maximum length: 73.6 cm
Maximum width at arms: 41 cm
Length of point from base: None
Number of pieces: 14
Number of rivets: 16

Thickness of arms: 4 mm
Width of upright: 12 mm
Thickness of upright: 3 mm
Space between bars: 3–12 mm

THE THIN, WIRE-LIKE METAL THAT composes the arms and lateral extensions distinguishes Cross 12 as one of the more delicately made crosses in the collection. This small, stylized cross, first photographed in 1960, shows no evidence that it ever had a tapered point, although the rounded end at the base of the upright once could have been used for installation on a roof. Attention focuses on the apical ornament, a prominent solid Latin cross with sharply pointed finials, positioned in the center of the dome on a bar that spans the distance between the two arms.

The arms, shaped from two thin, rounded pieces of iron, end in small, tight scrolls. The same material is used for the gently curved lateral extensions, which are attached to the upright and terminate in similar scrolled finials. Two lateral extensions frame a single lotus with upturned swirls. These graceful scroll and swirl motifs are characteristics of STYLE VII.

A single flattened bar, chiseled out at the center, forms the double bars of the upright, which are irregular and closely spaced from three to twelve millimeters apart with no inner ornamentation. The two rivets near the base on these vertical bars give no indication that they once secured additional ornaments or a tapered point. The uprights flare outward to meet the arms and then continue to form the apex in the shape of a church dome with a miniature conical roof topped with a rounded cap. Only one side of the flattened surfaces is longitudinally impressed with small circular punches.

Maximum length: 97 cm
Maximum width at arms: 39.5 cm
Length of point from base: 32 cm
Number of pieces: 30
Number of rivets: 34

Width of arms: 8 mm
Thickness of arms: 4 mm
Width of upright: 8 mm
Thickness of upright: 4 mm
Space between bars: 2–3 cm

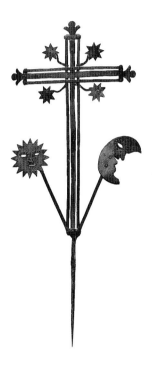

THIS IS ONE OF THREE CROSSES documented in a photo taken in the chapel at Na Bolom in December 1954, when, along with Cross 15 and Cross 17, it decorated the altar during the Christmas season. Sometime after May 1956 Cross 13 was moved to the central patio. Note the similarities in style with Crosses 1, 21, and 23. Distinguished by a celestial motif that may have pre-Columbian roots, all are examples of STYLE IV. Cross 13 appears to have been used as a pattern for two identical crosses made in the early 1970s that remain on roofs in San Cristóbal de Las Casas: one on a building at Harvard Ranch and the other at Los Baños Mercedarios in Barrio de la Merced.

The upright, formed by two pieces of metal spaced approximately three millimeters apart, is joined at the base with rivets to a separate iron bar that composes the point, which is rectangular in cross section. The arms, similar in construction to the upright, end in floral finials resembling the stylized lotus of the apical finial. Each of the three finials, reinforced from behind by a piece of iron that spans the space between the bars, is secured by three rivets. Flattened, thin iron strips interweave at the axis and fill the open spaces between the arms and the upright. The midline strip that courses through the upright is loose from its lower rivet. In addition to the four rivets that secure the pieces that meet at the axis, there are three other rivet holes near the axis that seem to have no specific function.

Four eight-pointed stars on axial extensions radiate outward from the axis, while a sun and last-quarter crescent moon with perforated facial features project from the base at the ends of flat lateral extensions. The sun, moon, and stars, all cut from metal one millimeter thick, show signs of deterioration, with the upward tilting chin of the moon broken off.

CROSS 14

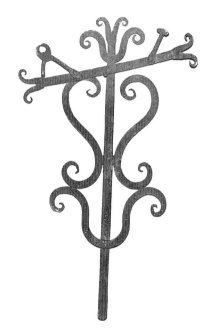

Maximum length: 51.5 cm
Maximum width at arms: 31.5 cm
Length of point from base: 12 cm
Number of pieces: 10
Number of rivets: 9

Width of arms: 14 mm
Thickness of arms: 4 mm
Width of upright: 16 mm
Thickness of upright: 4 mm
Space between bars: None

CROSS 14, AN EXAMPLE OF STYLE VII, suggests ingenuity on the part of the craftsman, with the arms seemingly deliberately set at a slight angle instead of in a straight line to form a true Latin cross, an unusual trait for a roof cross. This recent acquisition to the collection originally belonged to Señora América Penagos, the daughter of Señor Manuel Penagos, who was involved in the sale of Na Bolom to Frans Blom in 1950. Doña América maintained a life-long friendship with Gertrude Blom and association with Na Bolom, and in 1995, shortly after her death, Cross 14 was added to the collection.

Noteworthy are the ornaments of hammer and pincers, items usually considered implements of the Crucifixion but also symbols of the blacksmith trade during the Middle Ages.[131] Since it is uncommon to have hammer and pincers appear on a roof cross without other implements of the Crucifixion, their association on this cross may be related to the ironwork craft.

Variations of scroll motifs decorate the cruciform fashioned in a solid design. A small iron reinforcement appears midway along the upright to secure the two lateral extensions composed of S-curves resting on a lotus base. The finials bifurcate in a *moline* pattern with scrolled, recurved tips. The small lotus near the apex replicates the larger one at the base and balances the design, thus compensating for the offset arms. Rivets attach the small hammer and pincers to the arms. Note that a section from the lower handle of the pincers is missing. The iron is punched with small circular patterns along the midline of all frontal surfaces, except on the flattened point, adding a final decorative touch to the overall simple appearance.

Maximum length: 136.5 cm
Maximum width: 31.5 cm
Length of point from base: 49.5 cm
Number of pieces: 53

Number of rivets: 53
Width of upright: 3-4 mm
Thickness of upright: 3 mm
Space between bars: 8–13.5 cm

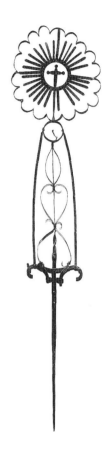

Cross 15, THE LARGEST AND MOST UNUSUAL cross, in the collection since at least 1954, was one of many religious items that Frans Blom purchased to decorate the chapel at Na Bolom. In 1960, he moved it to the central patio, where it hangs today on a corridor wall. Because of its size and striking ornamental features, this cross may have been made for the roof of a private chapel rather than a house. Its open design, elaborate apical ornament, and lack of an overall cruciform shape are characteristics of STYLE VI.

The dramatic ornate apical circle, suspended within and attached by four iron bars to a surrounding scalloped frame turned on edge, resembles the monstrance used in the Catholic church to display the consecrated host. The four bars serve as attachments as well as divide the circle into quadrants, each having seven rays projecting outwards, with two of the original twenty-eight missing. An inner cross, with exaggerated rounded finials and encircled by a broad circle from which the rays project, completes the apical ornament. Its upright extends downwards, attached by a rivet to a small

circle formed by the two ascending bars of the main upright.

The space between the parallel bars of the upright is decorated with a lower pair of S-curves, another pair of half curves in the middle, and an upper pair of elongated ovals, all turned on edge with the largest at the base and the smallest at the top. A central bar bisects the upright as well as the inner curves and ovals to end below the apical ornament in a small circle turned on edge. The two bars of the upright also join this small circle, which at one time may have held an inner ornament since remnants of metal ends still remain. At the base, two concave pieces of metal connected by a short horizontal bar support the upright. The lower pair of S-curves are tenuously secured to the base in three places by disintegrating black electrical tape. Two rivet holes indicate that there were once additional attachments near the base on the upper tip of the tapered point. The tapered end, broad and flat in cross section, is extraordinarily long and must have given the cross unusual height when placed on a roof.

CROSS 16

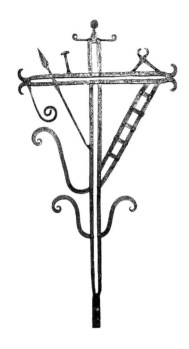

Maximum length: 81 cm
Maximum width at arms: 43.5 cm
Length of point from base: 9 cm
Number of pieces: 20
Number of rivets: 30

Width of arms: 10 mm
Thickness of arms: 3.5 mm
Width of upright: 10 mm
Thickness of upright: 3.5 mm
Space between bars: .8–1.2 cm

Cross 16, first documented as part of the collection in 1960, is noteworthy for its decorative balance, graceful lines, and exceptional craftsmanship. The use of only a few implements of the Passion suggests this example of Style VII represents a transition between older styles with no religious ornaments and the ornate crosses characteristic of Style VIII. Note the similarities in decorative motifs between this cross and Cross 27.

Three solid iron bars have been chiseled out to create the inner space between the arms and upright. The arms are shaped from one piece, the uppermost part of the upright and apical finial from a second piece, and the lower section of the upright and flattened end from a third. At the apex, the upright bars join to form a conical-shaped finial with a rounded cap that is accented by a thin horizontal bar ending in closed upward-turned swirls. Hammer and pincers adorn the upper bars of the arms, the ends of which recurve in a *moline* motif. Both handles of the pincers are riveted to the arm.

A ladder and triangular-headed lance project from the vertical bars of the upright. The ladder, made in flat profile lacking sides and rungs, is attached to the lower bar of the arm and to the upright by four rivets. The shaft of the lance is flattened as it passes behind the arm and terminates in a sharp point above the upper bar of the arm. These two lateral extensions are balanced by a single scroll projecting downwards from the arm and two lotus ornaments on the upright. The lowermost lotus, in two halves, differs from the upper lotus, a segment of which continues the lines of the side of the ladder.

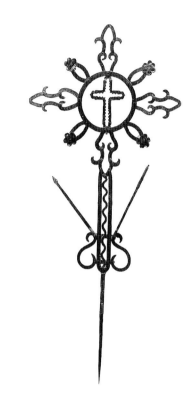

Maximum length: 107 cm
Maximum width: 47.5 cm
Length of point from base: 32.5 cm
Number of pieces: 47

Number of rivets: 53
Width of upright: 15 mm
Thickness of upright: 4 mm
Space between bars: 2 cm

THIS CROSS, AN EXAMPLE OF STYLE VI, along with Cross 13 and Cross 15 formed the original core of the collection as it was first documented in a 1954 photograph of the chapel at Na Bolom. In 1960, it was relocated to the corridor wall of the central patio. It is an exceptionally well-crafted cross, to which the ironworker added a special touch, barely visible: eight tiny Greek crosses on the front of the circle, one on each side of the four dominant fleurs-de-lis.

This large circle, shaped from a solid piece of iron and framing an open cruciform, is the focal point of the cross. Eight small pieces of iron form the interior cross, which is embellished with delicate inner serrations and distinct finials. Fourteen rivets are used in this single ornament alone, which is secured to the top and bottom of the circle. Eight ornate extensions radiate outward from the circle in a symmetrical pattern: four open ovates ending in single but two-sided petaled flowers and four large outlines of stylized fleurs-de-lis emerging from open heart-shaped bases. Each floral pattern is composed of four pieces secured with five rivets. Parts of the four flowers are worn or absent. An undulating line fills the space between the double bars of the upright. No distinct arms portray the typical cruciform common in most of the other crosses.

Two pieces of iron at the base reinforce S-curved ornaments from which project two lateral extensions, a spear and a staff with a missing finial. Rivets that secure them to the S-curves were loose when the cross was first photographed in 1954. As a result, these two extensions fell free to form a straight line parallel to the ground, a position depicted in all previous photographs. Remnants of thin metal around the staff suggest a banner once projected from the shaft. If so, a small cross most likely crowned the end of the staff. Several rivet holes, one on the large circle and two on one fleur-de-lis, appear to have had only a decorative function. The tapered point, thick and rectangular in cross section, is a separate piece riveted to the base.

DETAILS OF CROSS 17.
Two small crosses etched into a piece at the axis, suggesting the ironworker's subtle way of identifying his work.

CROSS 18

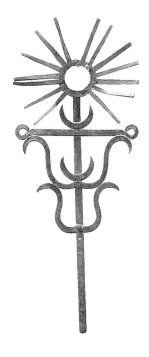

Maximum length: 67.5 cm
Maximum width at arms: 26.7 cm
Length of point from base: 21.5 cm
Number of pieces: 23
Number of rivets: 24

Width of arms: 13 mm
Thickness of arms: 4 mm
Width of upright: 15 mm
Thickness of upright: 4 mm
Space between bars: None

A DOMINANT LOTUS MOTIF IN combination with a sun portrayed as a circle surrounded by radiating rays adds to the simple but dramatic appearance of Cross 18. The lotus flower, which opens in the early morning and closes in the evening, is often a symbol of the sun and, in Christian iconography, may also indicate the Resurrection: death and closing of the flower at night, reopening to a new life at dawn.[132] When this cross was first photographed in 1958, a small solid Latin cross filled the circle along with fifteen projections; however, the inner cross and one projection are now missing.

The lotus-shaped ornaments, formed in two sections, each of which is riveted to the upright, identifies the cross as an example of STYLE VII. The uppermost, and larger of the two, supports the short transverse arms, which terminate in small closed disks formed by the ends of the arms looping back. The two crescent moons, attached to the upright and each cut from a solid piece of metal, may represent attributes of the Virgin Mary. The upright, also a solid piece, terminates in an imposing apical circle, from which

radiate fourteen blunt-ended projections one and a half to two millimeters thick.

What remains of the point, a continuation of the flat upright, is blunt rather than tapered. Near the base and lower lotus there is an open rivet hole of unknown function. Two additional rivets, one located midway between the smaller lotus motif and the end of the point, the other at the end, could have secured a now missing section of the point.

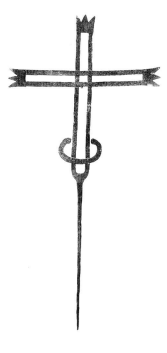

Maximum length: 89.3 cm
Maximum width at arms: 44.5 cm
Length of point from base: 43 cm
Number of pieces: 7
Number of rivets: 12

Width of arms: 13 mm
Thickness of arms: 3 mm
Width of upright: 13 mm
Thickness of upright: 5 mm
Space between bars: 1.8–2.5 cm

AN EXAMPLE OF STYLE III, CROSS 19 has been part of the collection since 1959 and is thus one of the older crosses. Although it is sparsely decorated, it is rich in symbolism. The dominant, yet subtle, lunar and coronal motifs represent one of several possible manifestations of the Virgin Mary, as well as a connection with the indigenous moon goddess. In the advocation of the Virgin of Guadalupe, the patroness of Mexico, these two broad concepts merge. In Catholic iconography alone, however, the coronal theme represents the crowned Queen of the Heavens, fitting for a roof cross that is placed in the open sky for protection against lightning storms.

The double bars, meeting at the axis to outline an open square, form the upright and arms that terminate in three finials depicting stylized crowns. An oval-shaped ornament, open at the top and reminiscent of a half moon, is the only other embellishment. Being off center, slightly above where the bars of the upright merge to shape the tapered point, this lunar ornament further suggests an association with the Virgin Mary, who is often depicted standing on a half moon. The point, square in cross section and almost half the overall height of the cross, is part of the solid piece of metal that includes the bars of the upright extending up to the apical crown. The only structural weakness on the cross is where the two rivets that secure the upper bar of the arm at the axis to the vertical bars of the upright are separating from the metal.

CROSS 20

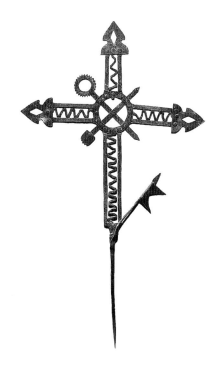

Maximum length: 57 cm
Maximum width at arms: 36.6 cm
Length of point from base: 17.8 cm
Number of pieces: 22
Number of rivets: 30

Width of arms: 8 mm
Thickness of arms: 5 mm
Width of upright: 8 mm
Thickness of upright: 5 mm
Space between bars: 1.8–2 cm

THIS RELATIVELY SMALL BUT STURDY CROSS was first photographed as part of the collection in 1985. In that photo, a second lateral extension, a staff topped with a small cross, projected to the left at a forty-five-degree angle and opposite the remaining extension consisting of a forked banner attached to a lance with a triangular point. Both motifs, symbolic of Catholic church authority, are typical of early twentieth-century roof crosses. The circle, as the central axial ornament, and the serpentine lines between the bars that compose the cruciform outline, are typical features of STYLE V.

The open double bars that form the arms and upright meet at the axis in a circle of broad metal. Two thick objects attached with rivets to the circle, possibly a nail and a key, crisscross the circle in an " X," reminiscent of a St. Andrew's cross. The arms and upright terminate in three conical-roofed turrets with diamond-shaped perforations in each, adding a decorative dimension to the finials. The tightly formed, angular, serpentine lines that course through the center of the spaces between the bars of the arms and upright are attached at both ends. The flat, blunt-ended point, which is square in cross section, along with the vertical bars of the upright that extend upward to the bottom of the circular axial ornament, are formed from a single piece of metal. The only remaining extension, the lance, is decorated with a banner, one millimeter thick, tightly wrapped rather than secured by rivets.

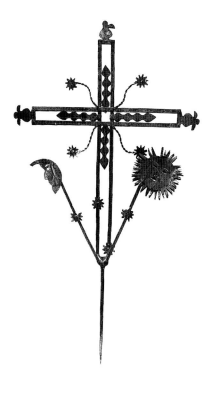

Maximum length: 109.5 cm
Maximum width at arms: 61 cm
Length of point from base: 31.5 cm
Number of pieces: 30
Number of rivets: 31

Width of arms: 14 mm
Thickness of arms: 4 mm
Width of upright: 14 mm
Thickness of upright: 5 mm
Space between bars: 2.6–3 cm

CROSS 21, FIRST PHOTOGRAPHED IN THE chapel at the time of Frans Blom's funeral in June 1963, was relocated to a corridor wall in the central patio by 1975. The celestial ornaments and open design of this large cross are similar in style and motif to Cross 1 and Cross 13, all examples of STYLE IV. In this style, a last-quarter crescent moon is usually depicted rather than a first-quarter moon such as that of Cross 21. The ironworker may have inadvertently transposed the placement of the sun and moon on the lateral extensions. The fact that the sun and star above it appear to compete for space further suggests that an error in location rather than a shift in lunar motifs occurred.

The widely spaced bars that fashion the upright and arms add to the striking appearance of this cross. One bar of the upright is a solid piece of iron that extends from the apical finial to the tip of the point, which is rectangular in cross section. Four broad, symmetrically notched extensions attached at the axis and terminating in points partially fill the space between the bars, where the arms meet in

an open square. Four eight- to ten-pointed stars at the tips of twisted iron axial extensions further punctuate the axis.

Three identical finials, which could be interpreted as angels with projecting wings or as stylized flowers, act as spacers and provide lateral support to the bars of the upright and arms. The wing or petal on the uppermost finial of the upright is missing. Cutouts of a first-quarter crescent moon and a full sun with perforated facial features are mounted at the ends of two straight lateral extensions that project from the base. Small stars, two on the vertical bars and two on the lateral extensions, balance the overall symmetry of the cross. A small piece of the lower face of the moon, several rays of the sun, and points on the stars are missing. These ornaments and the finials are cut from thin metal, a half to one millimeter thick, which makes them vulnerable to damage and deterioration.

CROSS 22

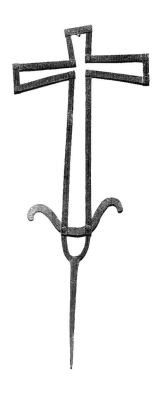

Maximum length: 52 cm
Maximum width at arms: 21 cm
Length of point from base: 16.5 cm
Number of pieces: 13
Number of rivets: 12

Width of arms: 9 mm
Thickness of arms: 4.5 mm
Width of upright: 9 mm
Thickness of upright: 4.5 mm
Space between bars: .5–2.5 cm

CROSS 22, WHICH HAS AN OPEN DESIGN constructed of thirteen pieces of metal joined with twelve rivets, has been part of the collection since 1956 and serves as an example of STYLE III. The very simplicity of this small, plain cross with minimal adornment makes a powerful artistic statement. The only ornament, a broad, lotus-like motif curving downward at the tips, balances the base of the cross with the arms.

Spaces between the double bars of the arms and upright are undecorated and vary in width from a half to two and a half centimeters. This variation in spacing lends distinction to the otherwise plain cruciform. The point, square in cross section, extends upward into a U-shaped base, where two rivets secure the point, along with the curved ornament, to the vertical bars of the upright. At the axis, these bars are riveted to two short pieces of metal that form the lower parts of the arms. The upper bars of the arms are joined to the upright in the same fashion. Simple spacers that lock the bars of the arms and bars of the upright together form the flattened ends to enclose the cruciform. The absence of decorative finials contributes to the geometrical balance of the overall design.

Maximum length: 72.5 cm
Maximum width at arms: 43 cm
Length of point from base: None
Number of pieces: 33
Number of rivets: 37

Width of arms: 8 mm
Thickness of arms: 3 mm
Width of upright: 8 mm
Thickness of upright: 3 mm
Space between bars: 2.3–2.5 cm

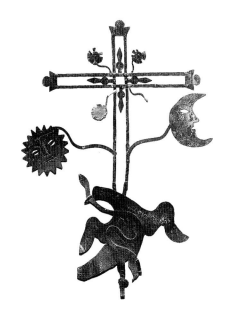

O N CROSS 23, THE NATIONAL SYMBOL OF Mexico is combined with the celestial motifs noted in Crosses 1, 13, and 21, all examples of STYLE IV. This familiar emblem, a large eagle with a serpent suspended from its mouth, represents the triumph of the eagle over the serpent according to Aztec lore. The detail on these figures dominating the base of the cross is remarkable. The beak of the eagle is perforated to hold the serpent's head, which is impressed with an eye and mouth. Unfortunately, the figures are not complete, since the tail of the serpent and the foot and talon of the eagle are missing. The cross, added to the collection around 1961, is generally in poor condition, perhaps due to the use of many pieces of scrap metal of varying lengths, which affects the durability of a roof cross. Five short sections of thin iron, for example, were joined to form the figure of the snake. In addition, the lower bar of the arms was fabricated from two pieces of iron, and a portion of the vertical bar of the upright has been reinforced.

A sun and last-quarter crescent moon with cutout facial features project above the eagle. Each is riveted to a gently curved lateral extension that is attached to a bar of the upright. Four tapered points, each emerging from a small solid orb, partially fill the space at the axis, where the upright and the transverse arms join to form an open square. The three finials are shaped in similar coronal motifs. Four curved axial extensions resembling those that support the moon and sun project from the center of the cross. Each ends in a single-sided stamped flower, one of which is missing, while two others are in various states of deterioration. Only a short segment of the flattened point remains below the base.

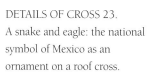
DETAILS OF CROSS 23.
A snake and eagle: the national symbol of Mexico as an ornament on a roof cross.

CROSS 24

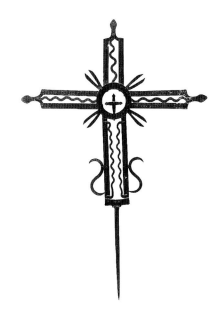

Maximum length: 93.5 cm
Maximum width at arms: 64 cm
Length of point from base: 31 cm
Number of pieces: 30
Number of rivets: 38

Width of arms: 17 mm
Thickness of arms: 4 mm
Width of upright: 18 mm
Thickness of upright: 4 mm
Space between bars: 2.2–4.6 cm

CROSS 24, IN THE COLLECTION SINCE 1957, remains in exceptionally fine condition with only the finial on the left arm being slightly bent. Serving as an example of STYLE V, it is one of the heavier crosses in the collection, with the cruciform made from metal ranging from four to five millimeters thick. The ornaments, three millimeters thick, also add to its physical strength as well as powerful presence.

Constructed in an open design, the double bars of the upright have more space between them than those of the transverse arms. Whereas two thick undulating lines course along the lower section of the upright, only one line bisects the arms and upper part of the upright. The three finials, elongated protrusions which could be interpreted as heads of serpents, flow gracefully from these single lines.

A circle with a small solid cross joins the arms, which taper as they merge at the axis. The miniature inner cruciform assumes the shape of a Greek cross with arrow-like finials. On both sides of the arms, eight spike-like axial extensions emerge from the circle in pairs, bifurcated as in open scissors. Balancing the overall design are two S-shaped scrolls attached with small supporting pieces at the base. The cross, resting on a gently tapered point, rectangular in cross section, is reinforced and secured to the base by four rivets.

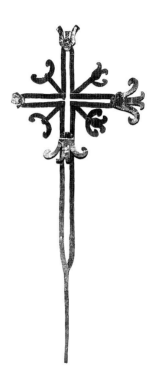

Maximum length: 75.5 cm
Maximum width at arms: 30.5 cm
Length of point from base: 20.5 cm
Number of pieces: 15
Number of rivets: 11

Width of arms: 12 mm
Thickness of arms: 3 mm
Width of upright: 12 mm
Thickness of upright: 3 mm
Space between bars: .5–1.5 cm

WHEN CROSS 25 WAS FIRST photographed in 1961, all decorative ends were intact. Although scant evidence of a complete decorative pattern remains on this cross, it is possible to surmise its original appearance from the stylized floral design evident at one end of the arm and on one lower axial extension. The motif on the lower right extension, which appears to be original, is an inversion of the one on the arm finial: the ends turn upwards to support the flowers, whereas those of the arm finial curve downwards. The ornamentation is decorative rather than symbolic, a characteristic of STYLE III. In addition to the fifteen original pieces on the cross, two more were added at different stages of repair.

The simple open design, composed of narrowly spaced double bars on the upright and transverse arms, lacks inner ornamentation. Four axial extensions project outward from the axis. The one complete arm finial on the right is soldered over a small remnant of the original ornament, as is a similar piece that spans the vertical bars of the upright below the axis. This latter ornament

seems out of character with the style and most likely was added later. Also apparently later additions, the finials are all cut from thin metal a half millimeter thick, painted black to blend with the cross, and soldered rather than riveted.

The two pieces that compose the lower section of the upright are melded at the base to form the tapered point, which is square in cross section. Each piece bends at a ninety-degree angle at the axis to continue as the lower bar of an arm. The upper section of the upright is treated in the same way to form the upper bars of the arms. Two rivet holes on one side of the upright could have originally supported an additional ornament.

CROSS 26

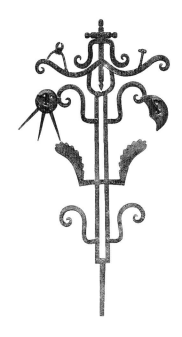

Maximum length: 82.5 cm
Maximum width at arms: 38.8 cm
Length of point from base: 14.8 cm
Number of pieces: 24
Number of rivets: 26

Width of arms: 15 mm
Thickness of arms: 3 mm
Width of upright: 13 mm
Thickness of upright: 3 mm
Space between bars: 1.5 cm

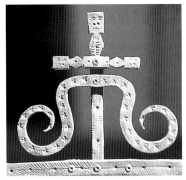

IMPRINTS.
Patterns on chisels used to decorate the iron on a cross in STYLE VII; from the collection of Susanna Ekholm in San Cristóbal de Las Casas.

FIRST PHOTOGRAPHED IN 1973, CROSS 26 was identified by a local ironworker as originating from an *herrería* in Barrio del Cerrillo near Na Bolom. All surfaces on the cross, with the exception of the sun and moon, are stamped with at least ten different chisels, including imprints of tiny crosses, a comb-like pattern, scales, flowers, hash marks, and circles. The wide range of motifs, the indented rivets, the inverted position of the sun and moon figures, and the part-solid and part-open design are characteristics of STYLE VII, as well as indicators that the cross was made within the last thirty years.

The upright consists of open double bars from which project ornaments symmetrically arranged in tiers on both sides. Near the base are two halves of a decorative lotus with swirled tips, a motif duplicated elsewhere on the cross to become the unifying theme. Two serrated, leaf-like lateral extensions project upward. At the next level, a sun with three downward-directed rays and a first-quarter crescent moon are sus-pended from half-lotus motifs similar to those near the base. This unusual pen-dant-like arrangement of the sun and moon, their size, and perforated facial features make them a dominant presence on the cross.

The upper bars of the upright flare outward in a broad U-shape to support a curved, solid transverse arm that ends in simple scrolls. At the apex, a small, solid Latin cross with notched finials is sup-ported from below its arms on an inverted lotus. A hammer and pincers rest on the transverse arms of the main cruciform, decorative items that can have a more secular than religious association when interpreted as symbols of the blacksmith trade as with Cross 14. The distal attach-ment, thin, short, and flat in cross sec-tion, substitutes for a point and could have been used for installation on a roof.

Maximum length: 90 cm
Maximum width at arms: 38.5 cm
Length of point from base: 32.5 cm
Number of pieces: 31
Number of rivets: 35

Width of arms: 13 mm
Thickness of arms: 4.5 mm
Width of upright: 15 mm
Thickness of upright: 4.5 mm
Space between bars: None

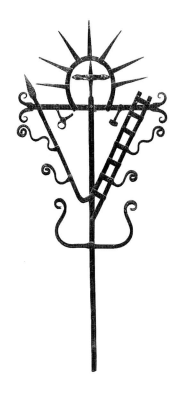

CROSS 27, ANOTHER EXAMPLE OF STYLE VII, was part of the collection by 1958. The upright and transverse arms follow the solid design and support four ornaments: a ladder, lance, hammer, and pincers. The date when the cross was acquired for the collection suggests that ironworkers started to incorporate implements of the Crucifixion into their styles sometime in the 1950s. Only in later years did they add the numerous implements characteristic of STYLE VIII.

The ends of the arms bifurcate and curve back in a *moline* motif with scrolled tips. Where the arms join the upright, a horseshoe-like corona projects upward with a Latin cross in the center, and seven rays, or thorn-like extensions, radiate outward. These extensions could symbolize the seven sorrows experienced by the Virgin Mary, one of which was the death of her son on the cross. Hammer and pincers hang downwards from the arms to avoid competing with the rays for space. Two lateral extensions, a ladder and a sharply pointed lance, project in front of and beyond the arms.

At the base, two halves of a lotus, elongated with scrolled tips, are riveted to the upright. This motif serves as a unifying theme that is repeated on the four thick tightly swirled ornaments projecting outwards from the ladder and lance. The upright is a solid piece of iron that extends upwards beyond the axis, where it tapers to form the smaller upright of the inner cross. The flattened end of the point, which is an extension of the upright, appears to have been severed from the point.

CROSS 28

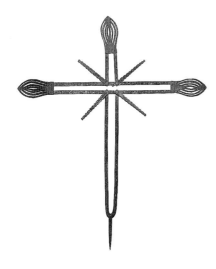

Maximum length: 78 cm
Maximum width at arms: 65.2 cm
Length of point from base: 10.5 cm
Number of pieces: 13
Number of rivets: 11

Width of arms: 12 mm
Thickness of arms: 4.5 mm
Width of upright: 10 mm
Thickness of upright: 4.5 mm
Space between bars: 1.5–2.4 cm

C ROSS 28, FIRST DOCUMENTED IN A photo-graph taken in the *comedor* at Na Bolom in 1988, hangs today at the center of the chimney above the mantel in this same room. Another example of STYLE III, its simplicity and coronal finials can be compared to Cross 19. The three crown-shaped finials, the major distinguishing features, appear as filigree in lace-like open-work created with a small chisel. As with Cross 19, this motif may have symbolic associations with the Virgin Mary. Imprints of a hatched, arc-like pattern on the iron of the arms, upright, and axial extensions add an overall decorative element to this otherwise plain cross.

The double bars of the upright and the arms are open and undecorated. Four serrated axial extensions project at forty-five-degree angles on either side of the axis, where the arms meet the upright. Because of the serrations, they could represent thorns or simply be an embellishment without symbolic significance. The upright is shaped from a solid piece of metal that extends from the curved base up to the lower bar of the arms. A rivet

attaches the unusually short point, flat and thick in cross section, to the base.

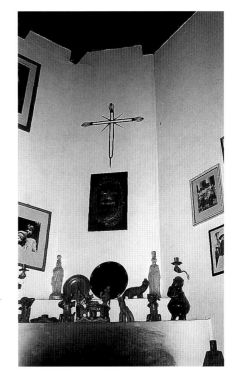

CROSS 29

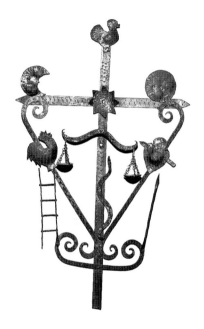

Maximum length: 76.5 cm
Maximum width at arms: 48 cm
Length of point from base: None
Number of pieces: 23
Number of rivets: 13

Width of arms: 25 mm
Thickness of arms: 3 mm
Width of upright: 25 mm
Thickness of upright: 3 mm
Space between bars: None

THIS CROSS PROVIDES THE BEST example in the collection of STYLE VIII, a roof cross modified into a wall ornament. Most likely purchased as a decorative item to represent a local craft, it was never on display in the collection but was first noted on a 1991 inventory of "Mitontic," a guest room at Na Bolom. It also appeared in a photograph published that same year of this room,[133] which continues to be its location. Note the solid design of Cross 29 in contrast to the open design of Cross 11, both of which lack a tapered point.

A floral rosette conceals the rivet that secures the upright to the arms, which terminate in plain, tapered points of a spear-like motif. A stylized bird acts as the finial for the upright, reminiscent of the mythical celestial bird that perched atop the branches of the Maya world tree. This symbol, which played a major role in the creation myth of the ancient Maya, contrasts with the Christian symbol of the rooster that serves as a reminder of St. Peter's denial of Christ.[134, 135]

Other ornaments include a rooster and pierced heart attached to two lateral extensions, and a lance and ladder secured to the basal ornament, both supports with scrolled ends. A scale hangs by thin chains from a curved bar attached to the upright. Below it, a serpent appears in motion as if crawling upwards. A sun and last-quarter crescent moon with impressed facial features rest prominently on the arms. All the flat-work, including the serpent, is impressed with S-curves and the six flat ornaments with crescents. Horizontal lines decorate the lance. The upright terminates abruptly at the distal end with an angular, uneven edge. The thirteen rivets appear as smooth heads of nails rather than the rough rivets used in older crosses.

CROSS 30

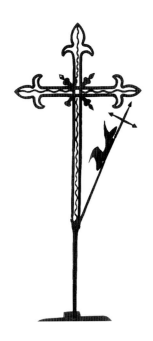

Maximum length: 68.5 cm
Maximum width at arms: 29 cm
Length of point from base: 22 cm
Number of pieces: 14
Number of rivets: 12

Width of arms: 7 mm
Thickness of arms: 6 mm
Width of upright: 7 mm
Thickness of upright: 6 mm
Space between bars: 1 cm

AN EARLY PHOTOGRAPH, POSSIBLY TAKEN IN Frans Blom's private office at Na Bolom, verifies that this cross has been part of the collection since 1957. A faint identification mark, "C-48," on the bottom of the wooden base on which it is mounted suggests the cross at one time may have been in the chapel. Today, it rests on the library mantel on the same wooden stand depicted in the 1957 photograph. Why this particular cross was chosen to be placed on a special wooden stand can only be surmised, perhaps either because of its extremely fragile condition or remarkable craftsmanship.

This is an unusually well-crafted roof cross, an example of STYLE V. The upright and transverse arms are made from a single piece of iron, including their respective finials. The centers of the iron pieces are chiseled out to create the open design. Notches on the bars of the arms and upright allow them to rest flat where they meet at the axis. Four rivets secure the bars, as well as hold the four axial extensions that project outward from each corner. These motifs produce a four-petaled floral pattern at the open square that forms the axis. The tip of the lower left extension is missing, and a rivet hole appears at the apex of the upper left.

The three finials, identical floral motifs, are contiguous with the upright and arms. The rivets at the apex of each finial serve to secure the undulating lines that course through the centers of the double bars. Where the bars of the upright narrow to form the point, a lateral extension that ends in a small cross with arrow-like finials projects off to the right. A flowing banner of thin metal wraps around the extension at a notched area, bends back, and is held in place by two small rivets. The entire border of the banner is embossed with a single row of closely spaced dots, and the banner is topped with a small cross, symbolizing either Christ's Resurrection or Catholic church authority. All other motifs, except the undulating lines perhaps representing lightning bolts or serpents, are decorative.

A large rivet secures the banner to the base of the cross along with the sinuous line that courses upward through the middle of the upright. Evidence suggests that this rivet also held a companion extension that emerged off to the left, opposite the one remaining on the right. Two indentations along the left side of the upright may have supported this missing extension, which was most likely absent when the cross was acquired for the collection. A fragile spot on the remaining extension near where it joins the upright indicates deterioration. The thin wire that was wrapped around the base shown in the photograph was removed since it served no specific purpose and only detracted from the graceful lines of the cross. The point, flattened and square in cross section, is embedded in a wooden stand.

Maximum length: 55.3 cm
Maximum width at arms: 28.5 cm
Length of point from base: 16.7 cm
Number of pieces: 13
Number of rivets: 11

Width of arms: 15 mm
Thickness of arms: 4 mm
Width of upright: 15 mm
Thickness of upright: 4 mm
Space between bars: None

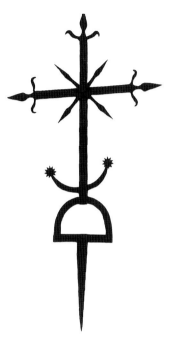

Cross 31, the only example of Style I in the collection, was rediscovered at Na Bolom in March 1997. No record exists in either archival photographs or on inventory lists to provide information on its provenance, date of acquisition, or previous locations in the house. Although corrosive pitting covers all surfaces, the cross is in good condition. The eleven rivets that secure the attachments show no signs of deterioration. Even though this is one of the smaller crosses in the collection, it is well crafted from iron four millimeters thick, with the iron for the unusually short point six millimeters thick.

The solid cruciform design and the four prominent sharp-pointed spears that crisscross at the axis are characteristics of Style I. The four tips of the axial ornament resemble the larger and more distinct triangular-pointed finials on the arms and upright. The tip of the apical finial is missing. The upright rests on a broad, handle-like base, reminiscent of the base in Cross 3 but slightly different in shape. This motif resembles one that occasionally appears on the finials of a Celtic cross (see illustration 2). The upright does not pass through the base to form the point as it does with Cross 3. The short, broad, flattened point is a separate piece of metal that is riveted midway along the horizontal bar of the base.

Slightly above where the upright begins, and projecting outwards on either side, is a broad crescent-shaped ornament tipped with two ten-pointed stars. Similar motifs that curve downwards are used to accent the pointed finials and thus integrate the ornamental features of the cross. This crescent theme, in association with the stars, may be another example of an advocation to the Virgin Mary, in her role as Queen of the Heavens.

CROSS 32

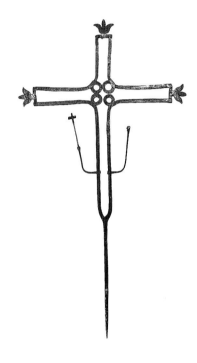

Maximum length: 93.5 cm
Maximum width at arms: 50.7 cm
Length of point from base: 34.5 cm
Number of pieces: 15
Number of rivets: 8

Width of arms: 10 mm
Thickness of arms: 4 mm
Width of upright: 10 mm
Thickness of upright: 4 mm
Space between bars: 2.3–3.5 cm

C ROSS 32, AN EXAMPLE OF STYLE III, was first photographed as part of the collection in 1958. In 1963, it was given by Frans Blom to Señora Beatriz Mijangos, who kept it as a memento of her early years at Na Bolom until 1997, when she returned it to the collection for permanent display.

The most unusual feature of the cross is the prominent axial ornament that consists of four circles. The four bars that fashion the upright loop around to form these closed circles at the axis before bending at a ninety-degree angle and continuing as the upper and lower bars of the arms. Other than this axial motif, which seems to have no symbolic meaning, the space between the bars is undecorated.

Three lotus-shaped finials, attached to spacers, span the distance between the bars of the upright and those of the arms. The cross terminates in a well-proportioned, tapered point, thickened and rectangular in cross section. It is riveted to the bars of the upright and reinforced by melding for added stability where the two upright pieces join. Two lateral extensions project from the sides of the upright, one topped with a small cross, the other missing the finial. If these extensions followed the usual ornamental motifs of STYLE III, a banner would have been once attached to the extension on the left and a spearhead with a crossbar positioned on the right. No specific evidence, however, remains to verify the appearance of the original ornaments.

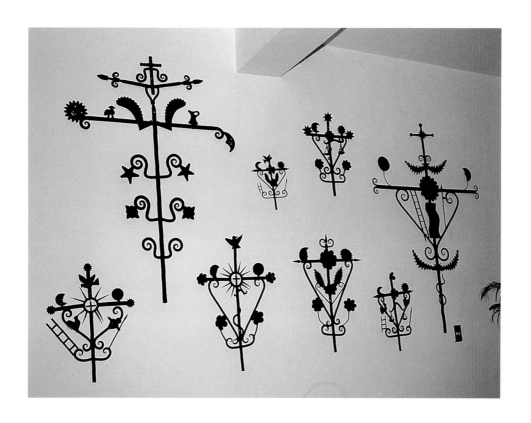

WALL DISPLAY.
Local craft as decoration in
Hotel Ciudad Real on the Plaza
in San Cristóbal de Las Casas.

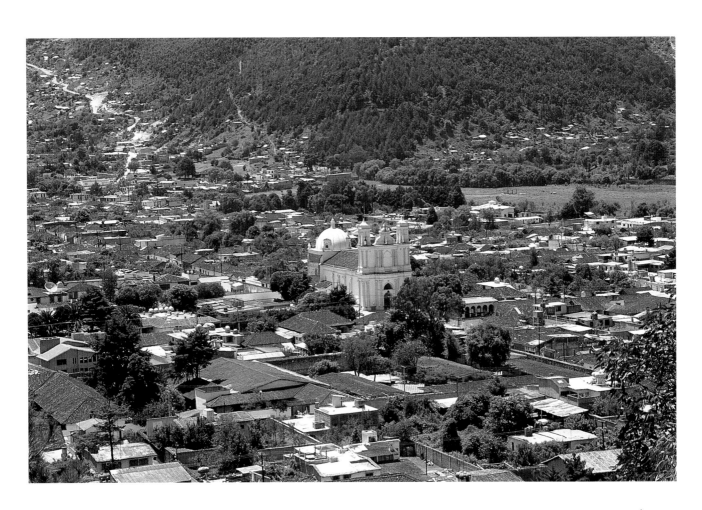

BARRIO DE SANTA LUCÍA.
View looking east from Cerrito
de San Cristóbal on to the tile-
roofed houses of this residential
barrio.

BARRIOS OF SAN CRISTOBAL DE LAS CASAS:
A WALKING TOUR

Travelers to San Cristóbal de Las Casas today can purchase a souvenir cross in one of the local tourist shops, seek out an ironworker who will handcraft a cross on special order, study the examples described in the Frans Blom Iron Roof Cross Collection at Na Bolom, or discover those still on roofs of houses scattered throughout the various barrios. If time permits, viewing the extant examples in situ offers the best opportunity to appreciate roof crosses as they were originally designed: the lower point hidden within the roof tiles with the cruciform profile soaring towards the ever-changing complexion of the open sky.

A stroll through any of the older barrios that fan outwards in all directions from the Plaza Central, often referred to as the Parque, rewards the walker with views of roofs with iron crosses as well as a number of wooden ones. A total of 450 roof crosses on private dwellings have been recorded to date (1998): 251 of iron, 189 of wood, and 10 of cement. Of these, 220 iron, 151 wood, and 8 cement roof crosses are located in the barrios included in the walking tour. These numbers change as crosses are removed, added, or fall into disrepair. Additional ones can be found atop churches, in newer *colonias* and barrios on the periphery of town, in private collections, or on buildings hidden behind high walls that line the city streets. Although all the crosses are in varying stages of preservation, those

visible from the street are apt to be in a more fragile state than ones protected from the weather. Some rest on their side along roof ridges where they were once carefully installed, while others have broken or missing finials or other parts on the extensions or ornaments. Often only a segment of an upright protrudes from a sagging roof, offering a mere hint of the original style of a cross. Nevertheless, a few dating to the early 1900s survive undamaged, carefully tended through four to five generations on the same roof or moved from one roof to another as families changed residences.

However, even crosses that have withstood the ravages of time are not safe from accidental damage due to falling objects. For example, the finials and ornaments often are broken by the *cohetes* used in barrio festivals. As these homemade skyrockets, composed of a long reed tail topped by a cane cylinder packed with gunpowder, explode with a thundering blast, the tails spin to earth under considerable force, striking roof crosses and breaking the tips of finials or other fragile ornaments. Crosses installed on roofs within the last twenty years, most belonging to Style VII and occasionally to Style VIII, are usually intact. Larger versions of crosses in Style VIII, reaching over a meter in height, waver precariously in the wind because they lack the long point to anchor them properly to the roof. Although they make a remarkable silhouette against the sky, they appear top heavy and out of proportion in contrast to those in other styles that complement the low profiles of the traditional wood and tile roofs.

To truly appreciate each cross, using binoculars, if possible, look at it in terms of its components: the cruciform, in either a solid or open design, and the ornaments or absence of decoration that identify its style. Observe the shape of the finials: a floral pattern typical of a lotus, fleur-de-lis, tulip, or rosette; a representative object such as a crown, cluster of grapes, lance point, nail, dome or tower. Identify the motifs, such as those originating from the heraldic tradition in *moline, botonée, pattée*, or ovate patterns. Note that occasionally the apical finial of the upright is different from those of the arms, often shaped as a bird. Notice the array of ornaments and the placement of lateral extensions that compose the unifying theme.

Further, observe how the crosses are installed. Ten to fifteen centimeters of the point are usually embedded in cement on the raised line of *tejas*

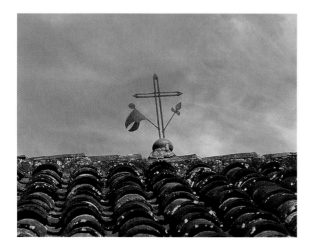

that form the roof ridge. Some sit higher above the peak, revealing more of the point and giving additional height to the cross, while others sit flat on their bases at the level of the ridge of the roof. A few hover above a ceramic *olla* filled with cement into which the point is inserted and which over time may have disintegrated, leaving a mound of cement that appears as a rounded pedestal for the cross. Occasionally, several ceramic shards can be detected around the concrete mold. As you scan the rooftops, look carefully at the end of the line of *tejas* that courses along the ridge, the spot where the *albañil* (stonemason) might have scratched a small cross into *la culata del canal*, the cement plug, before it dried. A discerning eye can detect these miniature crosses even if they are obscured by the natural discoloration of the concrete.

In addition, give some attention to the less dramatic wooden roof crosses. Although many are fashioned with two simple boards nailed together at the axis, others are carefully turned on a lathe. The finials also vary from those carved in a trefoil motif to some with enlarged lobes at the ends or that are gently forked. Although the Latin cross is the favored cruciform, some are in the shape of a Greek cross or a patriarchal cross. Finding and identifying the form add interest to viewing the seemingly similar wooden crosses, most of which are weatherworn, have a finial or arm missing, and

CROSS IN AN *OLLA*.
An alternate method of installing a roof cross: mounted within an *olla,* Barrio del Cuxtitali.

LA CULATA DEL CANAL.
A cross scratched into the cement plug at the end of the roof ridge as a sign of the *albañil's* work or a blessing on the house, Barrio de Cerrillo.

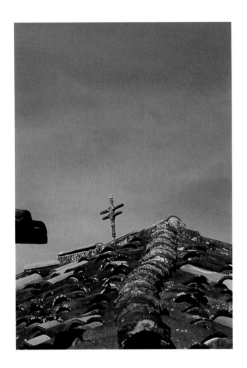

PATRIARCHAL CROSS.
A wooden cross from Barrio de
Cuxtitali.

are encrusted with moss. As an alternative to wood, some innovative residents have erected cement roof crosses to attain a more permanent fixture on their roofs. It is often difficult to distinguish between the two materials since the moss-covered wooden crosses can resemble those made of cement. The latter are formed by wiring two bars of *varilla* (reinforcing iron) into the shape of a cross. A wooden frame that outlines the desired size is then built around the iron cruciform, with a piece of the iron upright left free at the base to serve later as the roof attachment. Cement is then poured into the prepared mold and allowed to set. When the wooden framework is removed, the cross is ready for installation. Using this method, a homeowner can vary the size of a cross according to the roof dimensions.

The attentive walker with an eye for what to look for and where to find it will easily locate examples of most roof cross styles in the older barrios of the city. The majority of these will be those of STYLE I, STYLE III, and STYLE V, since only three examples of STYLE IV are still on roofs: two in Barrio de los Mexicanos and one in Barrio de la Merced. What follows are suggestions as to where the largest number can be found within a comfortable radius of the center of San Cristóbal. The eleven barrios selected represent the older and more traditional districts where there are more roof crosses. You can begin your walking tour at the entrance to Na Bolom on the corner of Avenida Vicente Guerrero and Calle Comitán. Viewing the Frans Blom Iron Roof Cross Collection will familiarize you with most of the styles you will encounter on your walk. From Na Bolom, Calle Comitán leads west as it bisects Barrio del Cerrillo, where you will find the greatest concentration of roof crosses. Or you can go north to the next corner, Calle Chiapa de Corzo, turn right or east along Calzada Frans Blom, and proceed into Barrio de Cuxtitali.

Yet another spot from which to begin is at the Plaza Central, or Parque, where you can choose one of four directions in which to walk. Before you set off from here, however, take an opportunity to visit several public places near the Parque where iron crosses are used as decorative items and samples of regional crafts. For example, the Tourist Information Office on the ground level of the Palacio Municipal at the west corner of the Parque has a large iron cross on display. Or turn to the north and scan the side of the

REJA.
Colonial ironwork on a south-facing window of the cathedral in San Cristóbal de Las Casas, Zona Central.

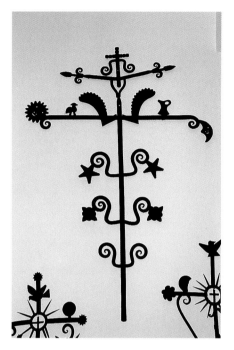

ROOF TO WALL CROSS.
In the 1960s, ironworkers began to forge crosses for wall decorations in STYLE VII, larger in size and without the point; from the collection at Hotel Ciudad Real in the Zona Central, San Cristóbal de Las Casas.

cathedral that parallels the Parque to find the wrought-iron grill that shields a window on that side. At the top of this grill, dating to the early eighteenth century, is a stunning example of a cross, perhaps once used as inspiration for roof crosses. Then cross the street on the south side of the Parque to the Hotel Ciudad Real, where a collection of eight crosses adorns the west wall of the restaurant. A short walk north along Avenida General Utrilla to the northeast corner of Calle María Adelina Flores takes you to the annex of the Posada Diego de Mazariegos, where two striking examples of contemporary-style roof crosses hang on the courtyard wall. Both, made as wall ornaments, are over a meter and a half in height.

After returning to the Plaza Central, you can either head east along Calle Real de Guadalupe into Barrio de Guadalupe or west down Calle Diego de Mazariegos into Barrio de la Merced. You can also walk south along Avenida Insurgentes into Barrio de Santa Lucía, or north along Avenida General Utrilla to the Churches of Santo Domingo and La Caridad, which divide Barrio del Cerrillo to the east and Barrio de los Mexicanos to the west. With a little more effort, you will also discover a scattering of roof crosses on houses in adjacent barrios. Although fewer roof crosses are found in these barrios located farther from the center of the city, such as Barrio de San Ramón, Barrio de San Diego, Barrio de Tlaxcala, and Barrio de San Antonio, they are well worth a visit. These districts may appeal to the more energetic walker.

Each barrio has its own church set off from the street by a small plaza. These Catholic churches, occasionally referred to as *templos*, have the same name as the barrio and define community identity for the residents, who gather there once a year to celebrate the feast of their patron saint, often the saint after whom the barrio is named. This fiesta is celebrated on the saint's day designated on the Catholic calendar, preceded by a novena, nine days of special prayers and religious services. In August, a particularly festive month for these rituals, four major celebrations occur: 6 August in Barrio del Cerrillo, the Feast of the Transfiguration; 15 August in Barrio de los Mexicanos, the Assumption of the Blessed Virgin; 18 August in Barrio de Tlaxcala, the Coronation of the Blessed Virgin; and 31 August in Barrio de San Ramón, the Feast of Saint Raymond Nonato. In addition, on 18 August *La Señora del Rayo* is honored in the cathedral, and the patron saint

of the Dominican Order, Santo Domingo, is feted on 8 August in the Church of Santo Domingo. Each celebration is preceded by a novena in the church dedicated to the saint, where the dates and times of the events are posted on the main doors. On these mornings the entire city awakens at dawn to the sound of exploding *cohetes* announcing the beginning of a new day's activities.

Although the churches are not always open, they serve as an orientation point to each barrio and provide an inviting place to rest in the area of the plaza. For more details on the history and architectural style of these barrio churches, refer to *Architecture and Urbanization in Colonial Chiapas, Mexico,* by Sidney David Markman or the useful guidebook by Richard D. Perry, *More Maya Missions: Exploring Colonial Chiapas.* Yet another book by local historian Andrés Aubry, *San Cristóbal de Las Casas: su historia urbana, demográfica y monumental, 1528–1990*, offers excellent background information on the history of the city and its residents.

The following descriptions and maps of individual barrios provide only a guide to where the largest number of roof crosses recorded to date can be seen from the streets. A serendipitous turn in any of them, however, may lead to a newly installed cross or one not yet documented. Note that the names of the barrios are often included on the street signs placed on the upper corners of buildings at intersections and that the names of the streets change relative to the cardinal directions at the Plaza Central. For example, Calle Diego de Mazariegos and Calle Francisco Madero are the streets where the north-south running *avenidas* cross and change their names, and Avenida General Utrilla and Avenida Insurgentes are where the east-west *calles* take on different names.

Walks through these neighborhoods offer an intimate glimpse into the daily habits of the *coletos*, the longtime residents, and the folklore that governs their tide of life in San Cristóbal. Along the way you will undoubtedly encounter ambulant vendors selling fruits and vegetables from house to house, local Indians carrying armfuls of bright flowers or sacks of charcoal to market, teams of donkeys laden with neatly bundled firewood that supplies the cooking fuel for more than half the houses in the city competing with noisy gas trucks loaded with gas cylinders for the other half, as well as speeding taxis plying the streets in search of fares. And if it happens

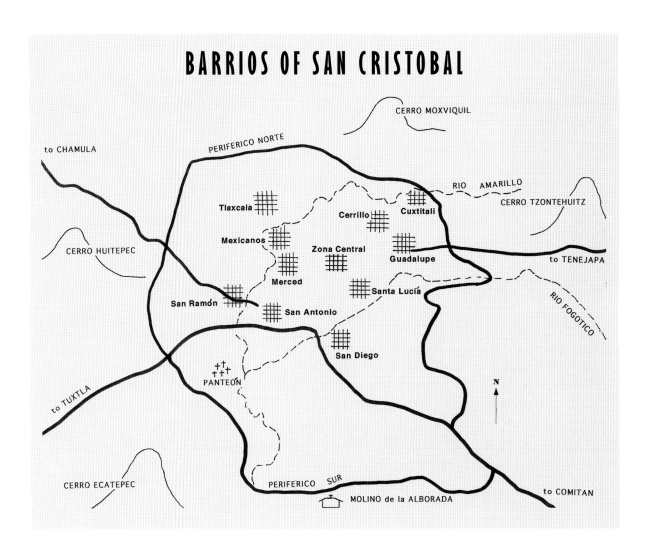

BARRIOS OF SAN CRISTOBAL

CERRO MOXVIQUIL

to CHAMULA

PERIFERICO NORTE

RIO AMARILLO

CERRO TZONTEHUITZ

Tlaxcala

Cerrillo

Cuxtitali

CERRO HUITEPEC

Mexicanos

Zona Central

Guadalupe

to TENEJAPA

Merced

Santa Lucía

San Ramón

San Antonio

RIO FOGOTICO

San Diego

PANTEON

N

to TUXTLA

CERRO ECATEPEC

PERIFERICO SUR

to COMITAN

MOLINO de la ALBORADA

to be a Saturday afternoon, along your route you will see some houses with a red lantern above their doorway, indicating that tamales, wrapped in banana leaves or cornhusks depending on the filling and concocted in private kitchens according to age-old recipes, are for sale there for a gathering of friends and family to eat traditional food. You may even come across a strolling group of guitar-playing minstrels followed by devotees bearing candles in honor of a favorite *santo*. On occasion, you can observe a similar procession where an image of a saint is carried to a house in the barrio to be tended by the occupants for the coming year. You may also see large black satin ribbons tied in neat bows above doorways to indicate a death has occurred in the household. And if you are especially observant you may notice how some residents bless themselves with the sign of the cross as they leave the safety of their homes and venture into the streets or make a similar gesture out of respect when they pass in front of the barrio church. Such encounters provide a perspective into the deeply religious environment in which the roof cross tradition evolved and has persisted through the centuries.

As you pause to examine a roof cross in more detail, the owner of the house may appear in the doorway with a quizzical expression. From my own experience in all the barrios, the residents welcome strangers who express interest and admiration for what to them is a significant symbol of their faith. They may even offer to tell you about their roof cross and what it means to them. If you wish to take a photograph of the cross, asking the owner's permission is recommended. And when your conversation is ended, they will undoubtedly send you on your way with the familiar wish extended to those passing by: "*Que le vaya bien.*"

ZONA CENTRAL

ESCUADRON 201

C. 28 de AGOSTO

C. EJERCITO NATIONAL

C. PRIMERO de MARZO

AV. 20 de NOVIEMBRE

AV. GENERAL UTRILLA

AV. CRISTOBAL COLON

C. MARIA ADEL. FLORES

CATHEDRAL

AV. 5 DE MAYO

C. GUADALUPE VICTORIA

C. REAL de GUADALUPE

PLAZA

C. DIEGO de MARZARIEGOS

C. FRANCISCO MADERO

C. CUAUHTEMOC

AV. INSURGENTES

AV. IGNACIO ALLENDE

TEMPLO de SAN CRISTOBAL

C. NINOS HEROES

C. FRANCISCO LEON

N

[BARRIO de la MERCED]

[BARRIO de GUADALUPE]

[BARRIO de SANTA LUCIA]

AT THE HEART OF THE CITY stands the commercial district, Zona Central, dominated by the tree-lined Plaza Central and the cathedral. The major streets and avenues that enter the town converge here and change names as they flow from east to west and from north to south. At the Plaza Central, named Plaza 31 de Marzo in commemoration of the city's founding date of 1528, Avenida Insurgentes entering from the south becomes Avenida General Utrilla, which leads north to the daily outdoor market; Calle Diego de Mazariegos comes from the west and changes to Calle Francisco Madero; and Calle Real de Guadalupe originating at the steps of the church dedicated to the Virgin of Guadalupe becomes Calle Guadalupe Victoria. The Plaza Central is surrounded by a two-block-square area that includes the colonial cathedral, the Church of San Nicolás, the original home of Diego de Mazariegos, several modest-sized hotels, banks and shops, the recently remodeled Teatro Zebadúa, built in 1931 and restored in 1995, and the Palacio Municipal, which houses governmental offices. The Parque gained worldwide attention on 1 January 1994 when a small group of Indians belonging to the Zapatista Army of National Liberation seized this civic center of San Cristóbal de Las Casas in protest against the national policies of the Mexican government. Thus began the latest revolution in Mexico's long history of social upheavals.

CHURCH OF SAN NICOLÁS. One of the oldest colonial churches of San Cristóbal de Las Casas, in Zona Central.

The cathedral, dedicated to Our Lady of the Annunciation, stands opposite the northwest corner of the Parque. Construction dates to 1533, but the impressive church that we see today has undergone many stages of reconstruction over the centuries. Since the first meetings to establish dialogues between representatives of the Zapatista Army and the Mexican government occurred here soon after the start of the 1994 Rebellion, it is now referred to with hope as the "Cathedral of Peace." Adjacent to the cathedral on the northeast corner is the Church of San Nicolás, constructed between 1613 and 1620 and restored in the early 1970s and in 1997 after incurring earthquake damage. It no longer functions as an active church but is now a museum for the Archdiocese of San Cristóbal. From its entry can be seen the winding outdoor staircase to the west that leads to the upper floor of the cathedral and the Archives of the Archdiocese. The residence of the bishop of San Cristóbal is located on the front side and northernmost extension of the west-facing cathedral.

The streets that traverse Zona Central are named after leading figures, as well as significant political dates and events in the history of the city and state. The northern boundaries are formed by Calles Ejército Nacional, Escuadron 201, and 28 de Agosto; Calle Francisco Leon and Calle Niños Heroes mark the southern limits; Avenida Cristóbal Colon defines the eastern border; and the western line is drawn by Avenida 5 de Mayo and Avenida Ignacio Allende. Zona Central is surrounded by Barrio de Guadalupe to the east, Barrio de Santa Lucía to the south, Barrio de la Merced to the west, and Barrio de los Mexicanos and Barrio del Cerrillo to the north. A *paseo* for pedestrians created in 2001 and inaugurated as "Andador Turistico" extends from the Church of Santo Domingo, passing in front of the cathedral and ending at the Church of El Carmen. Using the *andador* reduces the traffic noise in the center of town and allows for a better view of rooftops.

Because the majority of the buildings in Zona Central are now used for commercial purposes, there are fewer private residences and thus roof crosses than in neighboring barrios. Fifteen roof crosses of iron and seven of wood have been documented here. Although these are on buildings scattered throughout Zona Central, the best examples can be viewed along Avenida General Utrilla, Avenida 20 de Noviembre, Calle Primero de Marzo, and Calle Cuauhtémoc.

BARRIO DEL CERRILLO

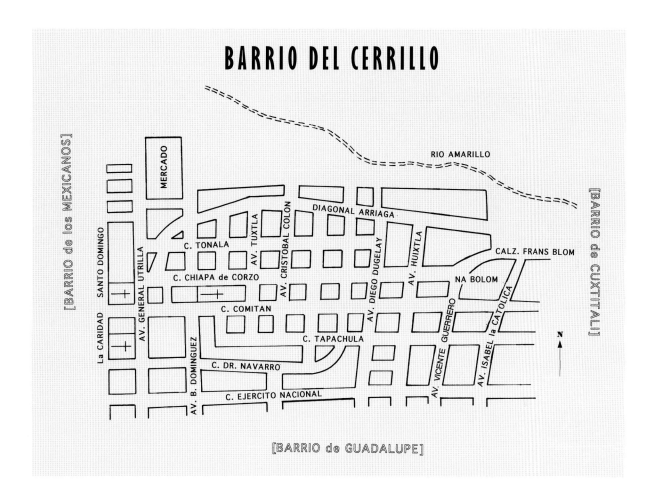

[BARRIO de los MEXICANOS]

[BARRIO de CUXTITALI]

RIO AMARILLO

MERCADO

SANTO DOMINGO

La CARIDAD

AV. GENERAL UTRILLA

C. TONALA

AV. TUXTLA

AV. CRISTÓBAL COLON

DIAGONAL ARRIAGA

AV. DIEGO DUGELAY

AV. HUIXTLA

CALZ. FRANS BLOM

NA BOLOM

C. CHIAPA de CORZO

C. COMITAN

AV. B. DOMINGUEZ

C. TAPACHULA

AV. VICENTE GUERRERO

AV. ISABEL la CATOLICA

C. DR. NAVARRO

C. EJERCITO NACIONAL

N

[BARRIO de GUADALUPE]

BARRIO DEL CERRILLO was established for the Tzotziles and Tzeltales, the original inhabitants of the Valley of Jovel. When the Spaniards arrived, they indentured these Maya-speaking Indians as manual laborers for the construction projects needed to establish the town. Largely due to the advocacy of Fray Bartolomé de Las Casas, who exposed the slavery-like bondage under which these indigenous Indians lived, they were granted freedom in 1549. After twenty years of servitude, they were placed under the stewardship of the Dominican friars, who set aside Barrio del Cerrillo, near the Church of Santo Domingo, for those who preferred to remain in town rather than return to their own communities. During the

BARRIO DEL CERRILLO.
Residents gather to honor
the patron of their barrio
on August 6.

colonial period, the barrio remained under the aegis of the Dominicans and the Church of Santo Domingo. A chapel existed on the current site of the barrio church as early as 1737, when the district was referred to as Barrio de Santo Domingo del Cerrillo.

Major construction on the present Church of El Cerrillo, located between Calle Comitán and Calle Chiapa de Corzo, started in 1835. Dedicated to *La Transfiguración del Señor* (the Transfiguration of the Lord), the feast is celebrated on 6 August each year. A large iron cross stands at the center of its high façade, which bears a remodeling date of 1890, and a smaller one is located on the east end of the church. The chapel faces west toward the Church of Santo Domingo and a plaza with an ornate bandstand topped with an iron weather vane decorated with figures of a sun, moon, and rooster. The barrio is bordered on the west by Avenida General Utrilla, which leads from the Parque in Zona Central to the outdoor market, Diagonal Arriaga on the north, Calle Dr. Navarro and Calle Ejército Nacional on the south, and Avenida Isabel la Católica on the east.

El Cerrillo, established as the center for the ironwork trade, is still the location of several ironworkers' shops, as well as Na Bolom. Almost 25 percent of the 220 extant iron roof crosses within the barrios described here, or 53, can be seen on houses in this district. Another 13 roof crosses of wood have also been documented. Most of the streets of this primarily residential barrio are named after major cities in the state of Chiapas. A walk along almost any street offers a view of iron roof crosses, with the majority located on Calle Chiapa de Corzo, Calle Comitán, Calle Tonalá, and Calle Tapachula.

BARRIO DE CUXTITALI

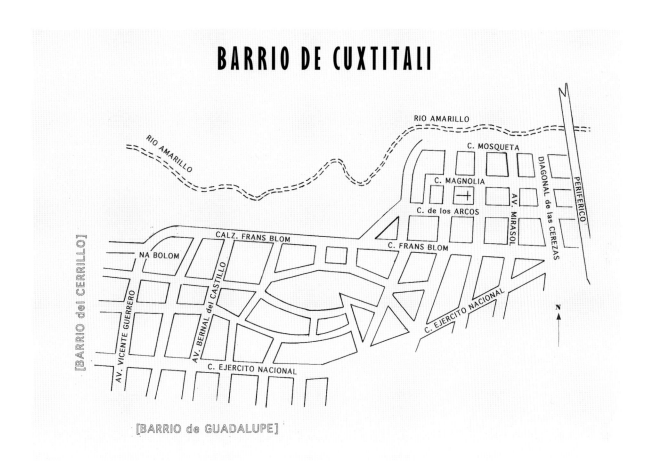

TWO BARRIOS, situated at the east and south entrances to the Valley of Jovel, were set aside to accommodate the Indians from Guatemala who left their homeland to accompany Pedro de Portocarrero on his expedition to claim Chiapas for el Reino de Guatemala. One of these, Barrio de Cuxtitali, provided a protective barrier at the northeastern edge of the new settlement. Of all the barrios, it preserves the most rustic ambience, with few paved streets and many narrow paths that meander away from an intimate church plaza. The covered bridge of Peje de Oro, which spans Río Amarillo near a colonial mill on the northern perimeter, served for centuries as one of the primary entrances to the city. Today, it is limited to foot traffic, used primarily by the Tzotziles when they come into town from

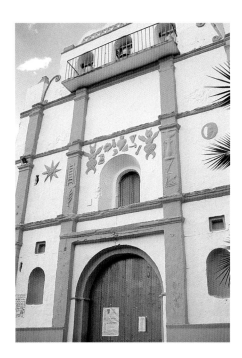

BARRIO DE CUXTITALI.
Symbols of the Passion and the Crucifixion adorn the stucco on the façade of the barrio church.

their mountain communities on Saturdays and Sundays with their wares of wooden furniture, loads of charcoal, and carts of lumber.

A conservative and self-contained atmosphere prevails throughout Barrio de Cuxtitali, where one finds few businesses. Renowned for pig raising and the production of pork products, residents tend small numbers of these animals in their backyards. Only within the last five years, due to population pressure, have newer and more spacious houses been built among the adobe dwellings. Streets and paths are named after flowers and fruits, with a few honoring local figures. Calzada Frans Blom, for example, begins at the corner near his former home, Na Bolom, becoming one of the main thoroughfares into the barrio.

A small plaza fronts the church, located between Calle de los Arcos and Calle Magnolia, which serves as the focal point for the barrio. Dedicated to *El Dulce Nombre de Jesús* (Holy Name of Jesus), it is newly painted each year in honor of this feast celebrated on 1 January. On its façade are stuccoed images in relief of the sun, moon, and implements of the Passion and the Crucifixion, reminiscent of those figures frequently adorning roof crosses. Calzada Frans Blom and Calle Mosqueta form the northern limits, with Calle Ejército Nacional providing the southern line, Avenida Bernal del Castillo the western boundary, and the Periférico the eastern border. Volkswagen vans used for public transportation, or *combis,* continually service Barrio de Cuxtitali, entering Calzada Frans Blom and exiting through Calle Ejército Nacional. Since 1997, when a paved road was cut through to the Periférico on the eastern edge, traffic has increased in this once quiet barrio. The majority of the twenty-one iron crosses in the area are found on house roofs along Calzada Frans Blom and Calle de los Arcos. Ten wooden and two cement crosses can be seen on the smaller unpaved streets that lead off these two main roads.

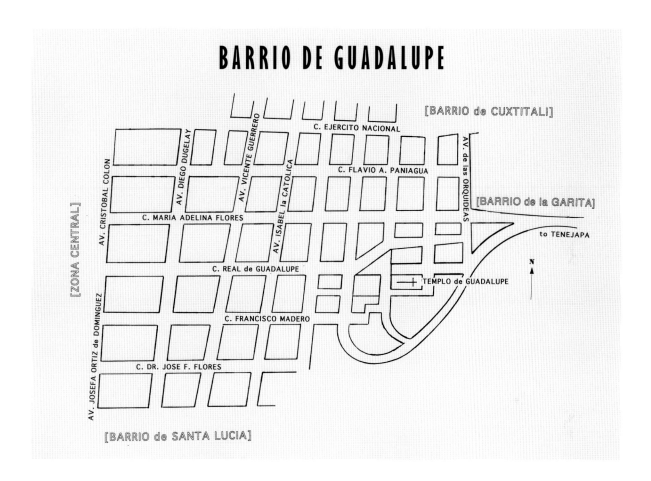

BARRIO DE GUADALUPE

[BARRIO de CUXTITALI]

C. EJERCITO NACIONAL

AV. CRISTÓBAL COLON

AV. DIEGO DUGELAY

AV. VICENTE GUERRERO

AV. ISABEL la CATOLICA

C. FLAVIO A. PANIAGUA

AV. de las ORQUIDEAS

[BARRIO de la GARITA]

[ZONA CENTRAL]

C. MARIA ADELINA FLORES

to TENEJAPA

C. REAL de GUADALUPE

N

TEMPLO de GUADALUPE

AV. JOSEFA ORTIZ de DOMINGUEZ

C. FRANCISCO MADERO

C. DR. JOSE F. FLORES

[BARRIO de SANTA LUCIA]

BARRIO DE GUADALUPE was founded around 1848 to accommodate the growing population in nearby Barrio del Cerrillo. Its church, constructed in 1854 and dedicated to the Virgin of Guadalupe, dominates the eastern skyline from a high hill that overlooks the city. In 1931, the image of the Virgin was officially crowned and the dome of the church inaugurated. This year marked the beginning of the custom of *peregrinaciones*, in which runners and pilgrims come here from throughout Chiapas, some carrying torches, to pay tribute to the Virgin of Guadalupe on her feast day of 12 December.

Another custom that started in the mid-1800s to mark the founding of the barrio involved a horseman who rode from the Church of San Nicolás on

RELIGIOUS SYMBOLS. Implements of the Passion and the Crucifixion painted on a wooden cross in front of the Church of Guadalupe.

the Plaza Central up Calle Real de Guadalupe to the steps of the church carrying the national flag and flanked by groups of young Ladino children dressed in the traditional clothing worn by local Indians. This custom continues today on 10 December in the parade referred to as *la subida de los indios*, when local townspeople dress their children in Indian costumes and escort them along Calle Real de Guadalupe to the church, where with flowers in hand they promenade in front of the statue of the Virgin. At the north side of the atrium of the church, stands a tall wooden cross, painted green and mounted on a high concrete platform. Although its rounded finials are reminiscent of those in the neighboring indigenous communities, this cross is decorated in a different manner. Christian symbols, including implements of the Passion and the Crucifixion, are painted on the arms and upright, rather than the floral patterns incised on the wooden crosses erected in nearby Indian communities. Its prominent position in this important pilgrimage site offers an example of how folk and orthodox Catholicism blend in this region.

A long flight of steps leads from the church down to a small plaza, where Calle Real de Guadalupe begins. This broad thoroughfare, bisecting the barrio and ending at the Plaza Central, is one of the major commercial streets of San Cristóbal. The street is known for local arts and crafts shops, small cafés, and economical *posadas*, or inns, for travelers. Barrio de Guadalupe is bounded by Calle Ejército Nacional to the north, Calle Dr. José F. Flores at the south, Avenida de las Orquideas on the east, and Avenida Cristóbal Colon and Avenida Josefa Ortiz de Domínguez on the west. The barrio, surrounded by Barrio de la Garita to the east, Barrio de Santa Lucía at the south, Barrio de Cuxtitali on the north, and Zona Central to the west, is a well-maintained district with several large colonial houses and a prosperous commercial district. This barrio is renowned for its cottage industries of wooden toys, leather goods, and candy making, sold, along with other local crafts, in the cluster of shops that line Calle Real de Guadalupe.

Of the forty roof crosses in Barrio de Guadalupe, twenty-three are of iron, fourteen of wood, and three of cement. Those in iron, displaying some remarkable and varied styles, are on houses scattered among the wide

streets, which are named to honor leading political and literary figures of Chiapas. The best streets for viewing roof crosses are Calle Francisco Madero and Calle María Adelina Flores.

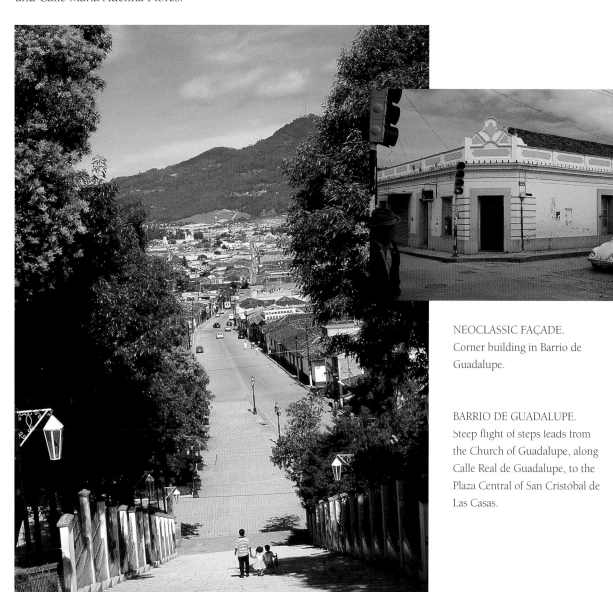

NEOCLASSIC FAÇADE.
Corner building in Barrio de Guadalupe.

BARRIO DE GUADALUPE.
Steep flight of steps leads from the Church of Guadalupe, along Calle Real de Guadalupe, to the Plaza Central of San Cristóbal de Las Casas.

BARRIO DE LA MERCED

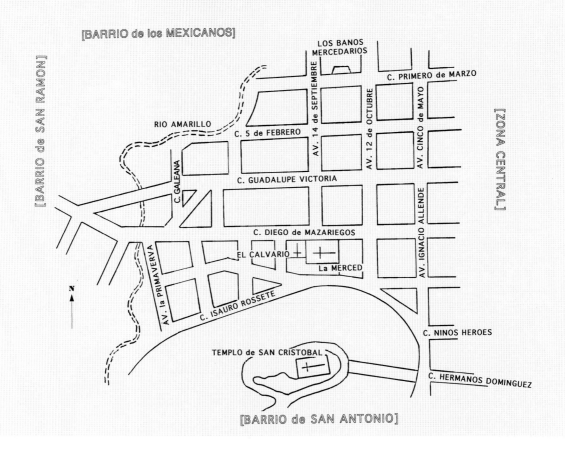

[BARRIO de los MEXICANOS]

[BARRIO de SAN RAMON]

[ZONA CENTRAL]

LOS BANOS MERCEDARIOS

C. PRIMERO de MARZO

RIO AMARILLO

C. 5 de FEBRERO

AV. 14 de SEPTIEMBRE

AV. 12 de OCTUBRE

AV. CINCO de MAYO

C. GALEANA

C. GUADALUPE VICTORIA

AV. IGNACIO ALLENDE

C. DIEGO de MAZARIEGOS

EL CALVARIO

La MERCED

AV. la PRIMAVERVA

C. ISAURO ROSSETE

N

C. NINOS HEROES

TEMPLO de SAN CRISTOBAL

C. HERMANOS DOMINGUEZ

[BARRIO de SAN ANTONIO]

BARRIO DE LA MERCED, one of the first habitation sites established at the founding of San Cristóbal de Las Casas, was originally the district for those who provided household service to the Spanish families living in Zona Central. Located to the north and to the south of Calle Diego de Mazariegos, which divides it, the barrio becomes an entrance to San Cristóbal from the west. The Church and Convento of La Merced (Our Lady of Mercy), the first Mercedarian house founded by this religious order in the New World, are the most impressive architectural features of the barrio. The *convento*, established in 1537, housed the friars who administered to the religious needs of the Spanish settlers. When the friars eventually left the territory, the *convento* served for many years as a jail and the central offices of the Procuraduro de Justicia, until, early in the 1990s, these services were moved along with other administrative offices to a new civic center located near Barrio de San Diego, south of the Pan American Highway and adjacent to the old airport of San Cristóbal. Today, the former *convento* has been renamed Centro Cultural La Merced and is occupied by the Museo del Ambar de Chiapas as well as various workshops for local crafts. The plaza in front of the Church of La Merced, a former site for the daily outdoor market that was moved to the north end of town in the 1970s, now provides an inviting public space for the neighborhood.

Two other prominent buildings are located in Barrio de la Merced: the Museo de Culturas Populares on the north side of Calle Diego de Mazariegos across from the plaza in front of the Church of La Merced, and Los Baños Mercedarios at the northern edge of the barrio along Calle Primero de Marzo. A replica of Cross 13 from the Frans Blom Iron Roof Cross Collection can be seen on the roof of Los Baños Mercedarios.

The barrio, known for its silversmiths, tinsmiths, and candlemakers, is also home to other craftsmen, mostly carpenters and electricians. These small businesses serve as the backdrop for a congenial blend of private residences, home workshops, and a few commercial stores. Río Amarillo courses along the western edge of the barrio. It is bordered on the north by Calle Primero de Marzo, on the south by Calle Isauro Rossete, on the east by Avenida Cinco de Mayo and Avenida Ignacio Allende, and on the west by Avenida la Primavera and Callejon Galeana. Barrio de la Merced, whose

REPLICA OF CROSS 13.
Two crosses on the roof of Los Baños Mercedarios in Barrio de la Merced, San Cristóbal de Las Casas. A wooden cross partly obscures the details of the iron cross, a copy of one in the collection at Na Bolom.

patroness *La Virgen de Merced* is honored on 24 September, is surrounded by Barrio de San Ramón to the west, Barrio de los Mexicanos to the north, Barrio de San Antonio to the south, Barrio de Santa Lucía to the east, and Zona Central. Twenty-four iron and nine wooden roof crosses can be found in Barrio de la Merced, the majority located along Calle 5 de Febrero.

The little church of El Calvario, tucked off Calle Diego de Mazariegos in the shade of the Church of La Merced, provides a pleasant retreat from the busy street. On the upper façade of this small eighteenth-century chapel that once belonged to the Franciscan Order, is a large stucco cross decorated with the implements of the Crucifixion in keeping with its advocation of *El Calvario* (Calvary). The iron gate that leads off the street to a small courtyard in front of the church is often locked, but when open the patio is well worth a visit as it affords a prime view of the iron cross on the apse of the Church of La Merced as well as the one on the façade of El Calvario.

Residents of this barrio occasionally fabricate their own version of a roof cross. Even when this occurs, the homemade cross, while creative and individualized, still follows the basic styles of roof crosses. One such example appears on the periphery of Barrio de la Merced along Calle Guadalupe Victoria near the bridge leading into Barrio de San Ramón. Produced of flat solid iron, four to five centimeters wide, it is shaped like a plain Latin cross with perfect circles punched out along the arms and vertical bars, and simple floral finials added to the arms and upright.

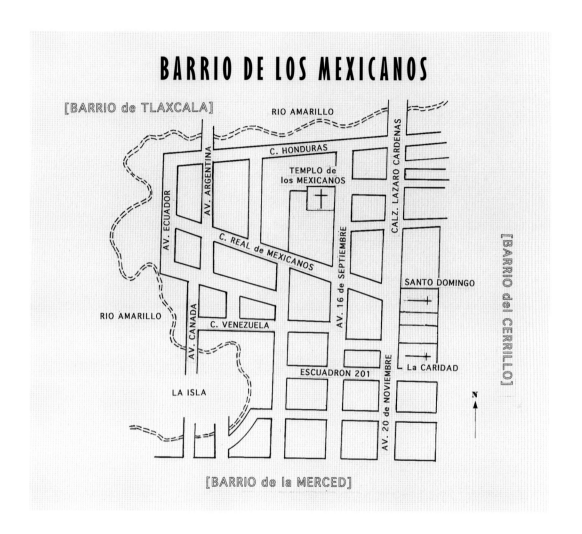

BARRIO DE LOS MEXICANOS

[BARRIO de TLAXCALA]

RIO AMARILLO

AV. ECUADOR

AV. ARGENTINA

C. HONDURAS

CALZ. LAZARO CARDENAS

TEMPLO de los MEXICANOS

C. REAL de MEXICANOS

AV. 16 de SEPTIEMBRE

SANTO DOMINGO

[BARRIO del CERRILLO]

RIO AMARILLO

AV. CANADA

C. VENEZUELA

La CARIDAD

ESCUADRON 201

AV. 20 de NOVIEMBRE

LA ISLA

N

[BARRIO de la MERCED]

BARRIO DE LOS MEXICANOS, one of the oldest districts in San Cristóbal de Las Casas, was established in 1528 for the Indians recruited from the Valley of Mexico who served in the army of Diego de Mazariegos. While these Indians maintained a harmonious relationship with the Spaniards, who depended on them as servants as well as craftsmen, they considered themselves "conquerors" and thus superior to the original Maya inhabitants of the valley. A covered bridge over Río Amarillo, reconstructed in 1995, connects Barrio de los Mexicanos with neighboring Barrio de Tlaxcala.

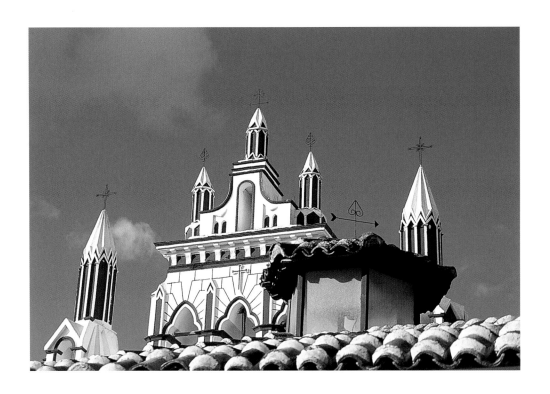

CHURCH OF MEXICANOS.
Iron crosses embellish the towers
of the church in one of the oldest
barrios in San Cristóbal de Las
Casas.

Barrio de los Mexicanos is home today, as it was in colonial times, to weavers, dyers, tanners, and tile makers. Until recently, one of the few remaining ironworkers maintained his *herrería* here. Most of the streets and avenues are named after countries of the Americas. Calle Honduras forms the northern border of the barrio; Calle Venezuela and Calle Escuadron 201 run along the southern edge; Avenida Cañada and Avenida Ecuador run parallel to the Río Amarillo at the western edge; and Calzada Lazaro Cárdenas separates the barrio on the east from the expansive plaza that surrounds the colonial Church of Santo Domingo and Church of La Caridad. Early each morning Indian vendors cover this space with their handwoven textiles laid out in a rainbow of colors to attract strolling tourists.

For centuries, the Church of Santo Domingo and the neighboring Church of La Caridad provided a physical barrier between Barrio de los Mexicanos and Barrio del Cerrillo. Any foot traffic that moved between these barrios had to pass through the center of town so that the Spaniards could monitor the activities of the Indians. In the early 1800s, a walkway

was established between the two churches to connect the neighboring districts. The Church of Santo Domingo, with its extraordinary façade and impressive *convento*, is crowned with some of the oldest ironwork in San Cristóbal.

The façade of the Church of Mexicanos, nestled in a small plaza at the north end of the barrio, bears the date 1904. This plaza and church come to life on 15 August in celebration of the patroness, *La Asunción de la Virgen* (The Assumption of the Virgin). The ironwork here is remarkable, especially the five magnificent crosses that crown the bell towers of the church and the weather vane that tops the large bandstand. The church is located in a quiet spot, just off Calle Real de Mexicanos, the main thoroughfare of the barrio that originates near the steps of the Church of Santo Domingo along Calzada Lazaro Cárdenas.

Barrio de los Mexicanos is an active barrio with its own primary school near the river on Avenida Ecuador and Calle Honduras. Many residents have workshops in their houses and offer such services as *piñata* making, upholstery work, weaving and dying cloth, and carpentry. Television antennas and satellite dishes spring from the roofs of both older and modern houses. Of the fifty-seven roof crosses scattered throughout Barrio de los Mexicanos, twenty-five are of iron and thirty-two of wood. The most visible crosses are found along Calle Real de Mexicanos, Calle Venezuela, and Avenida 16 de Septiembre.

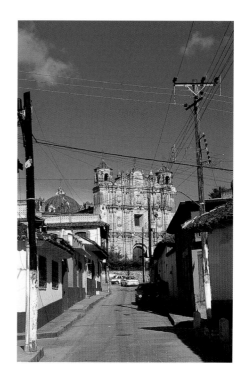

SANTO DOMINGO.
Ornate façade of Santo Domingo dating to the late 1600s faces west towards Barrio de los Mexicanos.

BARRIO DE TLAXCALA

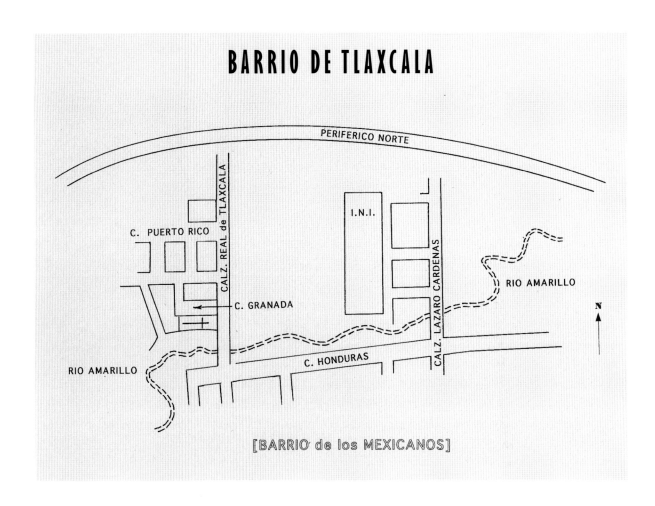

[BARRIO de los MEXICANOS]

B ARRIO DE TLAXCALA, at the northwest end of the city limits adjacent to Barrio de los Mexicanos, sits in a flat plain near Río Amarillo. It originally served as the district designated for the Indians from Tlaxcala who arrived with Diego de Mazariegos in 1528. It is bordered by Periférico Norte and the densely populated Colonia La Hormiga on the north, the Río Amarillo on the south, the compound of the Instituto Nacional de Indígenas on the east, and a broad floodplain that follows the river on the west. Barrio de Tlaxcala appears small in comparison to other barrios, with newer construction and little evidence of its long history as one of the original districts of the city. This may be due to its low-lying location and proximity to Río Amarillo, an area once heavily flooded during the rainy season. Changes in the drainage of excess water from the entire valley have now decreased annual flooding, resulting in new houses being constructed here. No craft, industry, or significant structures remain within its boundaries.

The feast of the patroness of Barrio de Tlaxcala, *La Coronación de la Virgen* (the Coronation of the Virgin), is celebrated on 18 August, three days after the festival honoring the Assumption of the Virgin in adjacent Barrio de los Mexicanos. The small barrio church on Calzada Real de Tlaxcala lies northwest of the recently constructed covered bridge that separates Barrio de Tlaxcala from Barrio de los Mexicanos. The simple church, with an unremarkable architectural style, has a rustic wooden cross installed on the apex of the façade. The few remaining colonial houses, scattered throughout the barrio, are surrounded by newer and more modern ones. Two iron roof crosses and one wooden cross can be seen along Calzada Real de Tlaxcala, which begins at the covered bridge and extends to Periférico Norte.

BARRIO DE SAN RAMÓN

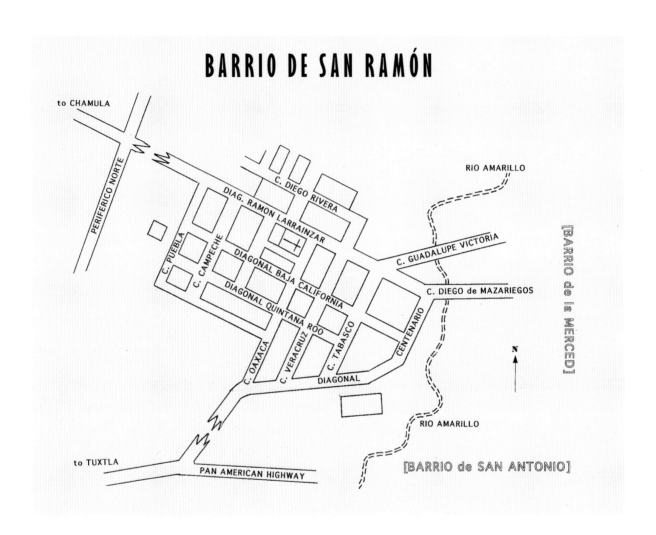

to CHAMULA

PERIFÉRICO NORTE

RIO AMARILLO

[BARRIO de la MERCED]

DIAG. RAMON LARRAINZAR

C. DIEGO RIVERA

C. PUEBLA

C. CAMPECHE

DIAGONAL BAJA CALIFORNIA

DIAGONAL QUINTANA ROO

C. OAXACA

C. VERACRUZ

C. TABASCO

DIAGONAL

C. GUADALUPE VICTORIA

C. DIEGO de MAZARIEGOS

CENTENARIO

N

RIO AMARILLO

to TUXTLA

PAN AMERICAN HIGHWAY

[BARRIO de SAN ANTONIO]

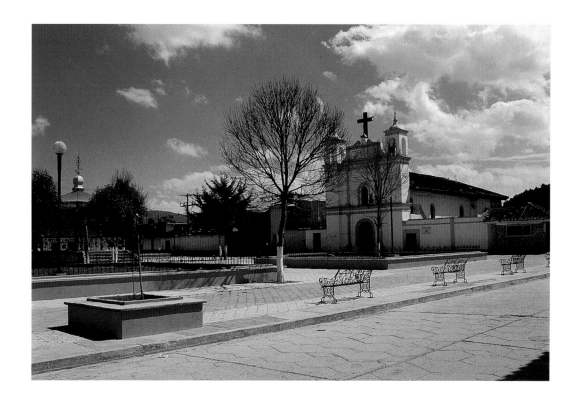

ARRIO DE SAN RAMÓN, home to the potters and tile makers of the city, serves as the western gateway into San Cristóbal de Las Casas. Diagonal Centenario leads off the main highway coming from Tuxtla Gutiérrez at the intersection between a monumental statue of Fray Bartolomé de Las Casas and a new theater completed in 1993 right before the Zapatista uprising. It divides at the Puente Blanco over Río Amarillo and proceeds east as Calle Diego de Mazariegos into Barrio de la Merced and the Zona Central, and continues northwest as Diagonal Ramón Larrainzar, the main street of Barrio de San Ramón. This thoroughfare terminates at Periférico Norte, where it then continues as the Chamula Road, passing through Colonia de la Quinta and on to the Tzotzil communities of San Juan Chamula, Zinacantán, San Andrés Larrainzar, and San Pedro Chenalhó.

Barrio de San Ramón was created in the mid-1800s, around the same year as Barrio de Guadalupe, to accommodate the increasing population in

BARRIO DE SAN RAMÓN. The expansive plaza in front of the barrio church provides a common meeting place for the residents.

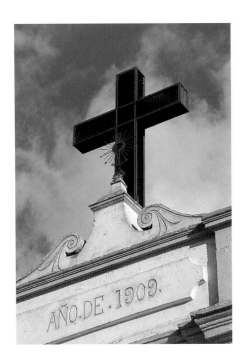

CHURCH OF SAN RAMÓN.
A large, modern cross
overshadows an older iron cross
with its distinctive lightning-like
projections.

the older barrios. The Church of San Ramón, in the heart of the barrio and dedicated to San Ramón Nonato (Saint Raymond), who is honored on his feast day of 31 August, has the date 1909 on its façade. At the apex of this façade, is a modern stained-glass Latin cross illuminated from within by electric lights. In front of it, and almost obscured by its massive shape, stands an older iron cross painted an ochre color. The apical orb of the cross, an example of STYLE VI, is surrounded by twelve radiating, jagged, lightning-bolt-like extensions and twelve additional extensions topped with pointed stars. These ornaments may have some relationship to the history of this barrio, which suffered inundations throughout the colonial period and until the mid-1970s, when a permanent drainage system was built to relieve flooding of the entire valley during the rainy seasons. This modest church, located off Diagonal Ramón Larrainzar, is fronted by a paved and tree-lined plaza. Several small houses, brightly painted and crowned with wooden roof crosses, border its park-like square.

Barrio San Ramón, with its own daily market and the only pottery factory in San Cristóbal, is set apart by natural and man-made boundaries. It is enclosed on the south by Diagonal Centenario, Río Amarillo on the east, Calle Puebla on the west, and Calle Diego Rivera and Periférico Norte to the north. The streets are named after the states of Mexico: Puebla, Campeche, Oaxaca, Veracruz, Tabasco, Quintana Roo, Baja California, and others. Of the forty-four roof crosses that can be seen on houses in Barrio San Ramón, most on older homes along Diagonal Ramón Larrainzar, twenty-six are of iron and the remaining eighteen of wood. Several small subdivisions of houses constructed from cement blocks and sharing common walls surround the core of the barrio. One of these newer residential sections, Colonia Echevarría located to the east of Diagonal Ramón Larrainzar and off Calle Diego Rivera, is the only neighborhood in San Cristóbal where twelve identical iron roof crosses can be seen. Of recent fabrication, but in the style of older roof crosses, they exemplify STYLE I, solid cruciforms with rosettes at their centers and open, diamond-shaped finials. All, located on houses within a two-block radius, are of similar construction and apparently designed by the same artisan.

BARRIO DE SANTA LUCÍA

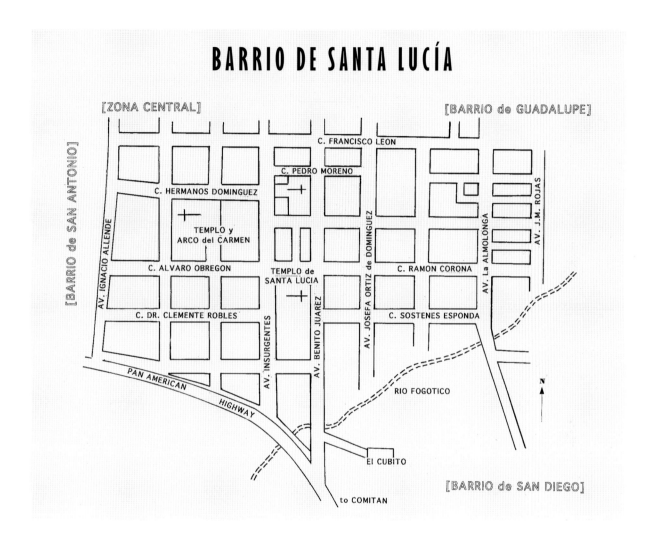

[ZONA CENTRAL]

[BARRIO de GUADALUPE]

[BARRIO de SAN ANTONIO]

C. FRANCISCO LEON

C. PEDRO MORENO

C. HERMANOS DOMINGUEZ

AV. IGNACIO ALLENDE

TEMPLO y
ARCO del CARMEN

C. ALVARO OBREGON

TEMPLO de
SANTA LUCIA

AV. JOSEFA ORTIZ de DOMINGUEZ

C. RAMON CORONA

AV. La ALMOLONGA

AV. J.M. ROJAS

C. DR. CLEMENTE ROBLES

AV. INSURGENTES

AV. BENITO JUAREZ

C. SOSTENES ESPONDA

PAN AMERICAN

HIGHWAY

RIO FOGOTICO

N

El CUBITO

[BARRIO de SAN DIEGO]

to COMITAN

JUST AS BARRIO DE GUADALUPE developed to accommodate the expansion of Barrio del Cerrillo, Barrio de Santa Lucía was founded for similar reasons in the mid-1800s in the southeast section of the city, adjacent to Barrio de Guadalupe and Barrio de San Diego. Avenida Insurgentes, one of the two major entrances into San Cristóbal de Las Casas from the Pan American Highway (MEXICO 190), runs through Barrio de Santa Lucía in a northerly direction on its route to the Plaza Central. Except for this busy thoroughfare, flanked on both sides with small businesses and restaurants,

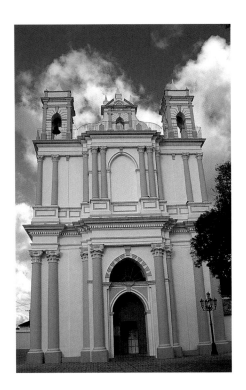

CHURCH OF SANTA LUCÍA.
One of the larger barrio churches
in San Cristóbal de Las Casas.

the barrio is primarily residential. Its boundaries extend to the east of Avenida Insurgentes with a smaller section off to the west.

The site of the Church of Santa Lucía, sitting back off Avenida Insurgentes and fronted by a small, intimate plaza, was a hermitage for Barrio de San Diego in the colonial period. The current structure, dating to the time when Barrio de Santa Lucía was established, has suffered major damage from earthquakes, first in the early 1900s and then more recently in 1979 and 1995. A date of 1909 appears on the façade, marking the year of the first major reconstruction. The charming church, in neoclassic style, is dedicated to the martyr Santa Lucía, whose feast is celebrated on 13 December. This tall, impressive structure, painted white and trimmed in a delicate blue hue, gives the impression of a brightly frosted wedding cake.

Craftsmen, mainly carpenters and stonemasons, reside in Barrio de Santa Lucía, which has streets named after well-known individuals in local and state history. Río Fogótico provides the natural border on the south, Avenida La Almolonga and Avenida J. M. Rojas on the east, Avenida Ignacio Allende on the west, and Calle Hermanos Domínguez and Calle Francisco Leon on the north. The Municipal Water District maintains a large headquarters at the southeast corner along Avenida La Almolonga. Many small open stalls, where residents buy their fresh fruits and vegetables, line this main avenue. The ruins of a once stately, double-towered colonial *capilla*, private chapel, can be viewed on Calle Sóstenes Esponda. Sixty-three roof crosses, twenty-eight of iron, thirty-two of wood, and three of cement, are scattered along the many quiet streets in this neighborhood. A representative sample of these can be seen clearly along Avenida Insurgentes near the barrio church and at the southern end of Avenida Benito Juárez.

BARRIO DE SAN ANTONIO

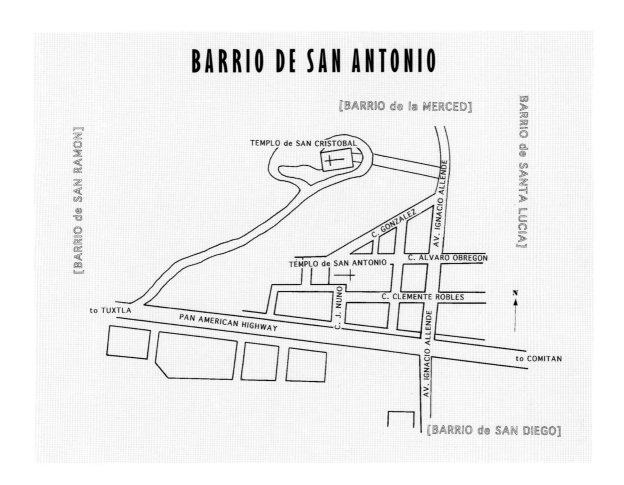

[BARRIO de la MERCED]

[BARRIO de SAN RAMON]

BARRIO de SANTA LUCIA]

TEMPLO de SAN CRISTOBAL

AV. IGNACIO ALLENDE

C. GONZALEZ

C. ALVARO OBREGON

TEMPLO de SAN ANTONIO

C. CLEMENTE ROBLES

C. J. NUÑO

N

to TUXTLA

PAN AMERICAN HIGHWAY

AV. IGNACIO ALLENDE

to COMITAN

[BARRIO de SAN DIEGO]

BARRIO DE SAN ANTONIO, one of the original barrios settled by the Indians from the Valley of Mexico who accompanied Diego de Mazarie-gos on his trail of conquest, has always supported only a small number of residents. Its general location, bounded by the Cerrito de San Cristóbal to the north on which stands Templo de San Cristóbal and the Pan American Highway (MEXICO 190) to the south, restricts any future growth. The Church of San Cristóbal, dedicated to Saint Christopher as the patron saint of the town, crowns the hilltop of the Cerrito, which offers a panoramic view of the valley as well as of Barrio de San Antonio. The road that leads off the highway to the Cerrito acts as the western edge of the barrio, while Avenida Ignacio Allende forms the eastern border. The limits of the barrio

extend across the highway along Avenida Ignacio Allende for a few short blocks, where the only iron roof cross in Barrio de San Antonio is located.

The colonial chapel of Barrio de San Antonio, dedicated to San Antonio de Padua (Saint Anthony of Padua), whose feast day is 13 June, was rebuilt in 1887. The barrio was once renowned for making fireworks and *cohetes*, the skyrockets considered essential to the celebration of any festival in San Cristóbal de Las Casas. With few commercial buildings located within its perimeters, the barrio has a residential ambience. Most houses are constructed from cement blocks and lack any suggestion of colonial architecture. Roof crosses do not appear popular here, perhaps because of the more contemporary materials used in house construction. Only two roof crosses were noted, one of iron, located along Avenida Ignacio Allende, and another of wood on a small house along Calle Alvaro Obregon.

BARRIO DE SAN DIEGO

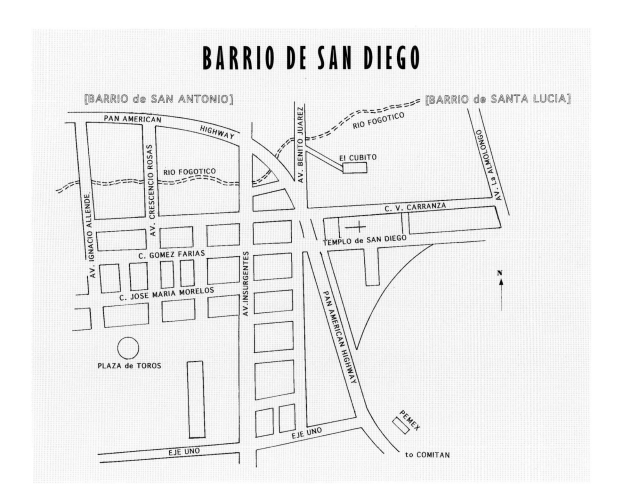

ARRIO DE SAN DIEGO, at the southeast end of San Cristóbal de Las Casas and divided by the Pan American Highway, was one of the two barrios founded for the Indians of Guatemala who accompanied Pedro de Portocarrero on his conquest. The Church of San Diego is located on the east side of the highway as it continues on to Teopisca, Comitán, and the international border with Guatemala. Dedicated to San Diego de Alcalá (Saint Didacus of Alcalá), the Franciscan lay brother whose feast is celebrated on 13 November, the church has had a troubled history. Originally constructed by Franciscan friars, it was destroyed by flood in 1651 and again in 1785. A date of *"14 de febrero 1946"* appears on the façade of the

present structure, indicating the most recent date of reconstruction. Two simple wooden crosses, a Latin cross on the nave and a patriarchal cross on the presbytery roof, are visible from the highway. Its plain outdoor atrium was once a favorite spot for Tzotziles to congregate and sell their bags of charcoal. In 2002, an elaborate wrought-iron fence was erected to enclose the entire atrium making it inaccessible to the itinerant vendors.

Barrio de San Diego is bounded by the Río Fogótico on the north, Calle José María Morelos on the south, Avenida La Almolonga on the east, and Avenida Ignacio Allende on the west. Avenida Insurgentes, the wide central thoroughfare of the barrio lined with small shops and outdoor vegetable stalls, is a southern extension of the main street that proceeds north to the Plaza Central of San Cristóbal. Just beyond the southern boundary of the barrio is the major bypass Eje Uno, which connects the Periférico with the Pan American Highway heading east. To the south of this bypass is another large outdoor market. While fourteen wooden crosses appear on several homes along this street, only two iron roof crosses are found in this barrio, both seen from the Pan American Highway. One tops the roof of a large modern private residence surrounded by high walls, and the other perches on the water tower of Hotel Maya Quetzal, the latter an example of STYLE VIII.

EL PERIFÉRICO

EL PERIFÉRICO, constructed in the late 1970s, encircles the city and offers an interesting perspective of the Valley of Jovel, as well as an appreciation for the effects of the increasing population on the physical boundaries of San Cristóbal de Las Casas (see map "Barrios of San Cristóbal de Las Casas"). This once small colonial town nestling in an ancient lake bed and guarded by the four sacred mountain peaks of the ancient Maya is rapidly changing. The forested hills that marked its periphery in the colonial era are now sites for growing *colonias* to accommodate the Indians expelled from indigenous communities because of their conversion to evangelism. In addition, as the demand for more construction increases, the hills are becoming barren from the mining of sand and stone, the basic building materials. The most expedient way to visit the outlying areas is by car. If you start the drive at Na Bolom, on the corner of Avenida Vicente Guerrero and Calle Chiapa de Corzo in Barrio del Cerrillo, you turn right on to Calzada Frans Blom and then almost immediately left on to Calzada Roberta. This short street takes you into Colonia de la Revolución, ending at the compound known as the Harvard Ranch.

In the early 1960s, this property provided housing and offices for the anthropologists associated with Harvard University who were involved in a twenty-year project to document the indigenous cultures of highland Chiapas. The central complex, no longer used by this university, is composed of four separate adobe buildings with tile roofs. The roof of each building has an iron cross, one of which is a copy of Cross 13 in the collection at Na Bolom and another a replica of a cross no longer in the collection. Since this is private property and not directly accessible to the street, it is necessary to get permission from the current residents to view these crosses. To the west of the ranch at the end of the street, a house has a roof cross very similar to Cross 3 in the collection at Na Bolom. Back along Calzada Roberta, turn west (right) for several blocks to Calle Ojo de Agua, which leads north to the Periférico. At Periférico Norte, turn left and proceed west, passing the Reserva Moxviquil, which was established by Pronatura Chiapas in 1997 to preserve over one hundred hectares of forest. The Maya ruins of Moxviquil, excavated by Frans Blom in the 1950s, stand to the east of the reserve on a hillside, not visible from the Periférico. Continue along

to Colonias de Mazariegos and de la Hormiga, where many Indians expelled from their communities now reside in newly established evangelical settlements. There are no roof crosses here, as the evangelists discourage such overt symbols.

At the major crossroads near the western border of Barrio de San Ramón, turn right (north) along the heavily traveled road that leads to the Indian communities of San Juan Chamula, Zinacantán, San Andrés Larrainzar, and San Pedro Chenelhó. Several kilometers along this busy connecting road you pass two large structures on the west side. The first is a recently constructed building that houses El Centro Asistencial para Indígenas, a social welfare office that administers to the needs of the indigenous population. A large roof cross crowns the building, an example of STYLE V. A few hundred meters along the road you come to La Quinta Esquipulas, the remnants of one of several *labores*, or agricultural lands, that once surrounded San Cristóbal, the major source of wheat for the five colonial mills of the city. Note the iron roof cross, another example of STYLE V, that remains at the center of the roof on the pillar-lined portico. This cross, dating to at least the early 1900s, offers a view of how these ornaments can best be appreciated on a colonial-style building. In 1993, La Quinta was totally remodeled to serve as a restaurant for tourists on their way to visit nearby Indian villages. In 1997, the restaurant was relocated a few kilometers to the north along this road to San Juan Chamula.

Retrace your steps through the small Colonia de la Quinta and back to Periférico Norte. At the intersection, turn right (west) and continue on the route. The paved road winds past a children's park on the left, a popular recreational spot for families on Sundays, and several private homes then enters a commercial district where large bottling and distributing companies are located. At the major intersection, cross the Pan American Highway (MEXICO 190) and continue along the Periférico, which now becomes Periférico Sur. To the left you can see the outline of the city's *panteón* (cemetery) and the broad bypass that connects to the main highway leading east toward Comitán and the Mexican border with Guatemala.

A stop at the *panteón*, where you can view a microcosm of the social structure that exists within San Cristóbal, is well worth the time. Elaborate

mausoleums line the main path from the entry, where members of prominent families are entombed. Roof crosses crown several of these structures, extending the tradition from houses of the living to those of the dead. On the periphery of the cemetery, are graves with large stone markers, and beyond are those either unmarked or adorned with simple wooden crosses. Frans and Gertrude Blom are buried in this cemetery at a site distinguished by an elaborate grave cover. After Frans's death in 1963, Gertrude Blom commissioned this stone carving of a foliated cross, representing the maize god and the central axis of the Maya world, as it was depicted on a panel of a temple at Palenque. At the foot of this famous Maya cruciform, stalks the jaguar she added in recognition of the familiar emblem often associated with Frans Blom and Na Bolom. In December 1993, Gertrude Blom was laid to rest here beside her husband.

Just beyond the *panteón* is a major intersection leading west towards the recently completed toll road to Tuxtla Gutiérrez and east to the bypass Eje Uno, which returns to the Pan American Highway. Continuing along the Periférico, you find several large *fincas*, or tracts of land for income-producing crops, located in this once rural area now being impacted by housing developments to accommodate the ever-increasing population. Note the four iron crosses that appear on the dome and façade of the church at Colonia de los Sumideros. On a hill to the right (south) side of the Periférico, stands the Hotel Molino de la Alborada, a small guest ranch built in the late 1960s by an American couple, Wally and Francese Franklin, who retired to San Cristóbal. Friends of Frans and Gertrude Blom, they had several of the roof crosses in the collection at Na Bolom copied and installed on the roofs of their guest cottages situated along the gently sloping hillside. After the death of the Franklins, the property was sold in the early 1990s, but the hotel continues operating under the management of a Mexican corporation. Just beyond the Hotel Molino de la Alborada and a warehouse for a local bottle distributing company turn left at Avenida Insurgentes. The road, which leads back into town, cuts through Colonia de María Auxiliadora, where many houses display wooden roof crosses. The road continues in front of the new market that opened in 1995. The intent of having a second market was to reduce the traffic flow through the center of San

FRANS BLOM'S GRAVE.
Stone carving depicting the foliated cross at Palenque marks the site of Blom's burial in the *panteón* of San Cristóbal de Las Casas.

Cristóbal to the old market at the northern edge of Barrio del Cerrillo, as well as to serve the growing population at the south end of town. A new municipal building is just beyond the intersection with the bypass Eje Uno.

Turn right on this bypass, and after a short distance turn right again (east) onto the Pan American Highway. At the second gasoline station (Pemex) on the left, turn left to the Periférico, which circles the eastern edge of the city. The road winds over a small bridge that crosses Río Fogótico and then up the hill toward Barrio de la Garita. Here you come to an intersection where a road leads east to the Tzeltal community of Tenejapa. Less than one kilometer along this road going east are several iron roof crosses on houses situated on both sides. Return to the intersection, which rejoins the Periférico, and proceed north to the eastern border of Cuxtitali. Turn left onto a narrow road that leads to the barrio, past the church of Cuxtitali to Calzada Frans Blom, and back to Na Bolom.

After completing this circle, you may want to stop for one last visit to the Frans Blom Iron Roof Cross Collection, where, after having viewed the many older crosses throughout San Cristóbal de Las Casas, you will better appreciate what motivated Frans Blom to begin his collection. Over a half century later, although a few faithful residents continue the custom, the hope for the survival of the craft rests in the hands of a small number of *herreros* who still turn to his collection for inspiration.

AFTERWORD

N FEBRUARY 2003, an exhibition dedicated solely to iron roof crosses opened in La Casa de la Cultura in San Cristóbal de Las Casas. The stark, white walls of the gallery accented the black forms of some fifty newly fabricated crosses that represent the designs and styles described in this study. All those on display were crafted by students and faculty of Centro de Capacitación para el Trabajo Industrial No. 133 (CECATI), an industrial arts school established in San Cristóbal to promote and preserve traditional crafts. Nineteen of the crosses on view were replicas of ones from the Frans Blom Iron Roof Cross Collection. The others were copies of crosses extant on roofs in the older barrios of the city or original creations by the ironworkers. The public showing of this body of work not only affirmed the goal of the school to maintain traditional crafts through specialized training but also awarded the students recognition for their accomplishments. In addition, the exhibit reminded the local residents of one of their more important artistic traditions as well as verified the presence of a new generation of craftsmen prepared to continue the ironworker's trade. It also explored the economic viability of a small-scale industry to produce iron crosses.

A comparison between the crosses from the exhibition and those described in this book illustrates the differences between the new and old ironwork techniques as well as the current state of the craft. The most apparent variation is in how these young artisans, working under the aegis of CECATI, embellish the crosses. They prefer to add ornaments as individual pieces to the cruciform rather than to bend and shape the iron with

hand tools to achieve the aesthetic results. The majority of the new crosses in the exhibit were larger than older examples, made from heavier iron, and often appeared cumbersome in contrast to the graceful crosses traditional *herreros* fabricated specifically for roofs. While the crosses on display were technically correct, their larger dimensions made them more suitable for wall hangings than for roof ornaments. The most subtle difference that sets the iron crosses fabricated at CECATI apart from crosses made prior to the 1960s, however, is the absence of the *herreros'* "fingerprints" on each cross. These imprints are the remnants of long hours spent working the iron with hand tools over the heat of their forges.

Just as these old *herreros* rarely offered ready-made roof crosses for sale in their workshops, none of the crosses on exhibit were for sale. Instead, after the month-long showing, the crosses went into a permanent display of students' works in a gallery set aside on the campus of CECATI. Here anyone can view them, select one from the array, and then commission a copy to be made as a special order. Because of their size and elaborate ornamentation, the cost of these crosses is often three to five times more than those fabricated in the traditional *herrería*, a price that may be prohibitive for local people seeking an iron cross for the roof of their home. While such items may appeal to tourists as a reminder of their visit to Chiapas, the dimensions of the crosses might discourage more practical travelers trying to limit the size and weight of their baggage. The clientele may ultimately be the gallery owner, collector, and the purveyor from Mexico or abroad who specializes in ethnic arts from this region. What is of interest is how similar these recently forged iron crosses are to the older ones described in this book, and how the influence of the Frans Blom Iron Roof Cross Collection continues to prevail. In addition, all of the crosses in the exhibit are easily recognized by their style and design as originating from San Cristóbal de Las Casas.

Although much has happened in the past decade since I first began this study of iron roof crosses in the early 1990s, the collection at Na Bolom remains intact. The number of roof crosses visible on houses in the barrios, however, has decreased by approximately 10 percent. While several of the older crosses I documented on roofs have disappeared, it is noteworthy

that very few new ones have been added. In those years as I walked through the streets of San Cristóbal de Las Casas in search of roof crosses, I had the opportunity to observe other changes occurring in the town. I witnessed the increasing presence of tourists and the opening of new shops filled with the wares of artisans eager to accommodate visitors' desires for local crafts, including iron roof crosses. The unexpected 1994 Rebellion in Chiapas, however, suddenly cut off this surge of visitors, who heeded advisories warning of the possible dangers in traveling to this region. The decline in tourism had an immediate negative impact on the artisan trade, and only the older and more established shops were able to withstand the decline.

As the tenth anniversary of the 1994 Rebellion approaches on the first day of January 2004, there is a widespread concern over how the date will be observed. On this day in 2003, more than twenty thousand Zapatista sympathizers crowded into the central Parque and the plaza in front of the cathedral. While this show of solidarity was peaceful, many residents of San Cristóbal de Las Casas fear that future demonstrations could prove troublesome and again have an adverse impact on the tourist economy of highland Chiapas. Although in the last decade a philosophical shift has developed from a military to a political movement, as well as in the focus of activity from the jungle regions of Chiapas into the highlands, the struggle remains the same. It continues to represent a statement against free trade and a desire to guarantee the basic rights of the indigenous people. In spite of the potential of political unrest, nevertheless tourists are once again returning to Chiapas.

Thus, a clear window into the future is obscured by the uncertainty of how the political and social struggle will evolve. My prediction is that the threads of tradition strengthened by strong religious beliefs and family ties to old customs will continue to bind the fabric of this society in the new millennium. Use of roof crosses may eventually decline to a custom practiced only in the more traditional families. And if tourism continues as a viable industry, a renewed demand for artisan crafts will be supplied by the upcoming generation of ironworkers who are trained in the technical aspects of ironwork. As style options may have run their course due to the

limited possibilities in manipulating iron, innovation may come through the decorative elements of ornamentation. We are fortunate that the Frans Blom Iron Roof Cross Collection remains as a permanent record. This collection will continue to provide the quintessential source of inspiration for future ironworkers. They, perhaps more influenced by economic incentives than by maintaining a custom, will be the ones who interpret the desires of potential clients, and in their own way will breathe new life into the craft. Whereas the final result may well be fine decorative iron crosses, the original function as roof crosses may become a mere footnote to the history of this craft.

NOTES

1. Nelson Graburn, ed., *Ethnic and Tourist Arts: Cultural Expressions from the Fourth World* (Berkeley and Los Angeles: University of California Press, 1976), 1–32.
2. Gertrude Duby, *Chiapas Indígena* (México: Universidad Nacional Autónoma de México, 1961), 7.
3. Jacques Lafaye, *Quetzalcóatl and Guadalupe. The Formation of Mexican National Consciousness, 1531–1813.* Trans. from French by Benjamin Keen. (Chicago: University of Chicago Press, 1976), 153–157.
4. Beatriz Andrea Albores Zarate, *El funcionalismo en la etnografía tzeltal-tzotzil: un análisis de sus implicaciónes teóricas y políticas* (Tuxtla Gutiérrez, Chiapas, México: Universidad Autónoma de Chiapas, 1978), 39.
5. George Willard Benson, *The Cross, Its History and Symbolism* (New York: Hacker Art Books, 1983), 31–35.
6. John Dombrowski, Elinor C. Betters, Howard I. Blutstein et al., *Area Handbook for Guatemala* (Washington, D.C.: Government Printing Office, 1970), 120–122.
7. Enrique Marroquin, *La cruz mesianica. Una aproximación al sincretismo católico indígena* (Oaxaca, México: Universidad Autónoma "Benito Juárez" de Oaxaca, 1989), 41–43.
8. Jan de Vos, *Kibeltik. Nuestra Raíz* (México: Editorial Clío, 2001), 17.
9. Gudrun Lenkersdorf, *Génesis histórica de Chiapas: 1522–1532* (México: Universidad Nacional Autónoma de México, 1993), 155–197.
10. Jan de Vos, *San Cristóbal: ciudad colonial* (México: Instituto Nacional de Antropología e Historia, 1986), 69.
11. Andrés Aubry, *San Cristóbal de Las Casas: su historia urbana, demográfica y monumental, 1528–1990* (San Cristóbal de Las Casas, Chiapas, México: Instituto de Asesoría Antropológica para la Región Maya, A.C., 1991), 18–22.
12. de Vos, *San Cristóbal: ciudad colonial*, 17–18, 25–26.
13. Ibid., 25.
14. Charles Gibson, *Spain in America* (New York: Harper and Row, 1966), 34, 96.
15. Lenkersdorf, *Génesis histórica de Chiapas: 1522–1532*, 251–257.
16. Dombrowski et al., *Area Handbook for Guatemala*, 15.
17. Sidney David Markman, *Architecture and Urbanization in Colonial Chiapas, Mexico* (Philadelphia: The American Philosophical Society, 1984), 33–37.

18. Jan de Vos, *Fray Pedro Lorenzo de la Nada: Misionero de Chiapas y Tabasco* (Tuxtla Gutiérrez, Chiapas, México: Consejo Estatal para la Cultura y las Artes de Chiapas, 2001), 37–38.

19. Benson, *The Cross, Its History and Symbolism*, 82–89.

20. Interview with Señor Manuel Burguete Estrada, chronicler of the city of San Cristóbal de Las Casas, 2 August 1995, San Cristóbal de Las Casas.

21. Joseph L. Cassidy, *Mexico: Land of Mary's Wonders* (Paterson, N.J.: St. Anthony Guild Press, 1958), 127–134.

22. Manuel Burguete Estrada, unpublished and untitled manuscript regarding *La Virgen del Rayo*, 1995.

23. *Novena a Nuestra Señora del Rayo* (México: Licencia Eclesiástica, n.d.), 1–16.

24. *Devoción a la Santa Cruz de Jerusalem* (México: Aprobación Eclesiástica, n.d.), 1–8.

25. Donald Bush Cordry and Dorothy M. Cordry, "Costumes and Weaving of the Zoque Indians of Chiapas, Mexico," *Southwest Museum Papers* 15 (1941): 28–32.

26. Florence H. Pettit and Robert M. Pettit, *Mexican Folk Toys: Festival Decorations and Ritual Objects* (New York: Hastings House Publishers, 1978), 124.

27. Virginia B. de Barrios, *The Cross in Mexico. A Guide to Churches, Saints, Symbols, Celebrations, Pilgrimage Sites, and Religious Art* (México: Editorial Minutiae Mexicana, S.A. de C.V., 1997), 40–42.

28. Norine Dresser, "The *Chupacabra:* An Expression of Real-World Anxiety," *Los Angeles Times*, 25 May 1996.

29. Mark Fineman, "Tales of Bloodthirsty Beast Terrify Mexico," *Los Angeles Times*, 19 May 1996.

30. Deborah Colvin, personal communication regarding story of *chupacabra* in Barrio de los Mexicanos, 21 August 1996, San Cristóbal de Las Casas.

31. Kazuyasu Ochiai, *Cuando los santos vienen marchando: rituales públicos intercomunitarios tzotziles* (Tuxtla Gutiérrez, Chiapas, México: Universidad Autónoma de Chiapas, 1985), 127–142.

32. Virginia Ann Guess, "Visiting Saints of Chiapas," *El Palacio* 88, no. 3 (1982): 14–22.

33. Gary H. Gossen, *Chamulas in the World of the Sun: Time and Space in a Maya Oral Tradition* (Cambridge, Mass.: Harvard University Press, 1974), 158.

34. Evon Z. Vogt, *Zinacantán: A Maya Community in the Highlands of Chiapas* (Cambridge, Mass.: Harvard University Press, 1969), 375.

35. Evon Z. Vogt, *Tortillas for the Gods: A Symbolic Analysis of Zinacanteco Rituals* (Cambridge, Mass.: Harvard University Press, 1976), 44–58.

36. Thor Anderson, "Kruston: A Study of House and Home in a Maya Village," unpublished paper submitted to the Department of Anthropology, Harvard University, 1975, 145–147.

37. Ian Graham and Eric von Euw, *Yachilán*, Vol. 3, Part 1 of *Corpus of Maya Hieroglyphic Inscriptions* (Cambridge, Mass.: Harvard University Press, 1977), 53.

38. Linda Schele and Mary Ellen Miller, *The Blood of Kings: Dynasty and Ritual in Maya Art* (Fort Worth, Tex.: Kimbell Art Museum, 1986), 268–269.

39. Paul Westheim, *Arte antiguo de México* (México: Fondo de Cultura Económica, 1950), 221.

40. David Freidel, Linda Schele, and Joy Parker, *Maya Cosmos: Three Thousand Years on the Shaman's Path* (New York: William Morrow and Company, 1993), 400.

41. The Guild of Straw Craftsmen, *Thatched Roof Ornaments*, http://www.strawcraftsmen. co.uk/finials.html, 25 September 2002.

42. *Arquitectura-arte decorativo* (Barcelona, Spain: Casellas Moncanut Hnos, 1925), Vol. 8, Plate 84.

43. George M. Foster, *Culture and Conquest: America's Spanish Heritage* (New York: Wenner-Gren Foundation for Anthropological Research, Viking Fund Publications in Anthropology No. 27, 1960), 127, 151, 190.

44. Written communication from George M. Foster, 12 October 1996.

45. August L. Mayer, *Architecture and Applied Arts in Old Spain* (New York: Bretano's, 1921), 72.

46. Robert Wauchope, *Modern Maya Houses: A Study of Their Archaeological Significance* (Washington, D.C.: Carnegie Institution, 1938), 115–116.

47. Cordry and Cordry, "Costumes and Weaving of the Zoque Indians of Chiapas, Mexico," 28–31.

48. Matthew W. Stirling, "On the Trail of La Venta Man," *The National Geographic Magazine* 91, no. 2 (1947): 151, 172.

49. Interview with Señor Isidro Gómez Nabuelú, 6 July 2001, Suchiapa, Chiapas.

50. Virginia Guess and Robert Guess, "*Tillandsia guatemalensis:* La Flor del Niño," *Journal of the Bromeliad Society* 48, no. 6 (1998): 257, 260.

51. Interview with Señor Cicerón Cuesta Grajales, historian and resident of Chiapa de Corzo, 15 August 1996, Chiapa de Corzo.

52. Interview with Señor Jorge Ramos Aguilar (Don Jorge), resident of San Cristóbal de Las Casas, 24 June 1997, San Cristóbal de Las Casas.

53. William J. Lippincott, *Color Is South: An Exhibit of Mexican Arts and Crafts, Ancient and Modern* (Santa Fe, N.M.: Museum of International Folk Art, 1957), 16.

54. Porfirio Martínez Peñaloza et al., *Arte popular mexicano* (México: Editorial Herrero, S. A., 1975), 112.

55. Verna Cook Shipway and Warren Shipway, *Mexican Homes of Today* (New York: Architectural Book Publishing Co., 1964), 143.

56. Carlos Navarrete, *La fuente colonial de Chiapa de Corzo: encuentro de historias* (Tuxtla Gutiérrez, Chiapas, México: Gobierno del Estado de Chiapas, 1991), 35.

57. Elizabeth Wilder Weismann, *Americas: The Decorative Arts in Latin America in the Era of the Revolution* (Washington, D.C.: Smithsonian Institution Press, 1976), 28.

58. Patricia Fent Ross, *Made in Mexico* (New York: Alfred A. Knopf, 1952), 220–223.

59. Leonard Williams, *The Arts and Crafts of Older Spain* (London and Edinburgh: T. N. Foulis, 1907), Vol.1, 123–159.

60. Manuel Toussaint, *Colonial Art in Mexico*, trans. and ed. by Elizabeth Wilder Weismann (Austin: University of Texas Press, 1967), 67.

61. Luz Elena Cervantes, *El cobre y el hierro en la artesanía mexicana* (México: Fondo Nacional para el Fomento de las Artesanías, 1982), 33.

62. Janine Gasco, "Economic History of Ocelocalco, a Colonial Soconusco Town," in *Ancient Trade and Tribute: Economies of the Soconusco Region of Mesoamerica*, edited by Barbara Voorhies (Salt Lake City: University of Utah Press, 1989), 319–320.

63. Pál Keleman, *Folk Baroque in Mexico: Mestizo Architecture through the Centuries* (Washington, D.C.: Smithsonian Institution Press, 1974), 21 of the introduction to this unpaginated catalog.

64. Luis Pérez Bueno, *Hierros artísticos españoles de los siglos XII al XVIII* (Barcelona, Spain: Editorial y Librería de Arte, 1900), 10, 21; Figures 114–117.
65. Ibid., Figure 118.
66. María Elena Grajales, "La cruz procesional de Tapalapa," *Cultura Sur* 1, no. 6 (1990): 29–30.
67. Jorge Olvera, *La plata colonial de Chiapas* (Tuxtla Gutiérrez, Chiapas, México: Universidad Autónoma de Chiapas, 1992), 37, 49.
68. Patrice A. Marvin and Nicholas C. Vroomin, "Iron Spirits: Decorative Crosses on the North Dakota Plains," *Clarion* (Magazine of the Museum of American Folk Art, New York) 8, nos. 2–3 (1983): 26, 31.
69. Marija Gimbutas, *Ancient Symbolism in Lithuanian Folk Art*, Memoirs of the American Folklore Society, Philadelphia, 49 (1958): 1–15. Additional information at http://www.culture.lt/crests/en.html, "Crests and Sacred Arts in Lithuania," 25 September 2002.
70. Aubry, *San Cristóbal de Las Casas: su historia urbana, demográfica y monumental, 1528–1990*, 28.
71. Interview with Señor Carmen Penagos, *herrero* of San Cristóbal de Las Casas, 17 August 1995.
72. Toussaint, *Colonial Art in Mexico*, 369.
73. Graham Greene, *The Lawless Roads* (New York: Viking Penguin Books, 1982), 173–196.
74. Elektra y Tonatiuh Gutiérrez, "El arte popular de México," *Artes de México*, Número Extraordinario (México: Comercial Nadrosa, 1970–1971), 110.
75. Graburn, *Ethnic and Tourist Arts: Cultural Expressions from the Fourth World*, 31.
76. Elizabeth Wilder Weismann, *Mexico in Sculpture, 1521–1821* (Cambridge, Mass.: Harvard University Press, 1950), 189.
77. Ibid., 189–190.
78. Angela Moscarella, "Maestro herrero en Puebla," *México Desconocido* 17, no. 198 (1993): 31.
79. Interviews with Tomás Johnson, founder of Cloudforest Initiatives, based in San Cristóbal de Las Casas, Chiapas, and in St. Paul, Minnesota, 4 July 2002 and 22 July 2002, San Cristóbal de Las Casas.
80. Information from brochure on course work at Centro de Capacitación para el Trabajo Industrial No. 133 (CECATI), training center located in Colonia de María Auxiliadora, San Cristóbal de Las Casas, 2002.
81. Personal communication with Aaron Johnson-Ortiz, 4 July 2002, San Cristóbal de Las Casas. He collaborates with and provides the designs for the Tzotzil-speaking artisans associated with Cloudforest Initiatives, based in San Cristóbal de Las Casas.
82. Personal communication with Patricia La Farge of *que Tenga BUENA MANO*, Santa Fe, New Mexico, 22 November 1995. A description of different artistic expressions of the cross, *The Southern Way of the Cross* (Santa Fe, N.M.: El Rancho de Las Golondrinas, 1992), accompanied a 1992 exhibition of her collection at El Rancho de Las Golondrinas.
83. Verna Cook Shipway and Warren Shipway, *Houses of Mexico: Origins and Traditions* (New York: Architectural Book Publishing Co., 1970), 196.
84. Ivan Vazquez, "Cañaris y sus ritos religiosos," Guayaquil, Ecuador: *El Universo: Noticias de Ecuador y el Mundo*, 7 de agosto, 1996, 7.

85. Personal communication with Eleanor Hopewell of Ethnic Arts, Berkeley, California, 11 December 1996.

86. Guillermo de Zéndegui, "Antigua: Monument of the Americas," *Américas* 26, no. 5 (1975): s1–16.

87. Personal communication with Samuel K. Clark, Ann Arbor, Michigan, March 1997. In the 1980s, he commissioned two crosses from an ironworker in Antigua, Guatemala, who provided him with a book that included many designs of old crosses from which to choose. Both examples appear here in illustration 6 and illustration 7. Another cross in his collection from Quito, Ecuador, appears in illustration 5.

88. Navarrete, *La fuente colonial de Chiapa de Corzo: encuentro de historias,* 35.

89. Louise C. Millikan, "A Joyful Art: The Crafts of Peru," *Américas* 30, nos. 11–12 (1978): 49–54.

90. Marion Oettinger, Jr., *The Folk Art of Latin America: Visiones del Pueblo* (New York: Museum of American Folk Art, 1992), 34.

91. Imelda de León, *Calendario de fiestas populares* (México: Dirección General de Culturas Populares, 1988), 251–253.

92. Frans Blom, *En el lugar de los grandes bosques: epistolario 1919–1922 y diarios de dos expediciónes* (Tuxtla Gutiérrez, Chiapas, México: Gobierno del Estado de Chiapas, 1990), 119–227.

93. Frans Blom and Oliver La Farge, *Tribes and Temples: A Record of the Expedition to Middle America Conducted by the Tulane University of Louisiana in 1925* (New Orleans: Tulane University, 1927), Vol. 2, 401–407.

94. Robert L. Brunhouse, *Frans Blom, Maya Explorer* (Albuquerque: University of New Mexico Press, 1976), 114–145.

95. Alex Harris and Margaret Sartor, eds. *Gertrude Blom Bearing Witness* (Chapel Hill: University of North Carolina Press, 1984), 12–15.

96. Taped interview with Señora Beatriz Mijangos Zenteno (Doña Bety), 12 July 1995, Na Bolom, San Cristóbal de Las Casas.

97. Fabiola Sánchez Balderas, *Cruces de hierro forjado: arte popular de San Cristóbal de Las Casas* (Tuxtla Gutiérrez, Chiapas, México: Consejo Estatal para la Cultura y las Artes de Chiapas, 2000), 25–26. Images in the book are copies of photographs that accompanied my unpublished manuscript entitled "Inventory of Iron Crosses in the Na Bolom Collection," 1995, placed in La Biblioteca Fray Bartolomé de Las Casas at Na Bolom as a record of my initial work. These images, plus three additional illustrations drawn for me by Will Ouimet, were used without my permission or without acknowledging Mr. Ouimet.

98. Charlotte M. Cardon, "Gertrude Blom and the Maya," *Pacific Discovery* 29, no. 2 (1976): 2.

99. M. R. Harrington, "A Visit to the House of the Jaguar," *The Masterkey* 32, no. 6 (1958): 185.

100. Gertrude Duby Blom, *The Story of Na-Bolom* (San Cristóbal de Las Casas, Chiapas, México, n.d., circa 1970), 6.

101. Harrington, "A Visit to the House of the Jaguar," 184.

102. Evon Z. Vogt, *Fieldwork Among the Maya. Reflections on the Harvard Chiapas Project* (Albuquerque: University of New Mexico Press, 1994), 217.

103. Interview with Señora Jovita González, owner of Los Baños Mercedarios, Barrio de la Merced, 7 August 1997, San Cristóbal de Las Casas.

104. Benson, *The Cross, Its History and Symbolism*, 47–56.

105. Ralph Mayer, *A Dictionary of Art Terms and Techniques* (New York: Thomas Y. Crowell, 1969), 99–100.

106. Richard D. Perry, *More Maya Missions: Exploring Colonial Chiapas* (Santa Barbara, Calif.: Espadaña Press, 1994), 38, 44, 60, 104. The author's illustrations provide an excellent guide to the many features noted on the colonial churches of Chiapas.

107. Johannes Troyer, *The Cross As Symbol and Ornament* (Philadelphia: Westminster Press, 1961), 15.

108. Gertrud Schiller, *Iconography of Christian Art* (Greenwich, Conn.: New York Graphic Society, 1972), Vol. 2, 109.

109. Benson, *The Cross, Its History and Symbolism*, 105–112.

110. Markman, *Architecture and Urbanization in Colonial Chiapas, Mexico*, 282.

111. Leopoldo Castedo, *Historia del arte iberoamericano*, Vol. 1, *Precolombino. El arte colonial* (Madrid, Spain: Alianza Editorial, 1988), 200–202.

112. Taped interview with Señora Beatriz Mijangos Zenteno (Doña Bety), 12 July 1995, Na Bolom, San Cristóbal de Las Casas.

113. Markman, *Architecture and Urbanization in Colonial Chiapas, Mexico*, 33.

114. James Hall, *Illustrated Dictionary of Symbols in Eastern and Western Art* (London: John Murray, 1994), 157.

115. Juan Ferrando Roig, *Iconografía de los santos* (Barcelona, Spain: Ediciónes Omega, S. A., 1950), 246, 292.

116. Susan Milbrath, *Star Gods of the Maya: Astronomy in Art, Folklore, and Calendars* (Austin: University of Texas Press, 1999), 23.

117. Octavio Paz, *Sor Juana, or, the Traps of Faith* (Cambridge, Mass.: Harvard University Press, 1988), 472.

118. Freidel, Schele, and Parker, *Maya Cosmos: Three Thousand Years on the Shaman's Path*, 61.

119. Jennifer Speake, *The Dent Dictionary of Symbols in Christian Art* (London: J M Dent, 1994), 134.

120. Albores Zarate, *El funcionalismo en la etnografía tzeltal-tzotzil: un análisis de sus implicaciónes teóricas y políticas*, 50.

121. Weismann, *Mexico in Sculpture, 1521–1821*, 9–11.

122. Benson, *The Cross, Its History and Symbolism*, 180–181.

123. Freidel, Schele, and Parker, *Maya Cosmos: Three Thousand Years on the Shaman's Path*, 251.

124. Donald E. Thompson, "Maya Paganism and Christianity. A History of the Fusion of Two Religions," *Middle American Research Institute Publication* 19 (1954): 11–22.

125. Peter Beagle, "Introduction," *The Fellowship of the Ring*, Part 1 of *The Lord of the Rings*, by J. R. R. Tolkien (New York: Ballantine Books, 1973), iii.

126. Arnold Whittick, *Symbols for Designers. A Handbook on the Application of Symbols and Symbolism to Design* (London: Crosby Lockwood and Son, 1935), 127–128.

127. Freidel, Schele, and Parker, *Maya Cosmos: Three Thousand Years on the Shaman's Path*, 332–334.

128. Troyer, *The Cross As Symbol and Ornament*, 55, 111. Troyer presents several variations of the Celtic cross. The particular one I reference is shown in illustration 2 and is seen in Cross 3 and Cross 31.

129. Walter F. Morris, Jr., *Living Maya* (New York: Harry N. Abrams, 1987), 8, 219, 222, 223.

130. Freidel, Schele, and Parker, *Maya Cosmos: Three Thousand Years on the Shaman's Path,* 399.

131. Whittick, *Symbols for Designers. A Handbook on the Application of Symbols and Symbolism to Design,* 158.

132. Ibid., 64.

133. Rebecca Bruns, "Mountain City of the Maya," *Travel & Leisure,* April 1991, 103.

134. Schele and Miller, *The Blood of Kings: Dynasty and Ritual in Maya Art,* 158.

135. Freidel, Schele, and Parker, *Maya Cosmos: Three Thousand Years on the Shaman's Path,* 149.

136. Ibid., 57, 73.

137. de Vos, *Kibeltik. Nuestra Raíz,* 174.

138. Keleman, *Folk Baroque in Mexico: Mestizo Architecture through the Centuries,* 19–28 of introduction to this unpaginated catalog.

139. Robert M. Adams, "Changing Patterns of Territorial Organization in the Central Highlands of Chiapas, Mexico," *American Antiquity* 26, no. 3 (1961): 341.

140. Dombrowski et al., *Area Handbook for Guatemala,* 122.

141. Ibid., 15.

142. Benjamin N. Colby, *Ethnic Relations in the Chiapas Highlands of Mexico* (Santa Fe, N.M.: Museum of New Mexico Press, 1966), 5–6.

143. de Vos, *San Cristóbal: ciudad colonial,* 69.

144. Schele and Miller, *The Blood of Kings: Dynasty and Ritual in Maya Art,* 268–269.

GLOSSARY

adorno	An object used as a decoration or an ornament.
albañiles	Stonemasons, bricklayers, construction workers.
ancient Maya	Early inhabitants of the New World who spoke various Mayan languages and built monumental ceremonial centers in Guatemala, Honduras, Belize, as well as Yucatán, Chiapas, Campeche, and Tabasco, Mexico, during the late preclassic through the postclassic periods (200 B.C. to A.D. 1200).
anticipo	An advance for a commissioned work, often half the total price of the item.
Antigua	City founded in 1524 as Santiago de los Caballeros, the first capital of la Capitanía General de Guatemala; noted for its colonial architecture; destroyed by earthquakes in 1541, 1717, and 1773.
atrium cross	A Latin cross of stone or wood erected in the courtyard of a colonial church.
audiencia	A judicial body as well as a territorial designation established by Spain to administer regions in the New World during the colonial period.
aureole	A symbol of radiance emanating from the image of a holy personage; frequently used in medieval and Renaissance art.
axis mundi	Term applied to the center of the world; frequently used in reference to the Maya cosmos.[136]
balconería	Workshop of a *herrero* who uses welding in the fabrication of grill-work and other metal products.
baroque	The ornate art style of the seventeenth and eighteenth centuries, which ironworkers in the Americas incorporated into their crafts.
barrio	A neighborhood or district of a town, often identified with a specific trade and/or ethnic group.
boss	A raised, knob-like ornament.
botonée	A decorative motif arranged in a cluster of three buttons or knobs.

canonization	The elevation to sainthood after the formal procedure outlined by the Catholic church to attain that status is completed.
casita	A small house or shelter.
cast iron	A hard, nonmalleable iron alloy formed by pouring iron in the molten state into a mold.
ceiba	A large tropical tree belonging to the silk-cotton tree family considered sacred by the ancient Maya.
Celtic cross	A Latin cross with a circle surrounding the axis placed closer to the finials than to the axis.
Chamulas	Modern Maya who speak Tzotzil and live in the municipality of San Juan Chamula, a few kilometers north of San Cristóbal de Las Casas.
Chiapa	The western province of el Reino de Guatemala during the colonial period; annexed by Mexico in 1824.
Chiapa de Corzo	Founded in 1528 by Capitán Diego de Mazariegos as the first town established in Chiapa by the Spaniards; renowned for its brick Mudejar-style fountain constructed in 1562 in the central plaza.
Chiapanecs	Ethnic group that migrated into the Central Depression of Chiapas between A.D. 500 and A.D. 900 to settle near present-day Chiapa de Corzo.
Chiapaneco	A resident of the state of Chiapas.
Ch'oles	Ch'ol-speaking Maya of northern Chiapas.
chupacabra	A mythical nocturnal vampire-like creature believed to cause mischief at night.
cincel	A chisel, the basic tool of ironworkers for shaping iron pieces.
cofradía	A religious brotherhood established to care for a particular saint and to carry out community traditions.
cohete	A homemade skyrocket, about one meter long, composed of a reed tail, topped by a cane cylinder filled with charcoal and saltpeter then packed with newspaper wadding.
coletos	Colloquial name for longtime residents of San Cristóbal de Las Casas.
colonia	A subdivision or district within a town.
colonial period	Time span from 1521 to 1821 when New Spain and el Reino de Guatemala were under the dominion of Spain.
comedor	A dining room.
conquistadores	Sixteenth-century Spanish soldiers who participated in the conquest of the New World.
convento	The residential section of a monastery.
corolla	The modified leaves or petals of a flower.
coronal motif	An artistic theme based on a crown, circle, or wreath.
costumbres	The beliefs, customs, and habits that belong specifically to an indigenous culture, such as religious rites, style of dress, crafts, and medical practices.[137]

cruciform	A form in the shape of a cross.
Cuenca	A once-powerful city of the Inca located along the Inca road from Cuzco, Peru, to Quito, Ecuador; early colonial city founded by the Spaniards on the same site.
Cuenca Valley	The region of central Ecuador that extends north from Cuenca to Cañar and south to Loja.
culata del canal	The end of the cement channel at a roof ridge or peak of a roof.
curandera/o	A female/male healer.
design	A plan, drawing, or sketch outlining basic features of an object.
Dominicans	Friars belonging to the Dominican Order, founded in 1215 by Saint Dominic, who evangelized the Indians and established monastery churches in el Reino de Guatemala during the colonial period.
Doña/Don	A title of respect used with a man or woman's given or Christian name.
el Reino de Guatemala	The Kingdom of Guatemala; a designation used in the colonial period for the territory, including Chiapas and all of Central America except Panama.
emboss	A relief formed by pounding metal outwards from the reverse side.
finca	A tract of land dedicated to income-producing crops.
finials	The terminal decorative features on the arms and upright of a cross.
fleur-de-lis	An ornamental motif based on a stylized lily or iris; a symbol often depicted with Saint Dominic, the founder of the Dominican Order.
folk baroque	A style of art that developed in Mexico as a result of blending native artistic elements with Christian iconography and baroque motifs.[138]
folk Catholicism	A form of Catholicism that incorporates Catholic doctrines with popular practices, such as a strong devotion to *santos* and membership in *cofradías*.
folk saint	A holy personage most often neither canonized nor recognized as a legitimate saint by the Catholic church.
forge	A furnace in which metal is heated until it is malleable and can be shaped into the desired form.
Greek cross	Two bars of equal length intersecting perpendicularly at their mid-points.
herrería	Workshop of an ironworker or a blacksmith who uses a charcoal-fed forge as the primary source of heat to shape iron.
herrero	An ironworker or blacksmith.
highland Chiapas	The central plateau of Chiapas inhabited from the early classic period up to the present by Maya people who maintain their own languages and customs.[139]
iconography	Description of pictures, symbols, or images represented in art.
implements of the Crucifixion	The tools used at the Crucifixion of Christ, such as hammer, nails, pincers, ladder, and spear.

implements of the Passion	The objects associated with the few days prior to the Crucifixion of Christ that represent his suffering, including a crown of thorns, scepter, whips, dice, and a crowing cock.
Inca	The ethnic group that controlled much of what is today Ecuador and Peru at the time of the Spanish conquest.
Indian Catholicism	A form of Catholicism in which indigenous people blend their pre-Hispanic rites with the liturgy of the Catholic church.[140]
jovel	The marsh grass that grew in the valley where San Cristóbal de Las Casas is now located; once used as roofing material by the indigenous inhabitants.
labores	Agricultural lands dedicated to the cultivation of crops such as wheat.
Lacandones	A small Maya group who live in the lowland jungles of southeastern Chiapas.
la Capitanía General de Guatemala	Political territory during the colonial period, also referred to as el Reino de Guatemala, that included Chiapas and all of Central America except Panama; under the control of a captain-general appointed by and responsible to the Spanish Crown; officially separated from the viceroyalty of New Spain in 1560.[141]
Ladino	An ethnic designation based on cultural and genetic traits; used in Chiapas and Guatemala for *mestizos* and for acculturated Indians who speak Spanish, dress in Western-style clothing, and no longer live in their indigenous communities.[142]
Latin cross	A cross in which the upright (vertical bar) is longer than the arms (perpendicular bar) and the two intersect above the midpoint of the upright.
madrina	The ceremonial kinship name for a female sponsor or godmother.
mayordomo	A religious or political leader in an indigenous community.
mestizo	People of mixed Indian and European genetic traits.
milpa	A small plot of land for cultivating corn, often interplanted with beans and squash.
mitre	A liturgical hat worn by a bishop to denote his ecclesiastical position and authority.
modern Maya	Living descendants of the ancient Maya who speak a Mayan language, maintain their social and cultural traditions distinct from Ladino society, and live in autonomous communities.
moline	A decorative motif in which the ends are forked with two pointed tongues coursing outwards in the shape of a millstone rynd.
monstrance	An ornate receptacle used to contain the consecrated host during rituals of the Catholic church.
municipio	A municipality or political district established within a state.
nacimiento	Crèche; representation of the Nativity scene with figures of the Christ Child, Mary, Joseph, and the shepherds.

New Spain	Territory of the New World during the colonial period claimed by Spain and under the central control of a government established in Mexico City; included all of Mexico and part of southern United States.
noche buena	Christmas Eve, 24 December.
novena	The nine days of special prayers that precede the feast day of a saint.
ogee	A pointed arch with a reversed curve on each side of the apex.
olla	A clay cooking vessel with a broad mouth.
open design	A pattern with a space between the major design elements; a negative silhouette, or outline.
orb	A spherical body such as a celestial sphere.
orthodox Catholicism	An expression of the Catholic religion that strictly follows the doctrines and dogmas established by the Papacy in Rome.
padrino	The ceremonial kinship name for a male sponsor or godfather.
panteón	A cemetery.
paseo	A street or walkway dedicated to pedestrian traffic.
patriarchal cross	A Latin cross with an additional shorter bar intersecting the upright above the main and longer arm.
pattée	Decorative motif in which the arms narrow at the center and expand in an outward direction towards the ends.
peregrinaciónes	Pilgrimages often done on foot to honor a *santo*, to fulfill a promise, or as an act of penance.
plaza	A square, or open space, in the center of town or in front of a church.
posada	An inn or small hotel for travelers.
posh	Corn liquor.
pre-Columbian	The period of time preceding the arrival of Christopher Columbus in the New World; often used interchangeably with pre-Hispanic.
pre-Hispanic	The period of time preceding the arrival of the Spanish *conquistadores* in the Americas; often used interchangeably with pre-Columbian.
processional cross	An ornate cruciform often made of precious metal, mounted on a wooden staff, and carried by the lead person in a line of devotees participating in a ceremonial rite.
quatrefoil	A cluster of four petals, divisions, or lobes; four-lobed design.
rayo	Lightning bolt.
reja	Ornate grillwork or grating placed in front of an opening, such as a window, for decoration or security.
remache	The technique used to join two pieces of iron with a rivet.
rezadora/rezador	A female or male prayer specialist who conducts rites and recites special prayers in private homes where *santos* are honored.
rivet	A bolt with a head used to join two pieces of metal.
roof cross	A cruciform mounted on the roof and designed to be viewed from the front and the back.

roof ridge	The peak of the roof where the courses of tiles meet.
rosette	An ornament resembling the shape of a rose, usually a cluster of tightly placed petals arranged in a circle.
San Cristóbal de Las Casas	Colonial city in highland Chiapas founded in 1528 by Diego de Mazariegos that served as the first capital of the state of Chiapas from 1828 to 1892. Since its founding, it has had ten different names: Villa Real de Chiapa(1528–1529); Villaviciosa de Chiapa (1529–1531); San Cristóbal de Los Llanos de Chiapa (1531–1536); Ciudad Real de Chiapa and Chiapa de los Españoles (1536–1829); San Cristóbal (1829–1848); San Cristóbal Las Casas (1848–1934); Ciudad Las Casas (1934–1943); San Cristóbal de Las Casas (1943–present); and the local name of *Jovel* used by the native inhabitants.[143]
Santa Cruz	A belief centered on the protective power of the holy cross; in its symbolic representation, *Santa Cruz* lacks the body of the crucified Christ; the advocate of the stonemasons (*albañiles*) in Mexico and Latin America.
santo	A statue or image of a saint.
serpentine	Winding, turning, sinuous form resembling a serpent.
serrated	Marked with notches or tooth-like projections.
Soconusco	A province of el Reino de Guatemala that included the Pacific coastal plain of present-day Chiapas.
soldadura	The technique of joining metallic surfaces with a melted metal, metallic alloy (soldering), or intensive heat (welding).
solid design	A totally dark pattern that yields a silhouette.
St. Andrew's cross	A cross composed of two inclined arms of equal length intersecting at their midpoints in the shape of an "X."
style	The combination of features that gives a distinctive character to an artistic expression.
syncretism	An assimilation or combination of beliefs and/or practices that result in a different system.
talisman	An object that conveys power on those who display, wear, or own it.
teja	A roof tile made of fired clay; common roofing material in the highlands of Chiapas.
templo	A church or place of worship; term occasionally used to refer to the Catholic churches in San Cristóbal de Las Casas.
trefoil	An ornamental design composed of three divisions, or "foils"; three lobes or buttons in the shape of a cloverleaf.
Tzeltal	The Mayan language spoken by a group of indigenous people living in Chiapas.
Tzeltales	Present-day Maya who speak Tzeltal.
Tzotzil	The Mayan language spoken by a group of indigenous people living in Chiapas.

Tzotziles	Present-day Maya who speak Tzotzil.
varilla	Rounded iron employed as reinforcing bars in construction.
Valley of Jovel	Familiar name for the valley in which San Cristóbal de Las Casas is located.
viceroyalty	A political unit directed by a viceroy, who was the highest ranking representative of the monarchy; a division of the New World that eventually led to establishing national boundaries in the Americas.
volute	A scroll or spiral motif.
wall cross	An ornate cross, usually without a point, designed to hang on a wall with the decorative features facing outwards.
world tree	The center of the world, or axis mundi, in Maya cosmology; the symbolic connection between three realms: that of the living, the celestial, and the underworld or realm of the dead; at Palenque the tree is depicted as a cross with arms, and the celestial bird is perched at the apex.[144]
wrought iron	Metal that has been heated until malleable and hammered into an iron object.
zaguán	An entry or vestibule.
Zinacantecs	Modern Maya who speak Tzotzil, maintain their cultural heritage, and live in the municipality of Zinacantán, a few kilometers west of San Cristóbal de Las Casas.
Zoque	A non-Maya group that occupied western Chiapas, including the present site of Tuxtla Gutiérrez, at the time the Spaniards arrived in 1524.

BIBLIOGRAPHY

Adams, Robert M. "Changing Patterns of Territorial Organization in the Central Highlands of Chiapas, Mexico." *American Antiquity* 26, no. 3 (1961):341–360.

Albores Zarate, Beatriz Andrea. *El funcionalismo en la etnografía tzeltal-tzotzil: un análisis de sus implicaciónes teóricas y políticas*. Tuxtla Gutiérrez, Chiapas, México: Universidad Autónoma de Chiapas, 1978.

Anderson, Thor. "Kruston: A Study of House and Home in a Maya Village." Unpublished paper submitted to the Department of Anthropology, Harvard University, 1975.

Arquitectura-arte decorativo. Barcelona, Spain: Casellas Moncanut Hnos, 1917–1926.

Aubry, Andrés. *San Cristóbal de Las Casas: su historia urbana, demográfica y monumental, 1528–1990*. San Cristóbal de Las Casas, Chiapas, México: Instituto de Asesoría Antropológica para la Región Maya, A.C., 1991.

Beagle, Peter. "Introduction." *The Fellowship of the Ring*, Part I. *The Lord of the Rings*, by J. R. R. Tolkien, iii. New York: Ballantine Books, 1973.

Benson, George Willard. *The Cross, Its History and Symbolism*. New York: Hacker Art Books, 1983.

Blom, Frans. *En el lugar de los grandes bosques: epistolario 1919–1922 y diarios de dos expediciónes*. Tuxtla Gutiérrez, Chiapas, México: Gobierno del Estado de Chiapas, 1990.

Blom, Frans, and Oliver La Farge. *Tribes and Temples: A Record of the Expedition to Middle America Conducted by the Tulane University of Louisiana in 1925*. 2 vols. New Orleans: Tulane University, 1926–1927.

Brunhouse, Robert L. *Frans Blom, Maya Explorer*. Albuquerque: University of New Mexico Press, 1976.

Bruns, Rebecca. "Mountain City of the Maya." *Travel & Leisure*, April 1991, 96–105, 154–162.

Cardon, Charlotte M. "Gertrude Blom and the Maya." *Pacific Discovery* 29, no. 2 (1976):1–9.

Cassidy, Joseph L. *Mexico: Land of Mary's Wonders*. Paterson, N.J.: St. Anthony Guild Press, 1958.

Castedo, Leopoldo. *Historia del arte iberoamericano*. Vol. 1, *Precolombino. El arte colonial*. Madrid, Spain: Alianza Editorial, 1988.

Cervantes, Luz Elena. *El cobre y el hierro en la artesanía mexicana*. México: Fondo Nacional para el Fomento de las Artesanías, 1982.

Colby, Benjamin N. *Ethnic Relations in the Chiapas Highlands of Mexico*. Santa Fe, N.M.: Museum of New Mexico Press, 1966.

Cordry, Donald Bush, and Dorothy M. Cordry. "Costumes and Weaving of the Zoque Indians of Chiapas, Mexico." *Southwest Museum Papers,* no. 15. Los Angeles, California: Southwest Museum, 1941.

de Barrios, Virginia B. *The Cross in Mexico: A Guide to Churches, Saints, Symbols, Celebrations, Pilgrimage Sites, and Religious Art.* México: Editorial Minutiae Mexicana, S.A. de C.V., 1997.

de León, Imelda. *Calendario de fiestas populares.* México: Dirección General de Culturas Populares, 1988.

Devoción a la Santa Cruz de Jerusalem. México: Aprobación Eclesiástica, n.d.

de Vos, Jan. *San Cristóbal: ciudad colonial.* México: Instituto Nacional de Antropología e Historia, 1986.

——. *Fray Pedro Lorenzo de la Nada: Misionero de Chiapas y Tabasco.* Tuxtla Gutiérrez, Chiapas, México: Consejo Estatal para la Cultura y las Artes de Chiapas, 2001.

——. *Kibeltik. Nuestra Raíz.* México: Editorial Clío, 2001.

de Zéndegui, Guillermo. "Antigua: Monument of the Americas." *Américas* 26, no. 5 (1975): s1–16. Washington, D.C.: Organization of American States.

Dombrowski, John, Elinor C. Betters, and Howard I. Blutstein et al. *Area Handbook for Guatemala.* Washington, D.C.: Government Printing Office, 1970.

Dresser, Norine. "The *Chupacabra*: An Expression of Real–World Anxiety." *Los Angeles Times,* 25 May 1996.

Duby, Gertrude. *Chiapas Indigena.* México: Universidad Nacional Autónoma de México, 1961.

Duby Blom, Gertrude. *The Story of Na–Bolom.* San Cristóbal de Las Casas, Chiapas, México: Gertrude Duby Blom, circa 1970.

Fineman, Mark. "Tales of Bloodthirsty Beast Terrify Mexico." *Los Angeles Times,* 19 May 1996.

Foster, George M. *Culture and Conquest: America's Spanish Heritage.* Wenner–Gren Foundation for Anthropological Research, Viking Fund Publications in Anthropology, no. 27. New York: Wenner–Gren Foundation, 1960.

Freidel, David, Linda Schele, and Joy Parker. *Maya Cosmos: Three Thousand Years on the Shaman's Path.* New York: William Morrow and Company, 1993.

Gasco, Janine. "Economic History of Ocelocalco, a Colonial Soconusco Town." In *Ancient Trade and Tribute: Economies of the Soconusco Region of Mesoamerica,* edited by Barbara Voorhies, 304–325. Salt Lake City: University of Utah Press, 1989.

Gibson, Charles. *Spain in America.* New York: Harper and Row, 1966.

Gimbutas, Marija. *Ancient Symbolism in Lithuanian Folk Art.* Memoirs of the American Folklore Society, 49. Philadelphia: American Folklore Society, 1958.

Gossen, Gary H. *Chamulas in the World of the Sun: Time and Space in a Maya Oral Tradition.* Cambridge, Mass.: Harvard University Press, 1974.

Graburn, Nelson, ed. *Ethnic and Tourist Arts: Cultural Expressions from the Fourth World.* Berkeley and Los Angeles: University of California Press, 1976.

Graham, Ian, and Eric von Euw. *Corpus of Maya Hieroglyphic Inscriptions.* Vol. 3, part 1 *Yachilán.* Cambridge, Mass.: Harvard University Press, 1977.

Grajales, María Elena. "La cruz procesional de Tapalapa." *Cultura Sur* 1, no. 6 (1990):29–30.

Greene, Graham. *The Lawless Roads.* New York: Viking Penguin Books, 1982.

Guess, Virginia Ann. "Visiting Saints of Chiapas." *El Palacio* 88, no. 3 (1982):14–22.

Guess, Virginia, and Robert Guess. "*Tillandsia guatemalensis:* La Flor del Niño." *Journal of the Bromeliad Society* 48, no. 6 (1998):257–264.

Gutiérrez, Elektra y Tonatiuh. "El arte popular de México." *Artes de México,* Número Extraordinario. México: Comercial Nadrosa, S.A., 1970–1971.

Hall, James. *Illustrated Dictionary of Symbols in Eastern and Western Art*. London: John Murray, 1994.

Harrington, M. R. "A Visit to the House of the Jaguar." *The Masterkey* 32, no. 6 (1958): 184–185. Los Angeles, Calif.: Southwest Museum.

Harris, Alex, and Margaret Sartor, eds. *Gertrude Blom Bearing Witness*. Chapel Hill: University of North Carolina Press, 1984.

Keleman, Pál (Text). Photographs by Judith Hancock de Sandoval. *Folk Baroque in Mexico: Mestizo Architecture through the Centuries*. Washington, D.C.: Smithsonian Institution Press, 1974.

La Farge, Patricia. *The Southern Way of the Cross*. Santa Fe, N.M.: El Rancho de Las Golondrinas, 1992.

Lafaye, Jacques. *Quetzalcóatl and Guadalupe. The Formation of Mexican National Consciousness, 1531–1813*, translated from French by Benjamin Keen. Chicago: University of Chicago Press, 1976.

Lenkersdorf, Gudrun. *Génesis histórica de Chiapas: 1522–1532*. México: Universidad Nacional Autónoma de México, 1993.

Lippincott, William J. *Color Is South: An Exhibit of Mexican Arts and Crafts, Ancient and Modern*. Santa Fe, N.M.: Museum of International Folk Art, 1957.

Markman, Sidney David. *Architecture and Urbanization in Colonial Chiapas, Mexico*. Philadelphia: American Philosophical Society, 1984.

Marroquin, Enrique. *La cruz mesianica. Una aproximación al sincretismo católico indígena*. Oaxaca, México: Universidad Autónoma "Benito Juárez" de Oaxaca, 1989.

Martínez Peñaloza, Porfirio et al. *Arte popular mexicano*. México: Editorial Herrero, S.A., 1975.

Marvin, Patrice A., and Nicholas C. Vroomin. "Iron Spirits: Decorative Crosses on the North Dakota Plains." *Clarion* 8, nos. 2–3 (1983): 24–31. New York: Magazine of the Museum of American Folk Art.

Mayer, August L. *Architecture and Applied Arts in Old Spain*. New York: Bretano's, 1921.

Mayer, Ralph. *A Dictionary of Art Terms and Techniques*. New York: Thomas Y. Crowell, 1969.

Milbrath, Susan. *Star Gods of the Maya: Astronomy in Art, Folklore, and Calendars*. Austin: University of Texas Press, 1999.

Millikan, Louise C. "A Joyful Art: The Crafts of Peru." *Américas* 30, nos. 11–12 (1978): 49–54. Washington, D.C.: Organization of American States.

Morris, Walter F., Jr. *Living Maya*. New York: Harry N. Abrams, 1987.

Moscarella, Angela. "Maestro herrero en Puebla." *México Desconocido* 17, no.198 (1993): 28–31.

Navarrete, Carlos. *La fuente colonial de Chiapa de Corzo: encuentro de historias*. Tuxtla Gutiérrez, Chiapas, México: Gobierno del Estado de Chiapas, 1991.

Novena a Nuestra Señora del Rayo. México: Licencia Eclesiástica, n.d.

Ochiai, Kazuyasu. *Cuando los santos vienen marchando: rituales públicos intercomunitarios tzotziles*. Tuxtla Gutiérrez, Chiapas, México: Universidad Autónoma de Chiapas, 1985.

Oettinger, Marion, Jr. *The Folk Art of Latin America: Visiones del Pueblo*. New York: Museum of American Folk Art, 1992.

Olvera, Jorge. *La plata colonial de Chiapas*. Tuxtla Gutiérrez, Chiapas, México: Universidad Autónoma de Chiapas, 1992.

Paz, Octavio. *Sor Juana, or, the Traps of Faith*. Cambridge, Mass.: Harvard University Press, 1988.

Pérez Bueno, Luis. *Hierros artísticos españoles de los siglos XII al XVIII*. Barcelona, Spain: Editorial y Librería de Arte, 1900.

Perry, Richard D. *More Maya Missions: Exploring Colonial Chiapas*. Santa Barbara, Calif.: Espadaña Press, 1994.

Pettit, Florence H., and Robert M. Pettit. *Mexican Folk Toys: Festival Decorations and Ritual Objects*. New York: Hastings House Publishers, 1978.

Roig, Juan Ferrando. *Iconografía de los santos*. Barcelona, Spain: Ediciónes Omega, S.A., 1950.

Ross, Patricia Fent. *Made in Mexico*. New York: Alfred A. Knopf, 1952.

Sánchez Balderas, Fabiola. *Cruces de hierro forjado: arte popular de San Cristóbal de Las Casas*. Tuxtla Gutiérrez, Chiapas, México: Consejo Estatal para la Cultura y las Artes de Chiapas, 2000.

Schele, Linda, and Mary Ellen Miller. *The Blood of Kings: Dynasty and Ritual in Maya Art*. Fort Worth, Tex.: Kimbell Art Museum, 1986.

Schiller, Gertrud. *Iconography of Christian Art*. 2 vols. Greenwich, Conn.: New York Graphic Society, 1972.

Shipway, Verna Cook, and Warren Shipway. *Mexican Homes of Today*. New York: Architectural Book Publishing Co., 1964.

———. *Houses of Mexico: Origins and Traditions*. New York: Architectural Book Publishing Co., 1970.

Speake, Jennifer. *The Dent Dictionary of Symbols in Christian Art*. London: J M Dent, 1994.

Stirling, Matthew W. "On the Trail of La Venta Man." *The National Geographic Magazine* 91, no. 2 (1947):137–172.

Thompson, Donald E. "Maya Paganism and Christianity. A History of the Fusion of Two Religions." *Middle American Research Institute Publication,* no.19,1–36. New Orleans: Tulane University, 1954.

Toussaint, Manuel. *Colonial Art in Mexico*, trans. and ed. by Elizabeth Wilder Weismann. Austin: University of Texas Press, 1967.

Troyer, Johannes. *The Cross As Symbol and Ornament*. Philadelphia: Westminster Press, 1961.

Vazquez, Ivan. "Cañaris y sus ritos religiosos." Guayaquil, Ecuador: *El Universo: Noticias de Ecuador y el Mundo*, 7 de agosto, 1996.

Vogt, Evon Z. *Zinacantán: A Maya Community in the Highlands of Chiapas*. Cambridge, Mass.: Harvard University Press, 1969.

———. *Tortillas for the Gods: A Symbolic Analysis of Zinacanteco Rituals*. Cambridge, Mass.: Harvard University Press, 1976.

——— .*Fieldwork Among the Maya. Reflections on the Harvard Chiapas Project*. Albuquerque: University of New Mexico Press, 1994.

Wauchope, Robert. *Modern Maya Houses: A Study of Their Archaeological Significance*. Carnegie Institution Publication No. 502. Washington, D.C.: Carnegie Institution, 1938.

Weismann, Elizabeth Wilder. *Mexico in Sculpture, 1521–1821*. Cambridge, Mass.: Harvard University Press, 1950.

———. *Americas: The Decorative Arts in Latin America in the Era of the Revolution*. Washington, D.C.: Smithsonian Institution Press, 1976.

Westheim, Paul. *Arte antiguo de México*. México: Fondo de Cultura Económica, 1950.

Whittick, Arnold. *Symbols for Designers. A Handbook on the Application of Symbols and Symbolism to Design*. London: Crosby Lockwood and Son, 1935.

Williams, Leonard. *The Arts and Crafts of Older Spain*. 3 vols. London and Edinburgh: T. N. Foulis, 1907.

INDEX